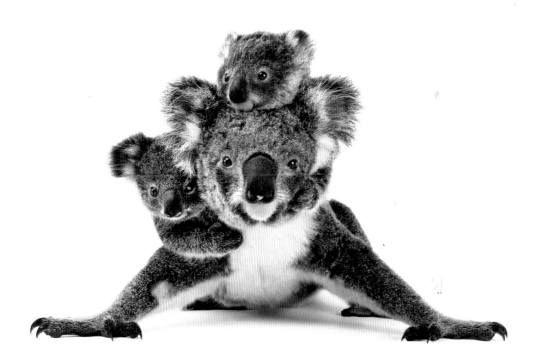

@NATGEO

THE MOST POPULAR Instagram PHOTOS

**NATIONAL
GEOGRAPHIC**

WASHINGTON, D.C.

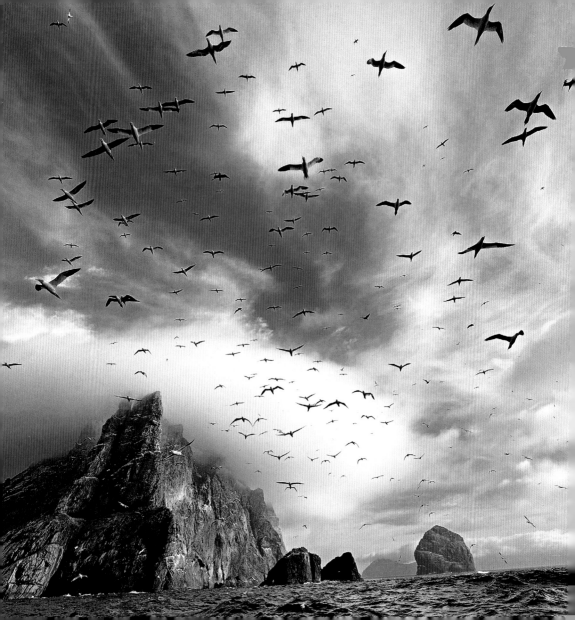

CONTENTS

PAGE 1: @JOELSARTORE *Augustine, a mother koala with her sons, Gus and Rupert, at the Australia Zoo*
OPPOSITE: @JIMRICHARDSONNG *A frenzy of gannet seabirds circle their roost on Boreray island in northern Scotland.*

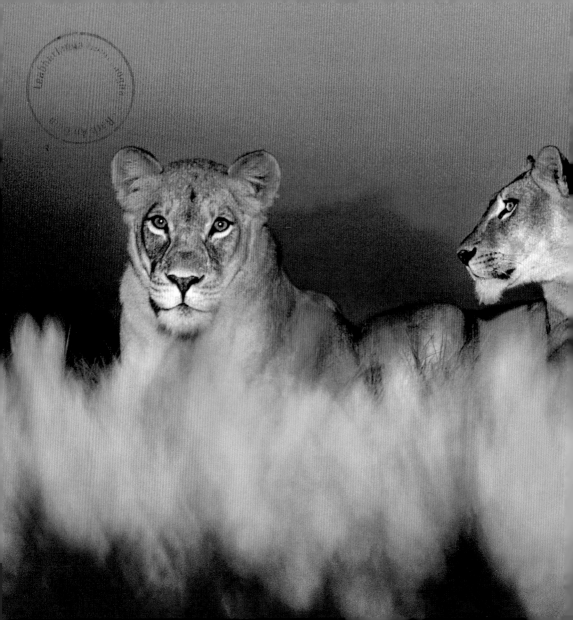

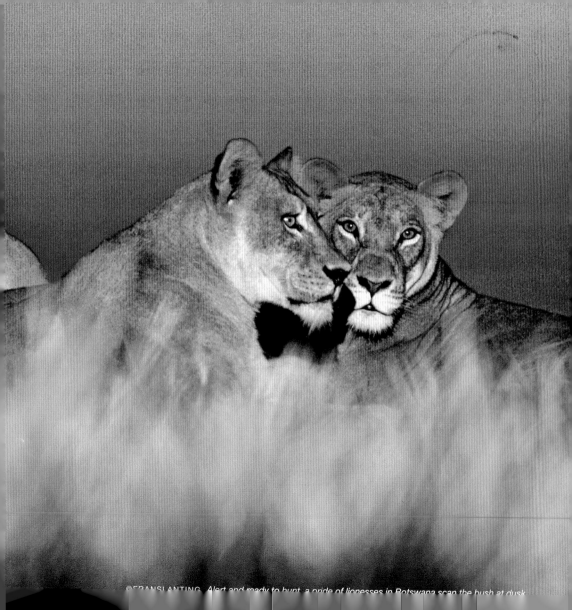

©FRANSLANTING *Alert and ready to hunt, a pride of lionesses in Botswana scan the bush at dusk.*

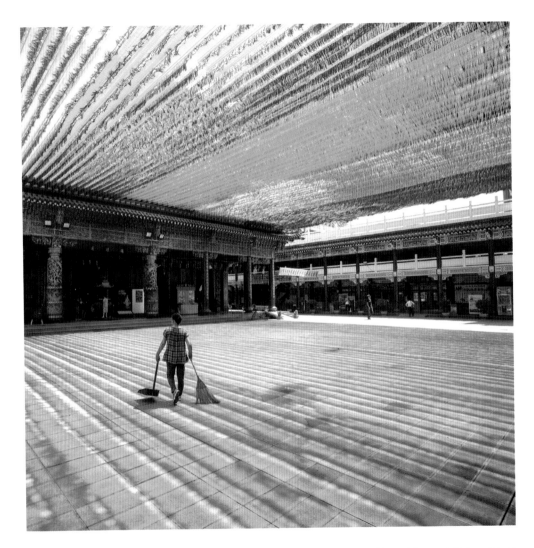

@YAMASHITAPHOTO *A rainbow-colored sunshade at a temple dedicated to Mazu, goddess of the sea, in Tainan, Taiwan*

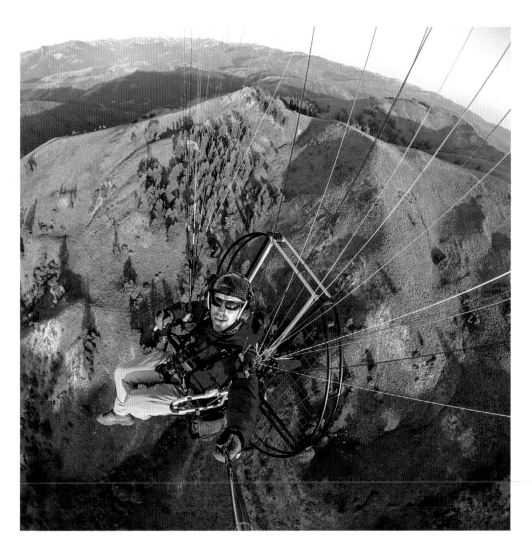

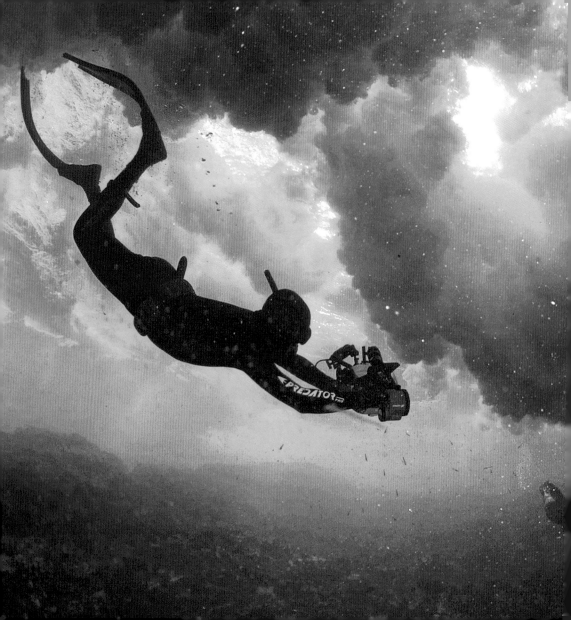

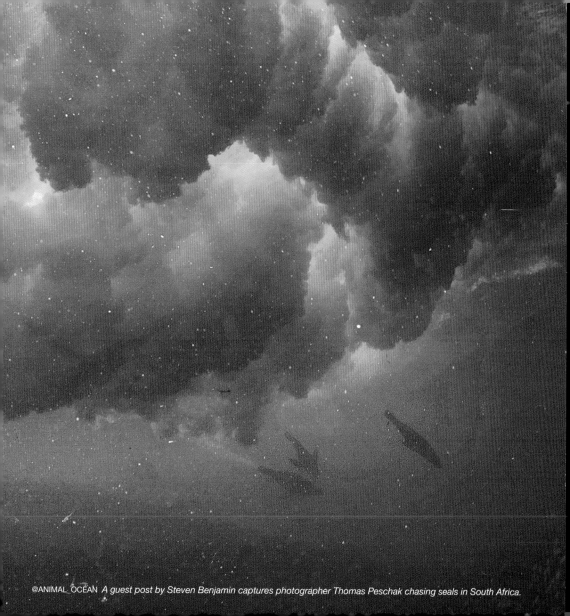

@ANIMAL_OCEAN *A guest post by Steven Benjamin captures photographer Thomas Peschak chasing seals in South Africa.*

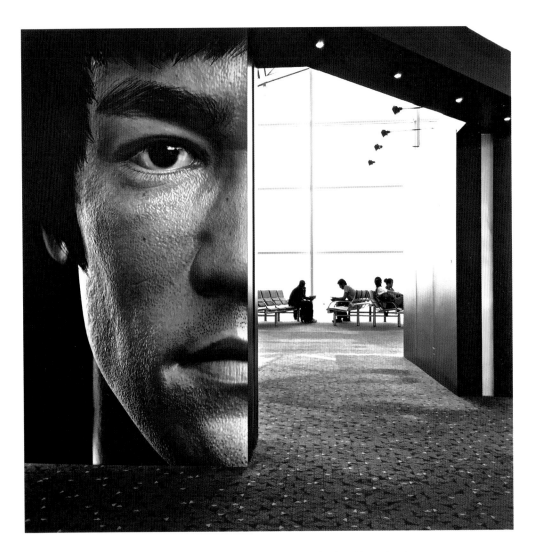

 A supersize portrait of Bruce Lee on exhibit at the Hong Kong airport

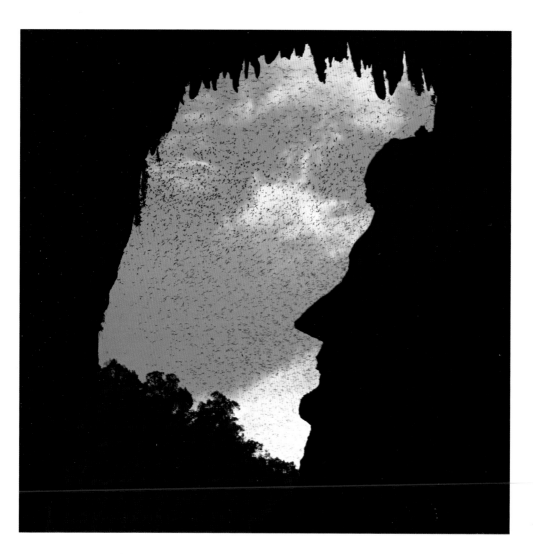

@SHONEPHOTO *Swarming bats fly by an uncanny likeness of Abe Lincoln at the entrance to Deer Cave in Borneo.* 13

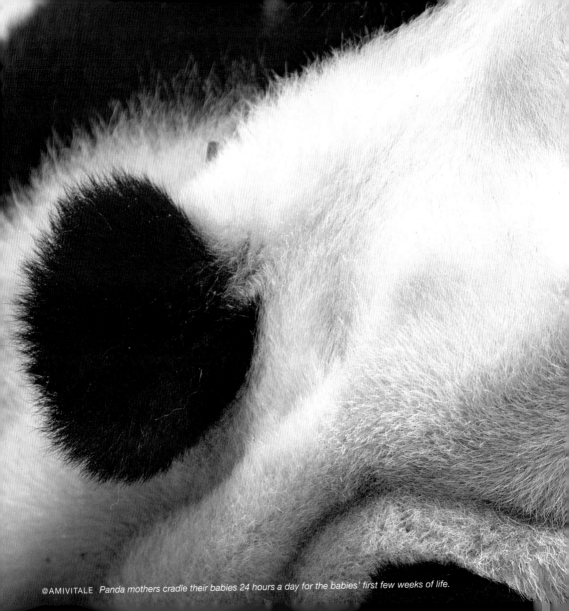

@AMIVITALE Panda mothers cradle their babies 24 hours a day for the babies' first few weeks of life.

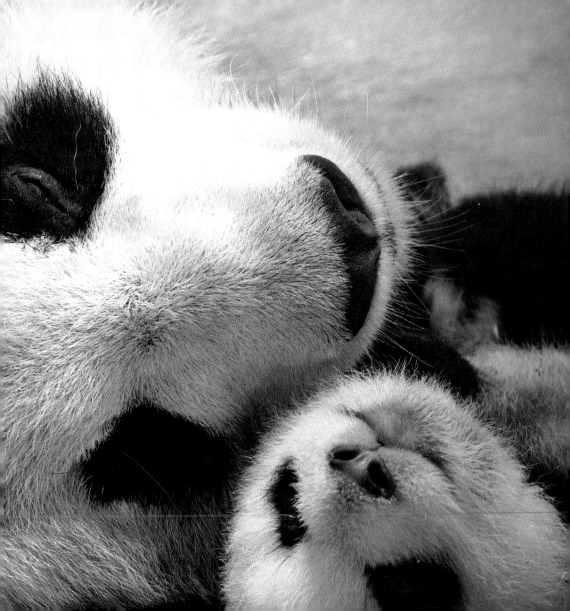

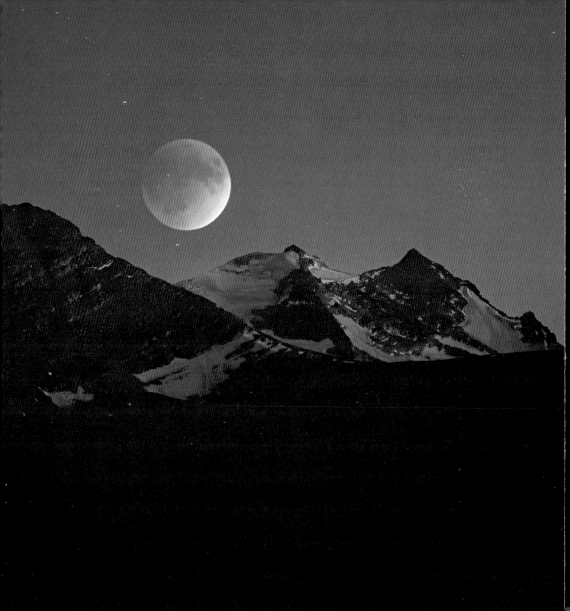

FOREWORD | KEVIN SYSTROM
CEO and Co-founder, Instagram

When I was young, I, like young people have for generations, spent hours captivated by the images of far-off places and cultures on the pages of *National Geographic* magazine. And with every yellow spine I added to my shelf, I was a little wiser and more curious about the world.

The @natgeo Instagram account celebrates what so many have treasured about the magazine for decades—that images have a unique power to transport and inform, to broaden our understanding, and to spark our imagination.

Together, the far-flung photographers of National Geographic have embraced the storytelling possibilities of Instagram for a new global generation to explore the world through their eyes. Millions of people tune in daily for instant and intimate access to extraordinary stories about our planet and the people behind the lens.

For a few moments a day, every @natgeo follower is an explorer, a seasoned globe-trotter, right from the palm of their hand. That is a remarkable gift.

FOREWORD | KEVIN SYSTROM
CEO and Co-founder, Instagram

When I was young, I, like young people have for generations, spent hours captivated by the images of far-off places and cultures on the pages of *National Geographic* magazine. And with every yellow spine I added to my shelf, I was a little wiser and more curious about the world.

The @natgeo Instagram account celebrates what so many have treasured about the magazine for decades—that images have a unique power to transport and inform, to broaden our understanding, and to spark our imagination.

Together, the far-flung photographers of National Geographic have embraced the storytelling possibilities of Instagram for a new global generation to explore the world through their eyes. Millions of people tune in daily for instant and intimate access to extraordinary stories about our planet and the people behind the lens.

For a few moments a day, every @natgeo follower is an explorer, a seasoned globe-trotter, right from the palm of their hand. That is a remarkable gift.

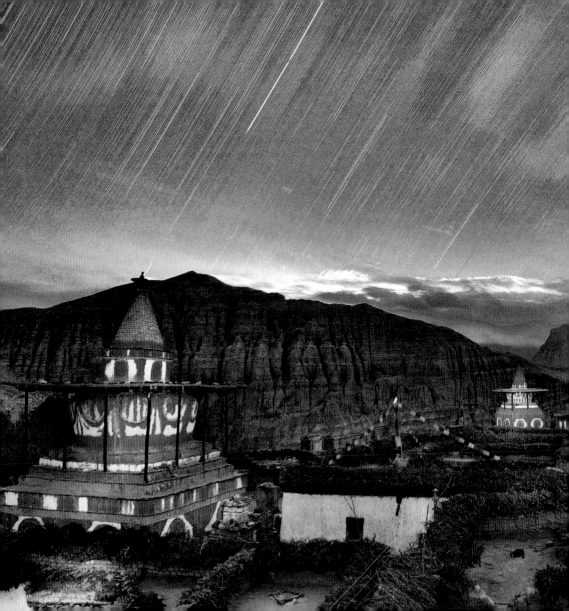

Thousands of years ago, the only evening light was fire, and the words and stories of our ancestors were illuminated by its subtle glow. It guarded us from darkness and guided us in the stories told in those moments. We have always been driven by illuminating stories and held captive by the dark. Since those early days, the flame has remained a constant, but how we fan it has transformed.

I remember sitting in a boardroom at National Geographic headquarters in 2012 before my second assignment for the magazine. En route to Everest, my climbing partner and I eagerly asked, "Do you have an Instagram account?" If National Geographic is a campfire, that was the day our community of photographers started an inferno. Today, at the tap of a screen, pictures become an instantaneous call to action, a voice in the silence, a catalyst for change. For me, @natgeo transcends the hurdle of moments captured and makes them into moments shared. It has become an invitation for all to participate, to be informed, and to change for the better. While the glow of campfires may have been replaced by the glow of screens, our desire for storytelling persists. This is the campfire of our human family. May our stories guide us through the nights ahead.

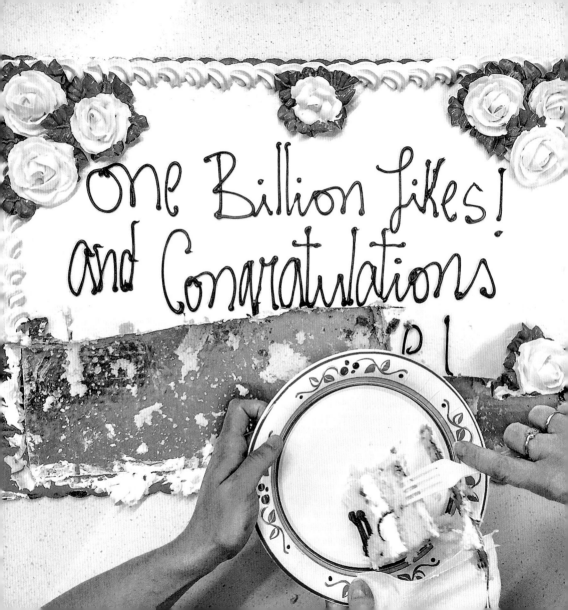

INTRODUCTION | KEN GEIGER
Former Deputy Director of Photography, *National Geographic* Magazine

I believe in the power of photography to change the world. That's not just one person's opinion. Rather, it's a belief shared by the world's most renowned photographers—all of whom have an uncompromising passion for visual narrative. We share a resounding, cumulative voice screaming: Visual journalism creates transparency, educates, illuminates, and can even change the course of history!

Only a few years ago, the chemical process of producing a photograph was a mystery to most and mastered by only a dedicated few. Now, with the proliferation of smartphones, more than a trillion photographs are made every year—and that's a conservative estimate. As we drown in digital images, it's not surprising that the unfiltered collective voice of the National Geographic photographers continues to rise above all. On Instagram, @natgeo has created something very rare, a photographic global community that, like a vintage wine, delivers complexity with every sip and with every post.

In these pages, you will experience the cumulative voice of the National Geographic photographers and their dedication to the visual narrative. The image juxtapositions will take you on a visual journey through life on this planet. I'm sure it will leave a smile on your face.

ERLUST

WÄN-DƏR-ˌLƏST

noun: *a strong longing for
or impulse toward wandering*

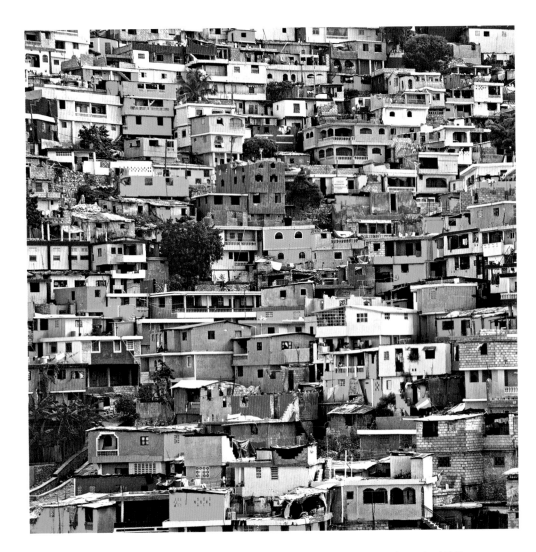

@EDKASHI *These candy-colored homes in Port-au-Prince exemplify both the vibrancy and poverty of Haiti.*

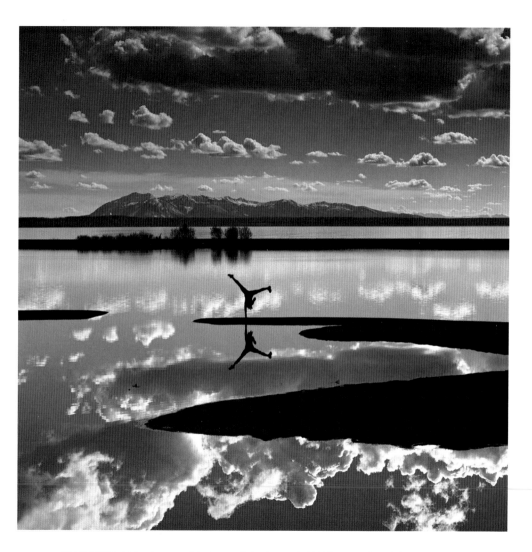

@LADZINSKI *A hiker turns a celebratory cartwheel over placid Yellowstone Lake in Yellowstone National Park.* 25

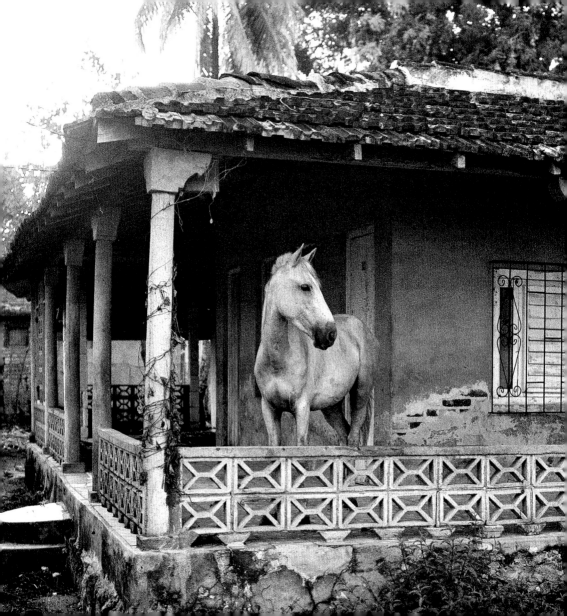

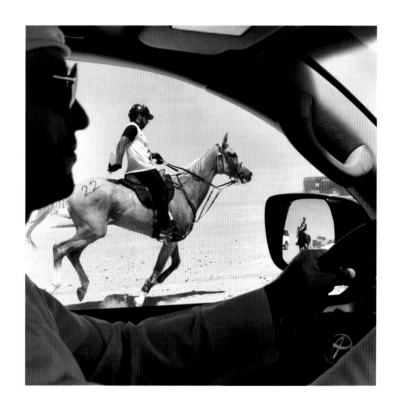

@DAVIDALANHARVEY *Speeding alongside an endurance horse race through the desert of Dubai*
OPPOSITE: @DAVIDALANHARVEY *A farmer's horse parked on his front porch in Trinidad, Cuba*

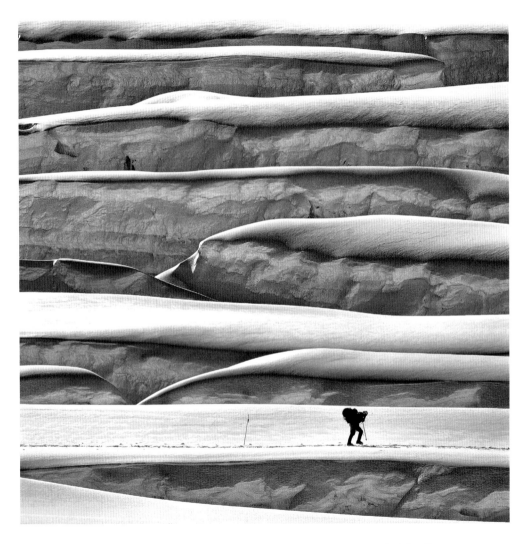

@JIMMY_CHIN *Carrying a 77-pound (35 kg) load, Lakpa Sherpa hikes above the Khumbu Icefall on Everest.*

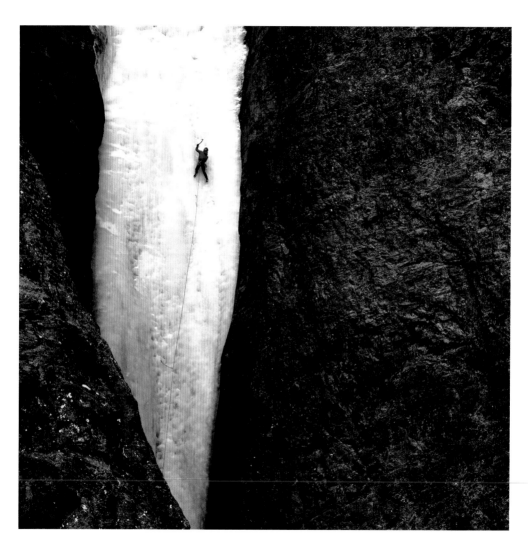

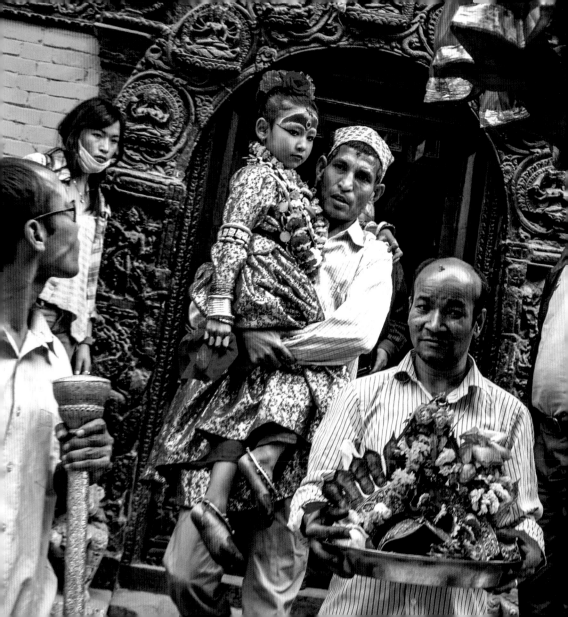

Unika Vajracharya is carried from her home to give blessings on an auspicious day. In Nepal, prepubescent Newari girls, such as Unika, are known as kumaris *and are worshipped as deities who are endowed with foreknowledge and the ability to cure the sick, fulfill wishes, and bestow blessings for protection and prosperity. They are the link between Earth and the realm of the divine and, above all, are believed to generate in their devotees* maitri bhavana—*a spirit of loving kindness toward all. Today there are just ten* kumaris *in Nepal, nine of them in the Kathmandu Valley. They're still selected only from families attached to certain* bahals, *or traditional courtyard communities, and all their ancestors must have come from a high caste.*

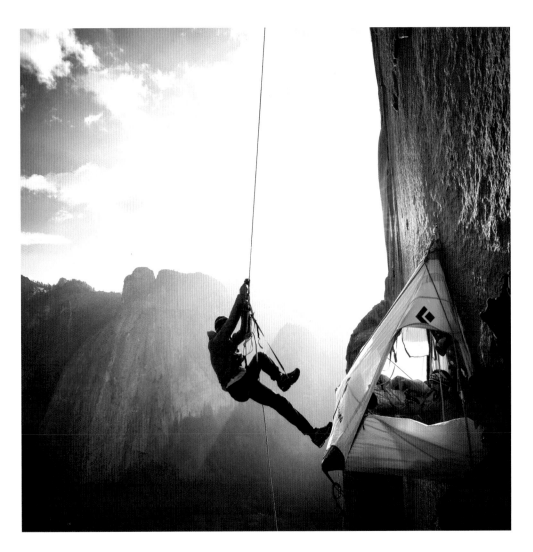

 Climbers leave their suspended camp on the Dawn Wall of Yosemite's El Capitan.

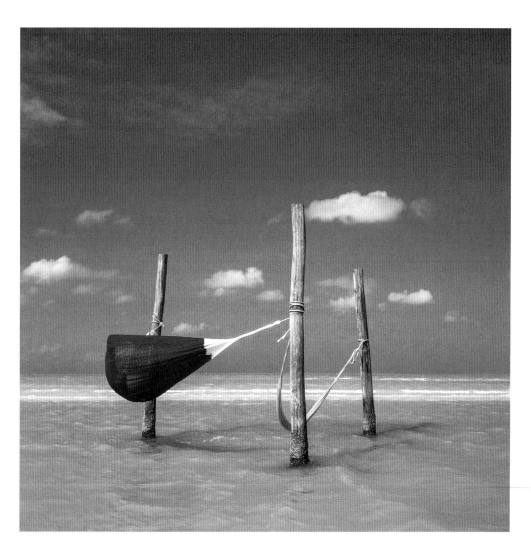

An inviting hammock flutters over knee-deep jade waters off Holbox Island, Mexico.

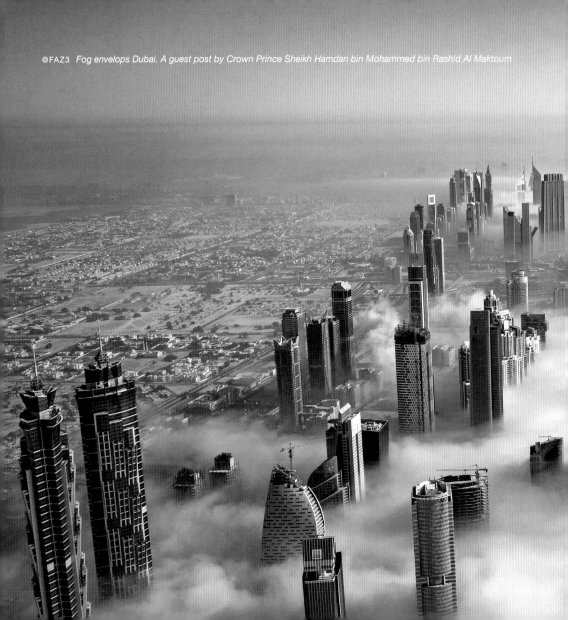
@FAZ3 Fog envelops Dubai. A guest post by Crown Prince Sheikh Hamdan bin Mohammed bin Rashid Al Maktoum

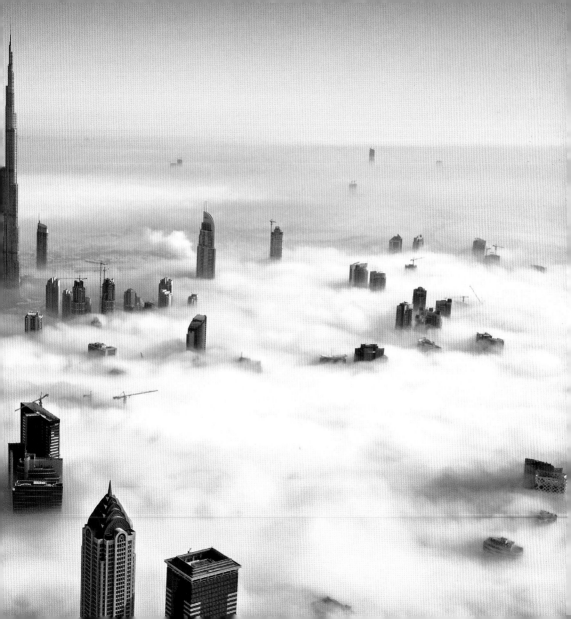

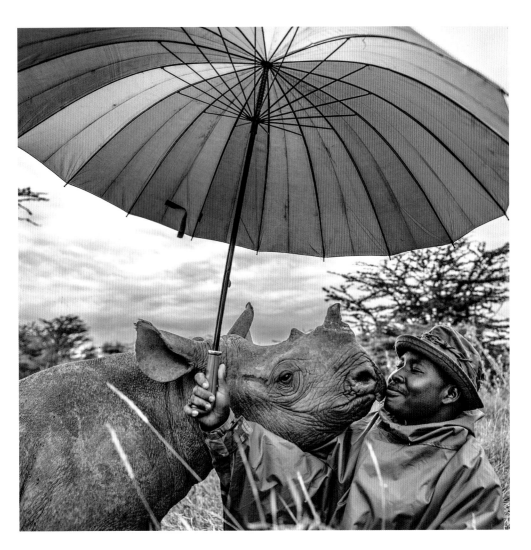

@AMIVITALE *Inspiring rangers are hand-raising three baby rhinos at Lewa Wildlife Conservancy in Kenya.*

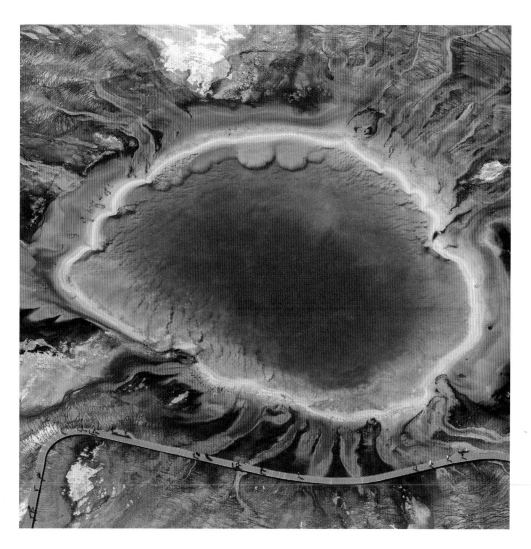

@YAMASHITAPHOTO *The largest hot spring in the United States seen from a helicopter over Yellowstone National Park* 37

♥ **363k+ Likes**
1,237+ comments

louisawood: This is where I did my geology dissertation and can truly say it is a beautiful place. Give the Isle of Raasay a visit if you ever get a chance!

naturalistamac: Cool, this is how my family came to Chile!

luluahsan: Beautiful capture

davitagrace: The colors of this photo are epic! I can't imagine what it would have felt like to be forced to leave this incredible home

@JIMRICHARDSONNG *Night falls on Hallaig on the Isle of Raasay, one of the Scottish villages evicted by the Highland Clearances of the 18th and 19th centuries. Entire communities were forced off their land, devastating Gaelic culture.*

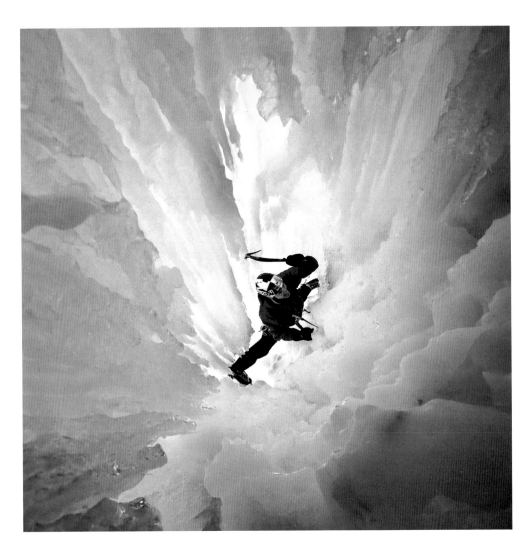

@JIMMY_CHIN *An ice climber scales a rarely formed tunnel in the Ghost River Wilderness Area in Alberta.*

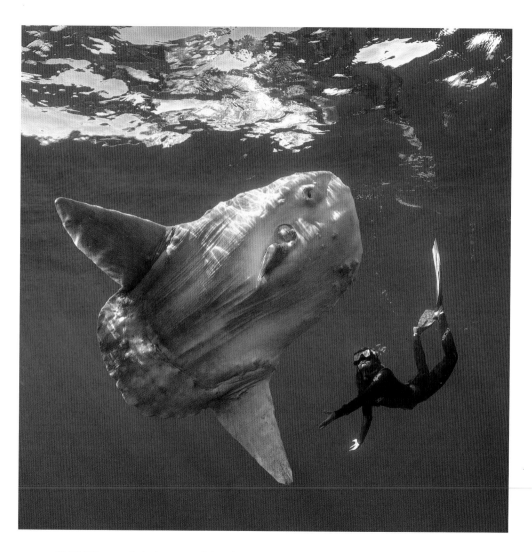

@PAULNICKLEN *A giant ocean sunfish and a diver perform a blue-water ballet off the coast of British Columbia.*

@CHIEN_CHI_CHANG *The photographer's collection of "Do Not Disturb" signs from around the world*
OPPOSITE: @ARGONAUTPHOTO *At a bar in Sturgis, South Dakota. Sometimes the greatest journey is in your backyard.* 43

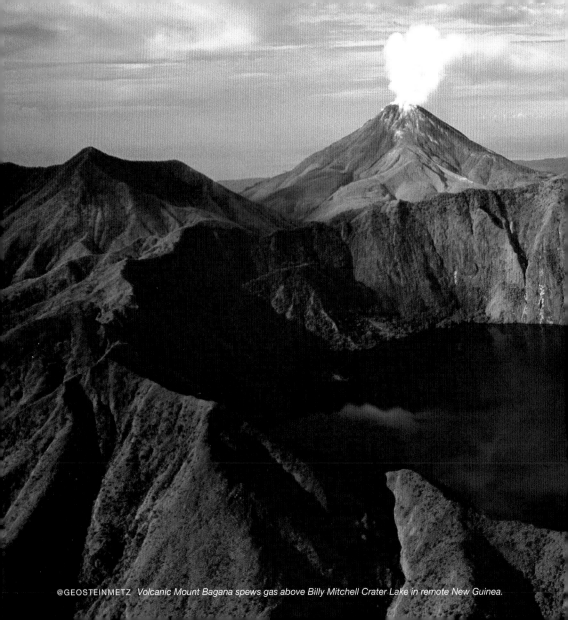

@GEOSTEINMETZ *Volcanic Mount Bagana spews gas above Billy Mitchell Crater Lake in remote New Guinea.*

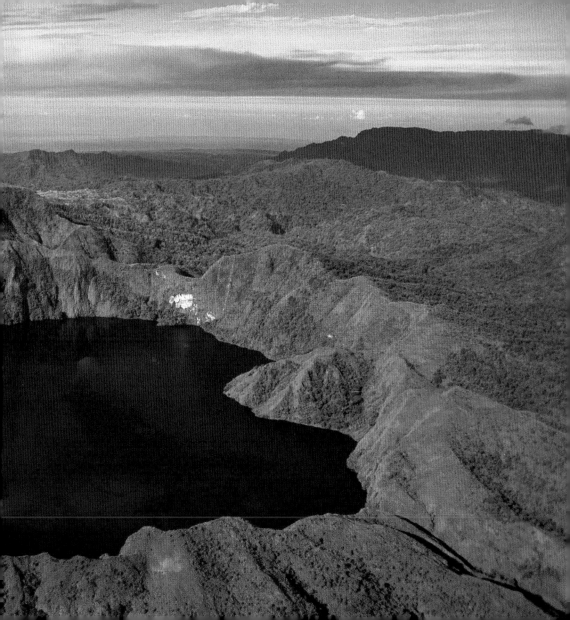

#TBT

J. Baylor Roberts | 1936

As the streamlined Mercury train pulls out of Cleveland, Ohio, it engulfs Skyscraper Terminal in clouds of exhaust. On board is enough coal to heat a suburban home through a winter. The photograph appeared in a 1936 feature article on the United States' ultramodern railways. The author dined on 35-cent meals in a red, plush passenger train and then hopped a freight locomotive delivering live chickens and car parts. His essay tells of the regiment of staff on the railroad payroll, the luxuries of pampered passengers, and the eager spectators who line way stations for a glimpse of the "trains of tomorrow." Today's travelers may prefer to fly, but no transportation has the romance of the rail.

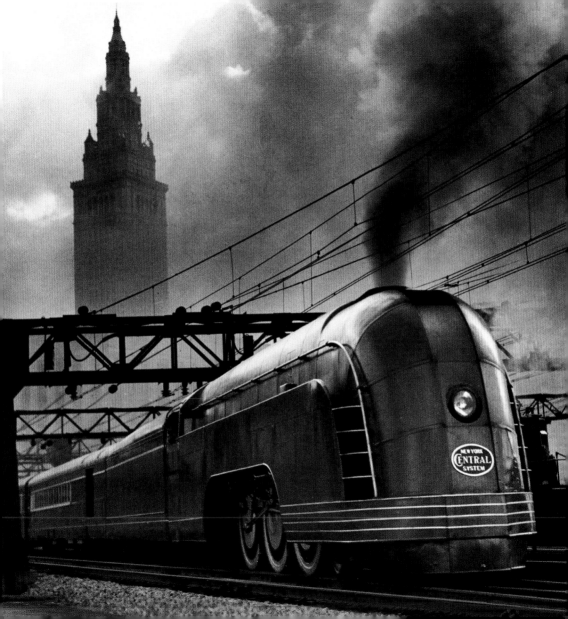

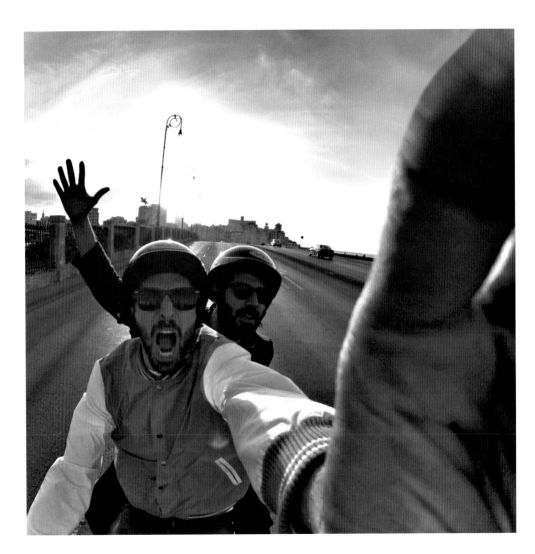

@JR *French street artist JR motorbikes through Havana, Cuba, a city that boasts several of his murals.*

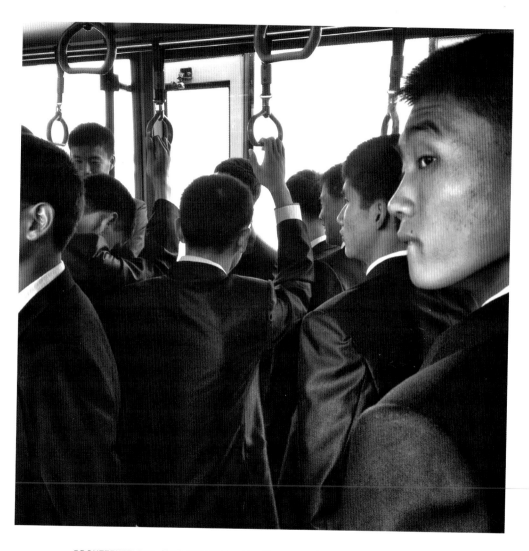

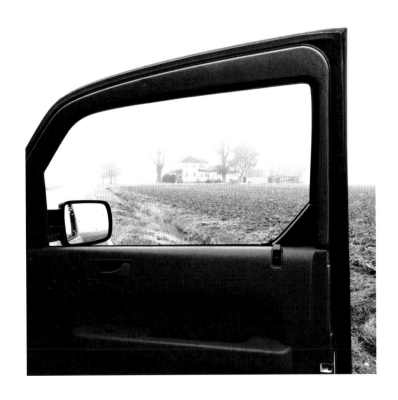

@DAVIDALANHARVEY *A roadside stop to capture a farmhouse in the Outer Banks, North Carolina*

OPPOSITE: @GEOSTEINMETZ *Salt crystals and stalactites line a cave on the Jordanian shore of the Dead Sea.*

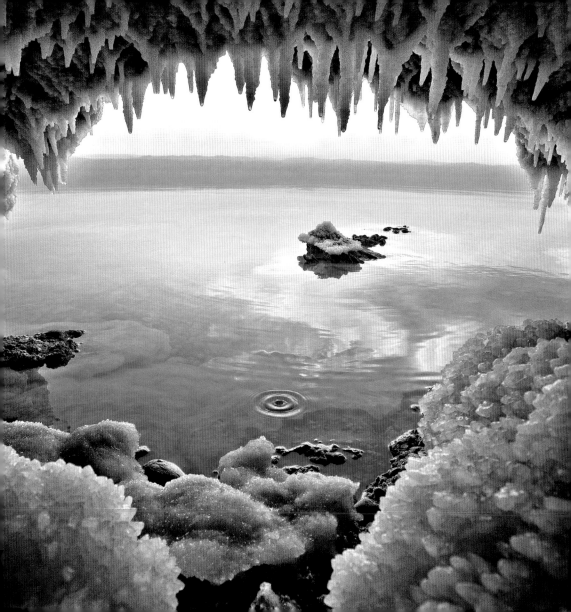

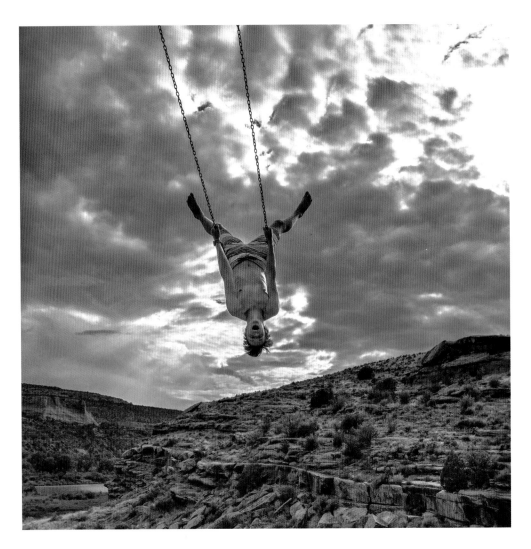

@PEDROMCBRIDE *Flying through the last weeks of summer on the banks of the Colorado River near Fruita, Colorado*

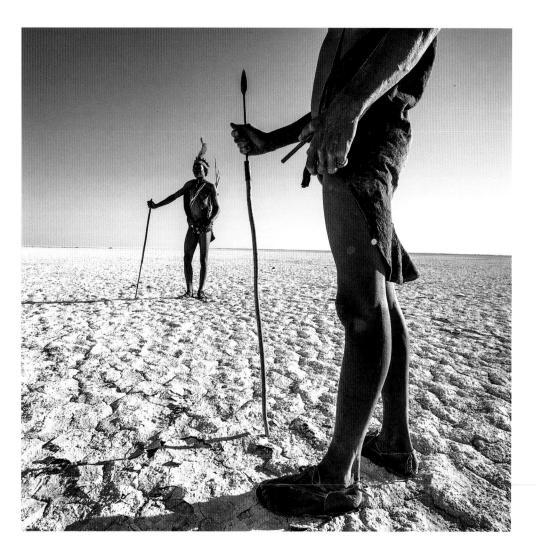

@CORYRICHARDS *Two San men work as tourism guides on the Makgadikgadi salt flats in Botswana.* 53

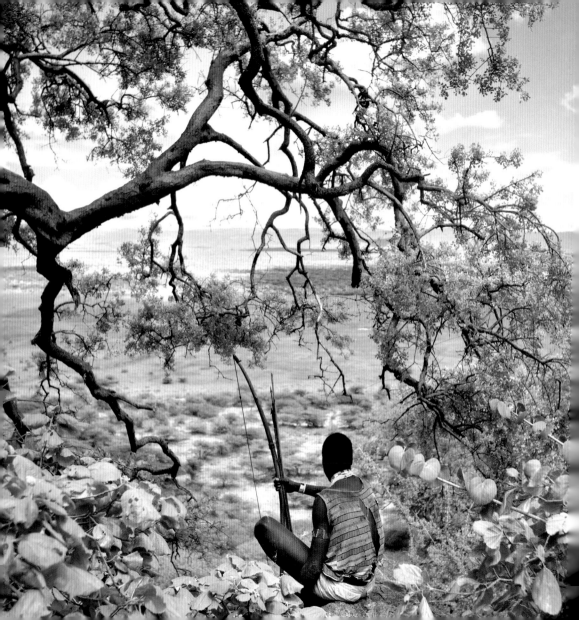

An indigenous Hadza from Tanzania, Isak takes a break on a hunt to survey the rolling grasslands that are both his home and pantry. The Hadza people are full-time hunter-gatherers. When the Hadza get up in the morning, there is nothing to eat in camp, so they head to the savanna and feed from nature. They are fearless hunters who at night traverse the bush—the territory of lions, leopards, and hyenas. It is a lifestyle we all had thousands of years ago. The Hadza have been living in this area for approximately 40,000 years and have left no impact on their environment.

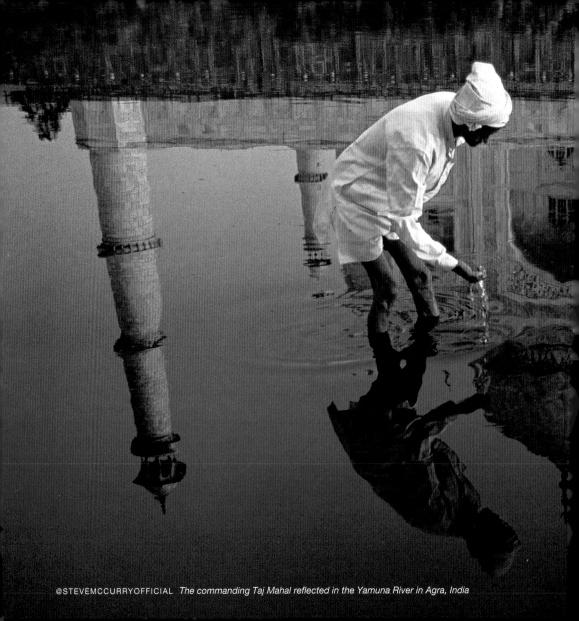

The commanding Taj Mahal reflected in the Yamuna River in Agra, India

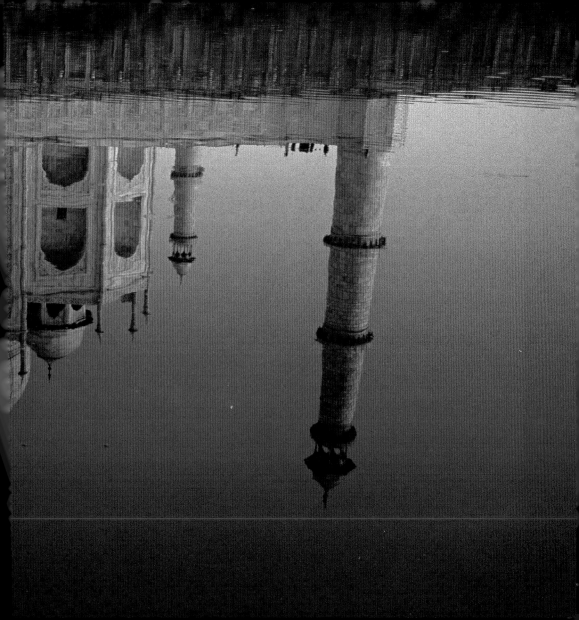

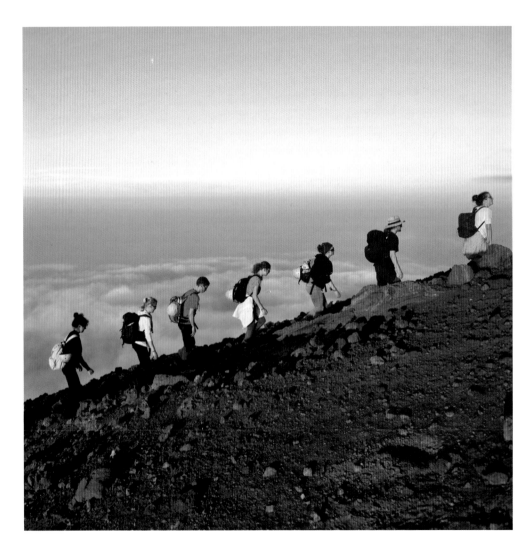

 Hikers climb the steep slope of the active Stromboli volcano in Italy.

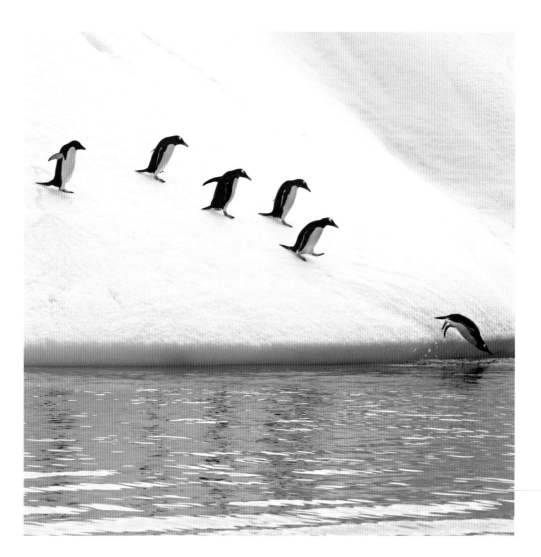

@PEDROMCBRIDE *A young gentoo penguin leaps into Antarctica's icy waters.* 59

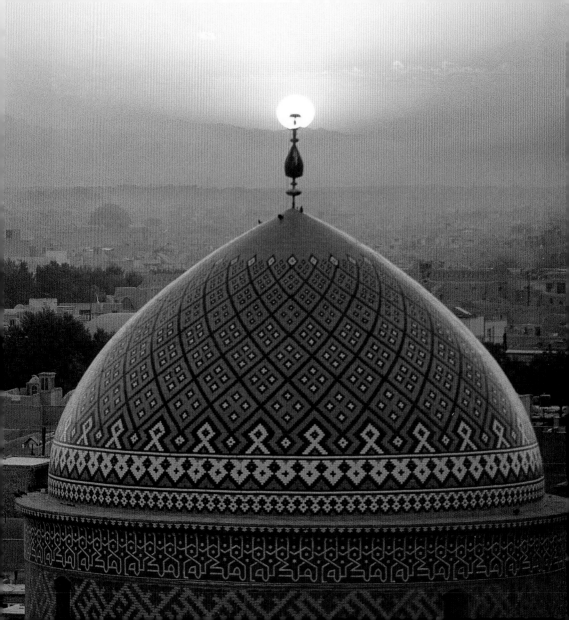

@IRABLOCKPHOTO *The largest moon of 2013 rises over Lower Manhattan, New York City.*
OPPOSITE: @YAMASHITAPHOTO *Sunset inflames the tiled dome of the Jame Mosque in Yazd, Iran.* 61

#TBT

Andrew H. Brown | 1951

Tunnel Log was carved after a fallen giant sequoia blocked a road in Sequoia National Park in 1937. The tree's age probably exceeded 2,000 feet (84 m) high and was 21 feet (6.4 m) in diameter at the base. The rare sight brings joy to this family, who, like many park visitors, arrived by car. Cars made the parks much more accessible, and by the 1950s journeying to natural landmarks became an American rite of passage. Park protectors faced a challenge: How to share the beauty of the wilderness while protecting natural lands from increased traffic? They devised an infrastructure of roads for cars and cabins for tourists, but more important, they taught visitors how to engage in conservation and embrace a "leave no trace" policy.

♥**356k+ Likes**

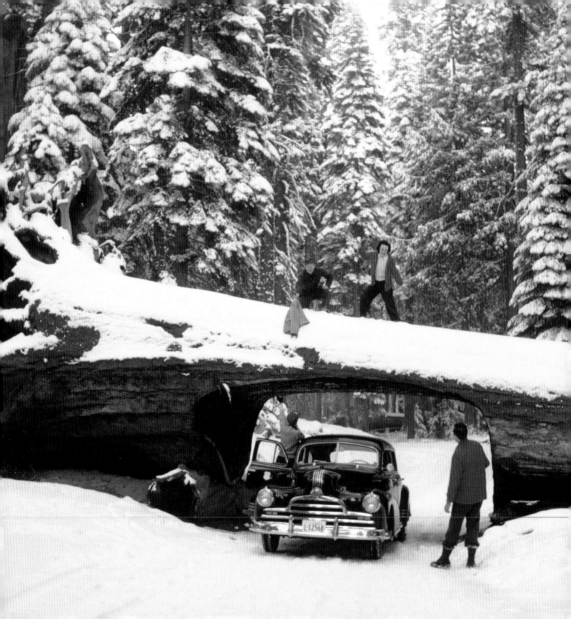

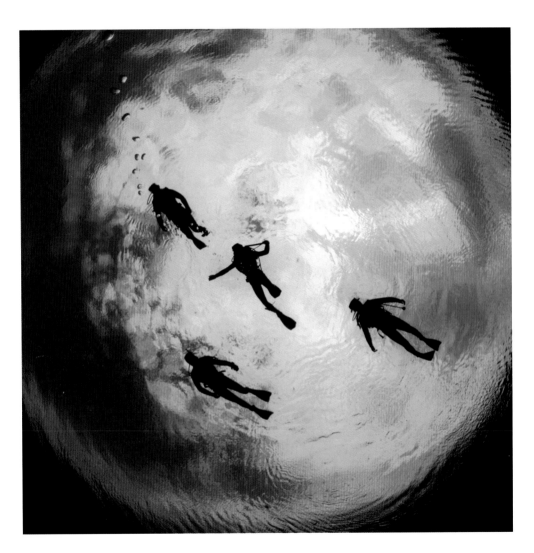

 Divers explore underwater limestone chambers in Australia.

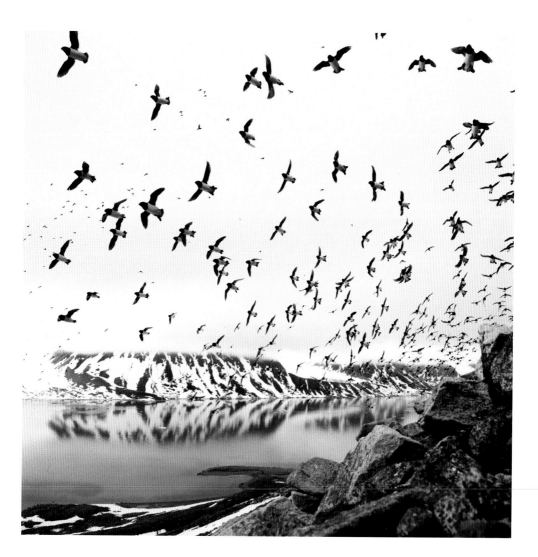

@PAULNICKLEN *A bounty of little auks, also known as dovekies, fill the landscape on the shores of Svalbard, Norway.*

@EDKASHI *A mash-up of iPhone shots made with collaborator @laura_eltantawy*
OPPOSITE: @DAVIDALANHARVEY *A view of Freedom Tower, formally known as One Word Trade Center, in Lower Manhattan*

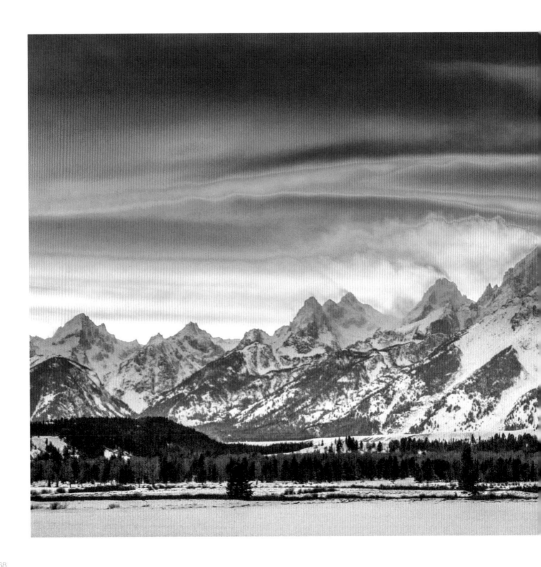

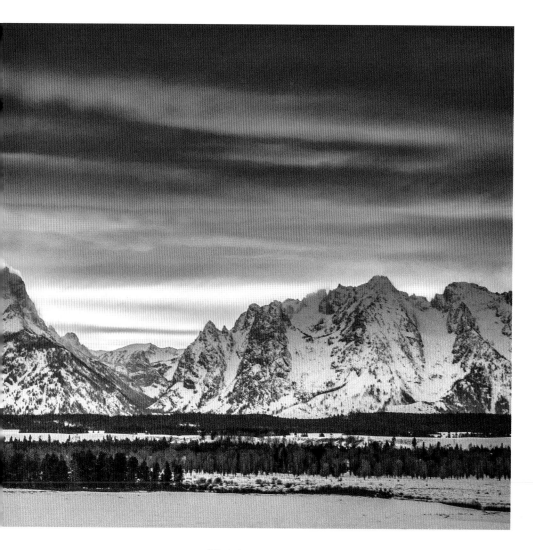

@CHAMILTONJAMES *Wind blows powdery snow off peaks of Wyoming's Teton Range at sunset.*

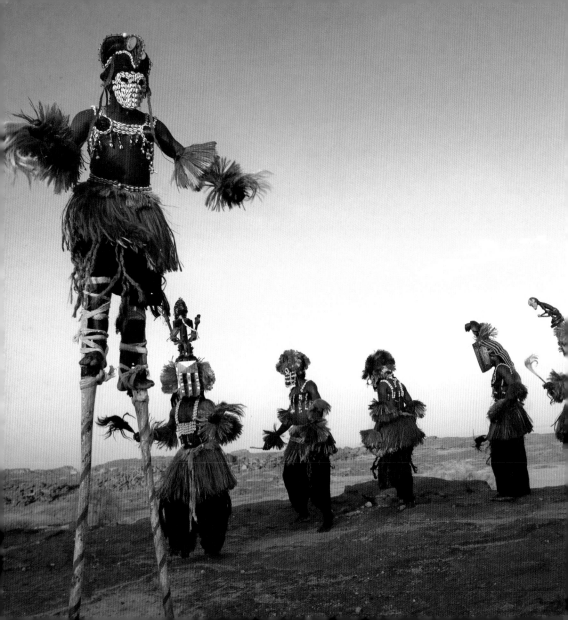

smokey.friday: This tradition lives on during carnival celebrations on my island Dominica.

whereisthemisterparsons: Spectacular

sparker2014: Great how the composition of this photo is able to stay so powerful in the smaller Instagram size. While I'm sure it was not on purpose (maybe it was), it definitely shows the importance of being conscious of your work being shown on social media where there is such a large audience.

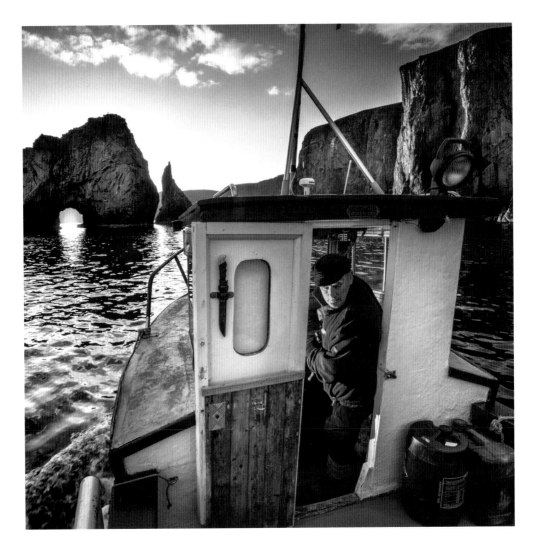

@CHAMILTONJAMES *A veteran mariner navigates his boat around the island of Vaila in Shetland, Scotland.*

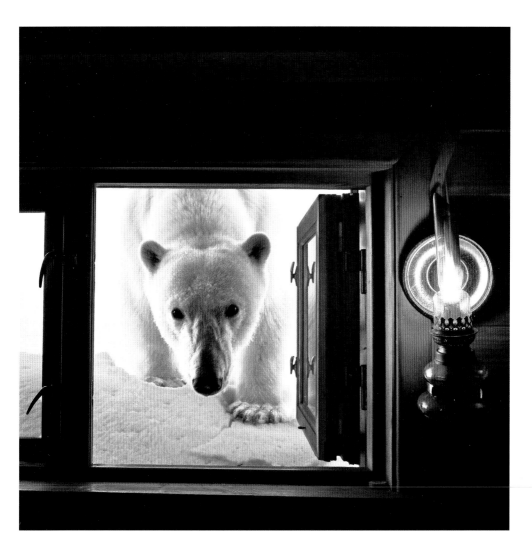

@PAULNICKLEN *A curious female polar bear noses into the photographer's cabin in Svalbard, Norway.* 73

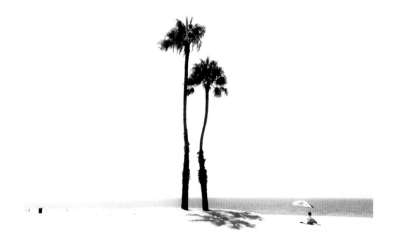

@IVANKPHOTO *Lone man on a beach in Los Angeles*

OPPOSITE: @PETERESSICK *A gentle aurora graces a stand of snow-burdened spruce in Oulanka National Park, Finland.*

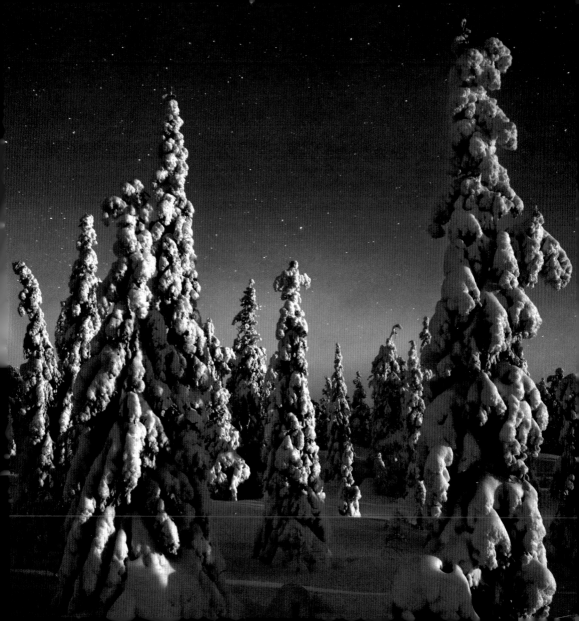

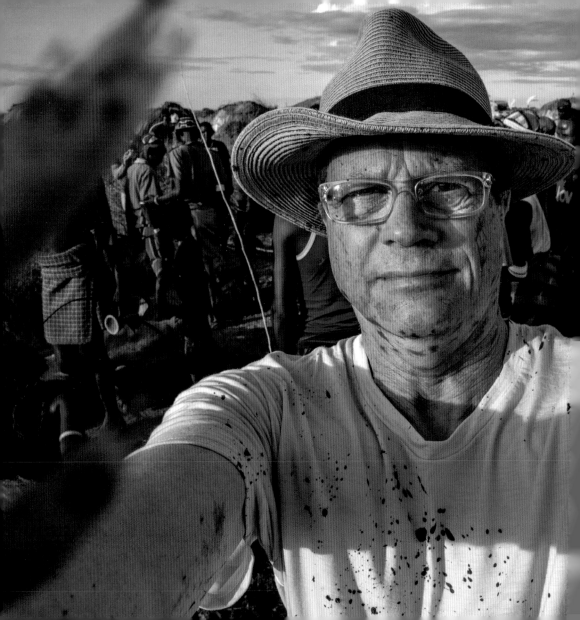

@RANDYOLSON

Randy Olson, spattered with blood. We'd crashed a party, a celebration of the Daasanach people on Kenya's Lake Turkana, and Randy was photographing the ritual slaughter of a bull that would feed many families. Warriors had speared the beast. Its blood pooled on the ground. All around, men and women were singing and dancing, shaking stone-filled gourds, losing themselves in trances. One young man stomped past the bull's leaking body and sent a wave of gore crashing over Randy, who choked, spit, and cursed. We stumbled to the edge of the crowd, and a woman approached us. She pointed at Randy's shirt. "Can I have it?" she asked. Then another came, and more followed, each asking for the shirt and offering congratulations. "That blood is good luck," they said. "It's a blessing!" At first Randy thought it less blessing, more biohazard, but soon he was smiling again. In the end he wore it home.

—AS OBSERVED BY NATIONAL GEOGRAPHIC WRITER NEIL SHEA

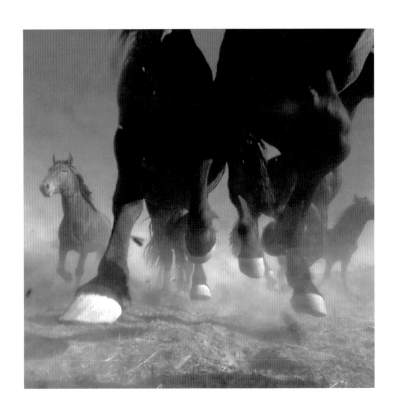

@MELISSAFARLOW *Spirited wild mustangs caught by the photographer's planted camera in Nevada*

OPPOSITE: @TIMLAMAN *The photographer's children leave snow angels at the foot of the Teton Range in Wyoming.*

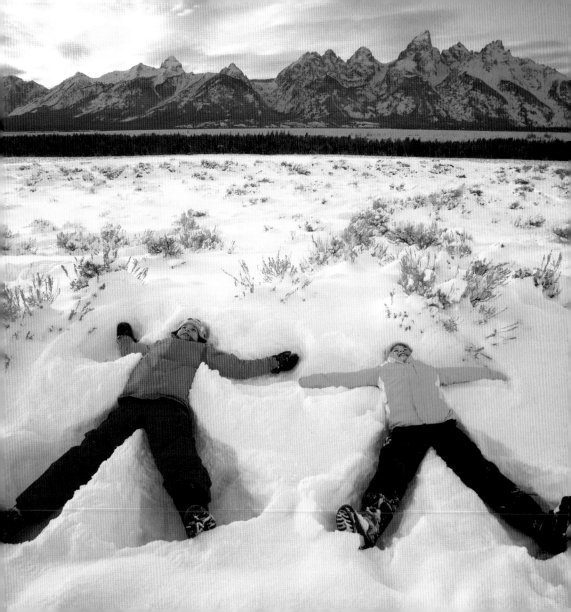

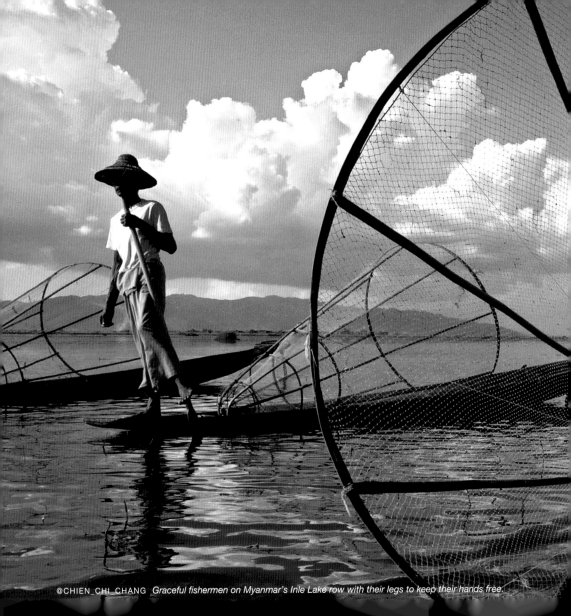

@CHIEN_CHI_CHANG *Graceful fishermen on Myanmar's Inle Lake row with their legs to keep their hands free.*

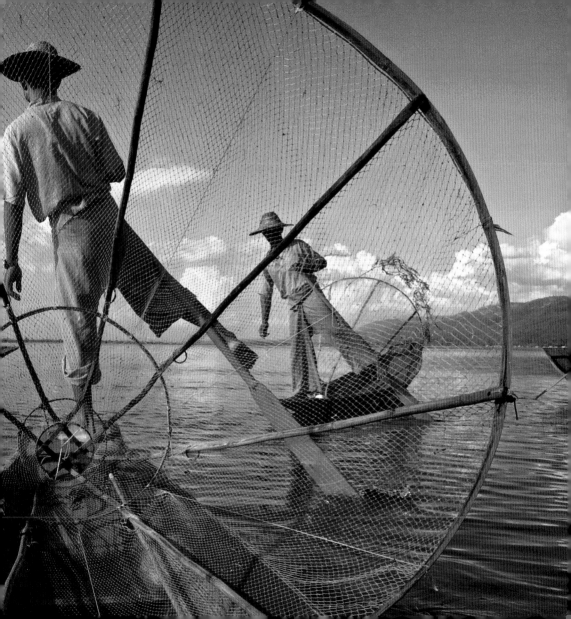

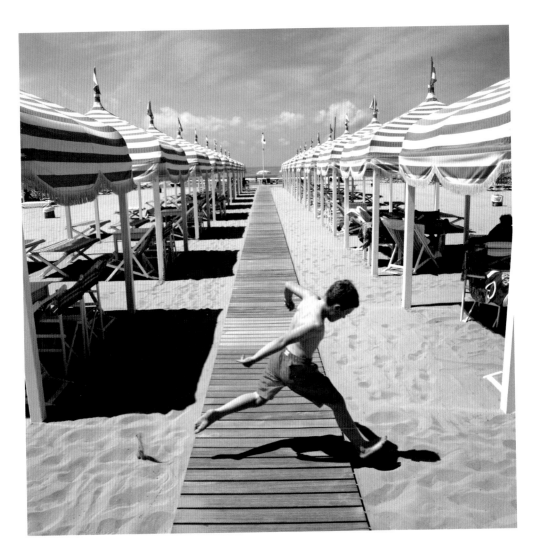

@DAVEYODER *A boy jumps over a hot walkway in Lido di Camaiore, a beach town near Pisa, Italy.*

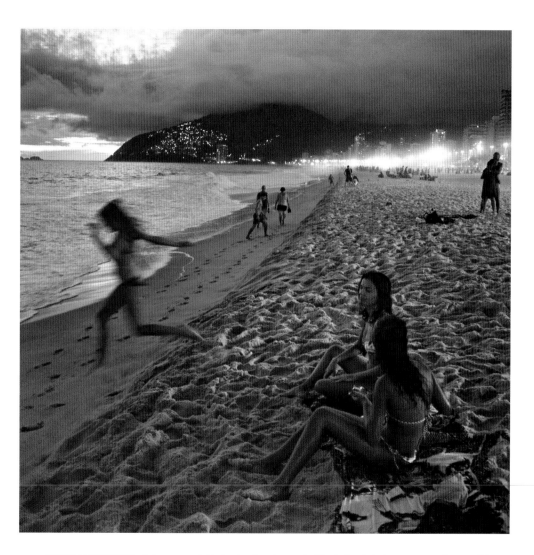

@DAVIDALANHARVEY *Hot summer nights beckon beachgoers to Rio de Janeiro's Ipanema waterfront at all hours.*

Dogs that have been dropped from their teams, either as a result of injury or as part of a musher's strategy, wait to fly out of Eagle, Alaska. Bags keep the dogs calm in flight. These resilient husky mixed breeds, unique to the region, are competitors in the Yukon Quest, the world's toughest sled-dog race. Crossing 1,000 bone-freezing miles (1,600 km) of northern Canada through some of the wildest backcountry in the world, teams commonly face high winds and whiteouts. At minus 50°F (-45°C), mushers face daunting sleep deprivation and fear while staving off frostbite and dehydration. But most often the dogs trot into the next checkpoint with tails wagging, smiling wide dog smiles.

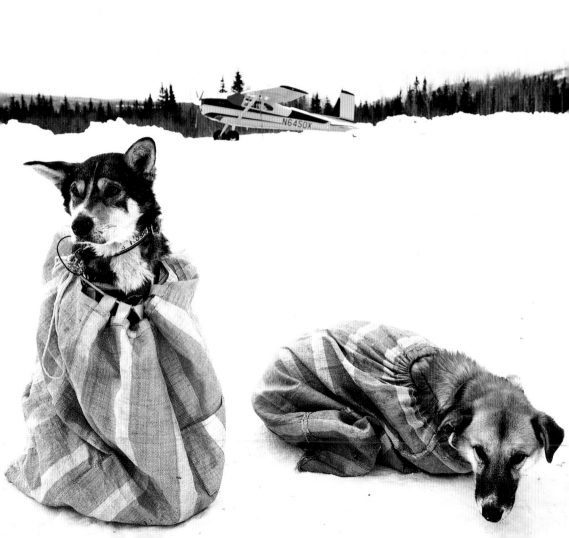

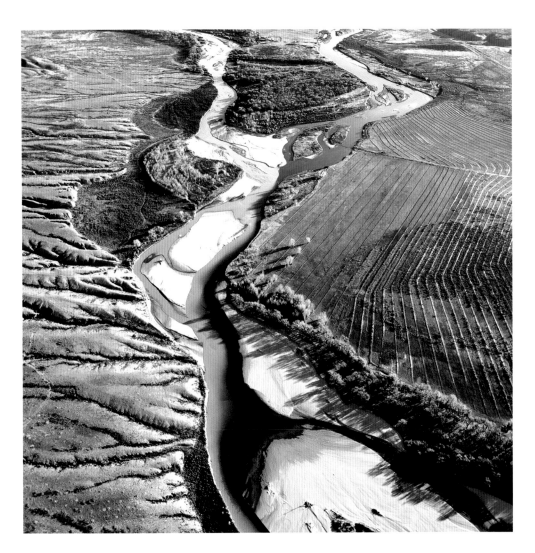

@PEDROMCBRIDE *The colorful confluence of the Little Snake and Yampa Rivers in Colorado*

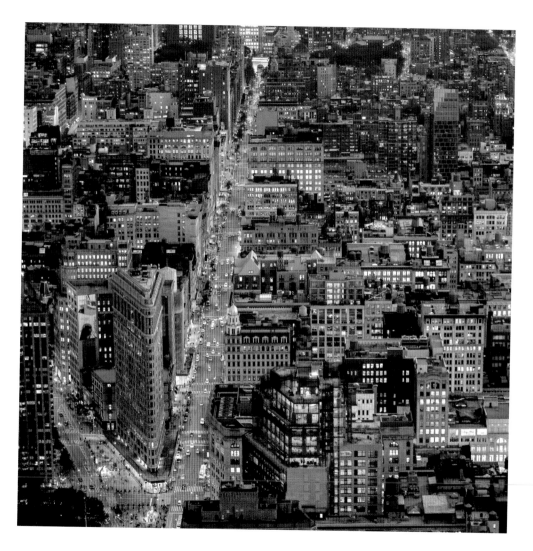

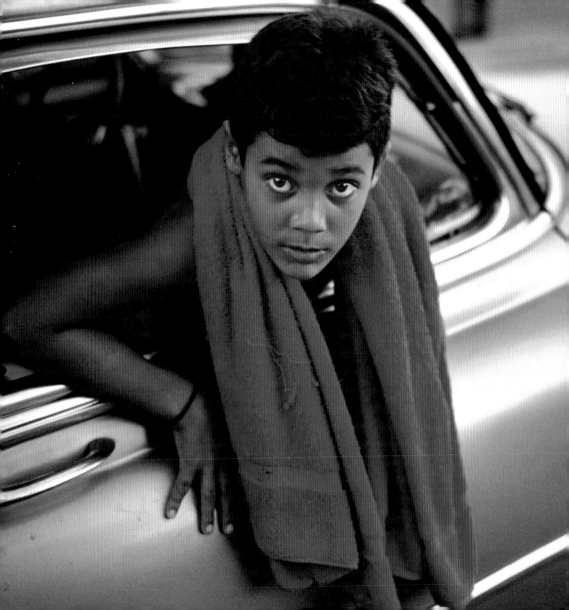

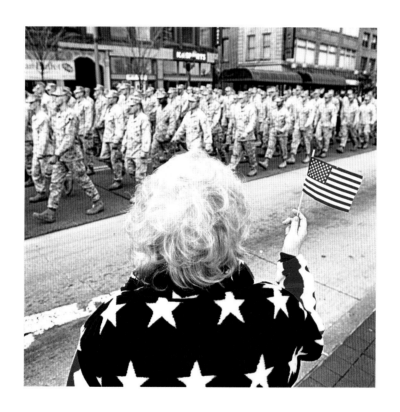

@EDKASHI *A Marine unit based in Columbus, Ohio, marches in the Veterans Day parade.*
OPPOSITE: @DAVIDALANHARVEY *A nine-year-old boy in a 1953 Chevrolet after his birthday party in Camagüey, Cuba*

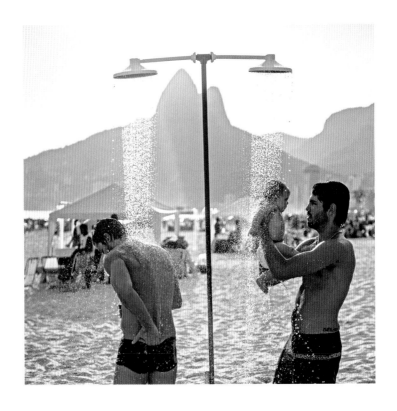

@DAVIDALANHARVEY *A father rinses his baby of saltwater in the beach showers at Ipanema in Rio de Janeiro.*
OPPOSITE: @TIMLAMAN *A male red bird of paradise in his inverted display in the forest of Batanta Island, Indonesia.*

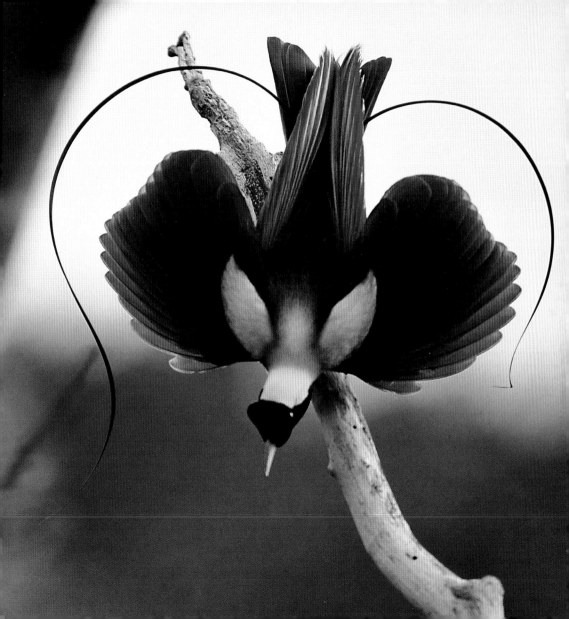

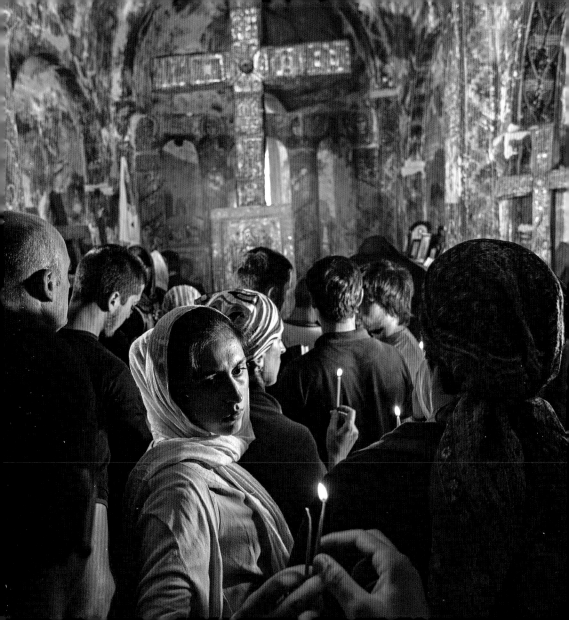

♥152k+ Likes
899+ comments

gdolidze: @argonautphoto Love the Svaneti shot. I am flying to Georgia tomorrow. Any suggestions for a fellow adventurer?

argonautphoto: Good timing! Head to the mountains for great colors!

abee02: I can't stop looking at this picture.

marilal0: My beautiful homeland. My soul belongs to God and my heart belongs to Sakartvelo.

dawa_lhamo: Fantastic shot. The colors remind me of a renaissance painting.

mothermitch: I can almost smell the candles.

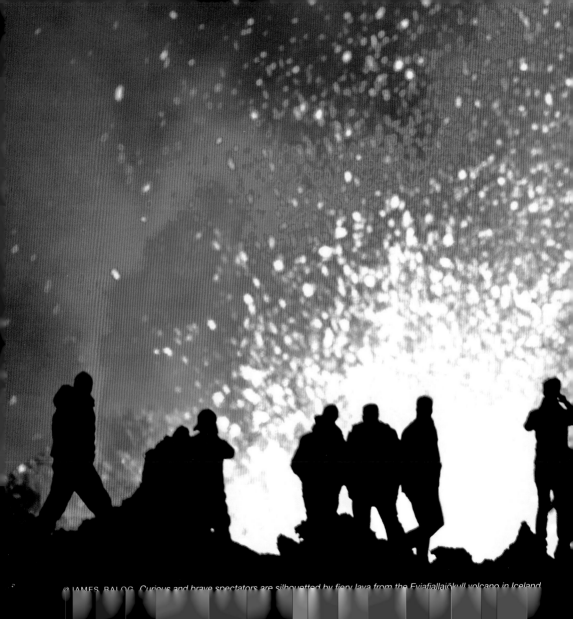

Curious and brave spectators are silhouetted by fiery lava from the Eyjafjallajökull volcano in Iceland.

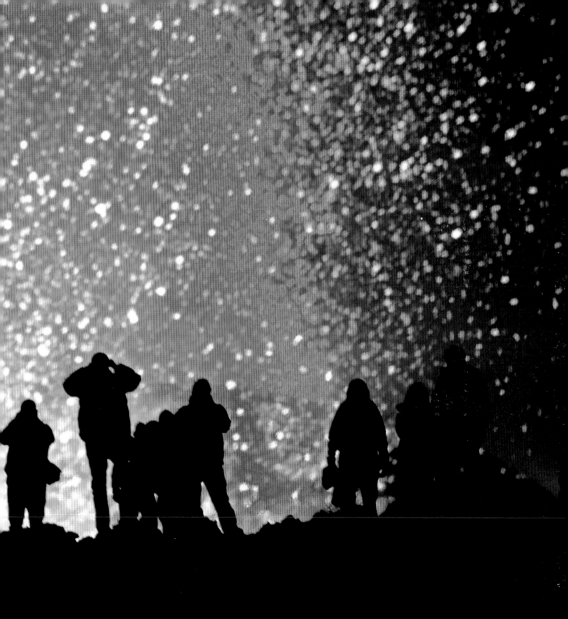

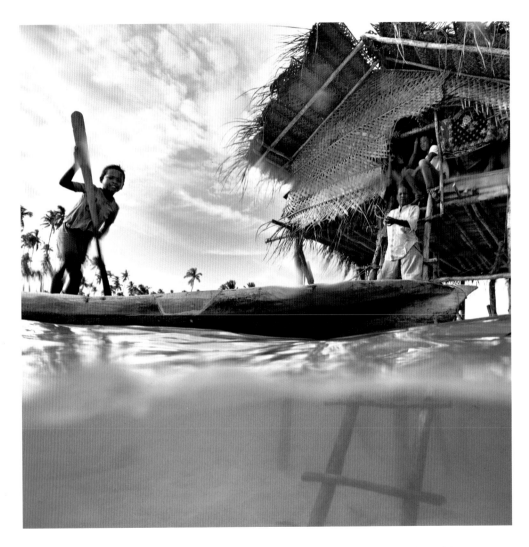

@PALEYPHOTO *The Bajau people of Malaysia live in stilted homes, travel by canoe, and eat the fruits of the sea.*

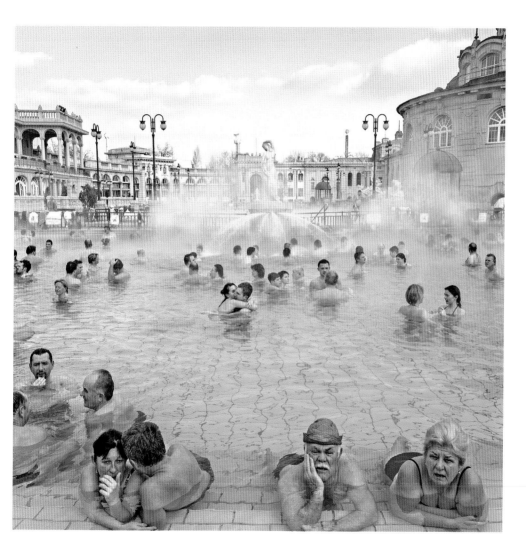

@AMIVITALE *Rich in thermal springs, Budapest, Hungary, offers traditional outdoor bathing.*

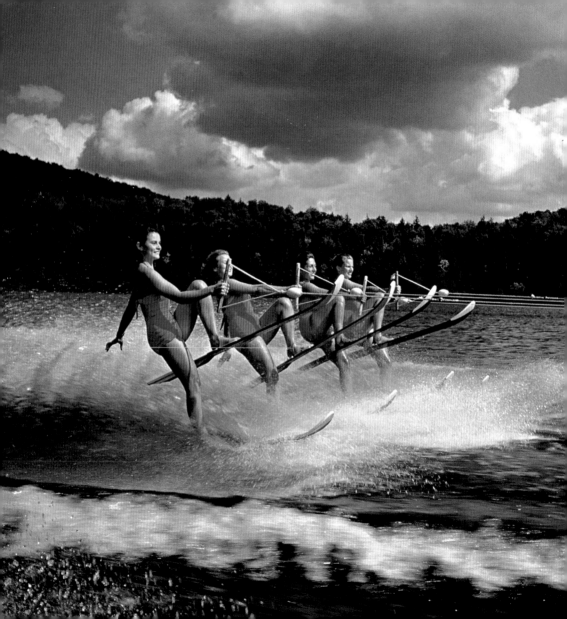

#TBT

Robert Sisson | 1956

A women's water ski team skims the surface of Dart Lake at 23 miles an hour (37 kph). A French invention, waterskiing was one of the fastest-growing sports in the United States in the 1950s. This team performed three times a day for visitors to the Adirondack Mountains in upstate New York, a popular summer-holiday destination. The region experienced a tourist boom once the construction of a cross-state highway placed the scenic haven just four hours from New York City. When it was completed in 1956, the thruway was the longest toll road in the world. National Geographic *magazine named the highway New York State's "new Main Street." It showcased the splendor of the Empire State, from the towers of Manhattan to the torrents of Niagara Falls.*

RIOSITY

KYƱR-Ē-ˈÄ-S(Ə-)TĒ

noun: *the desire to learn or know more about something or someone;*
something that is interesting because it is unusual

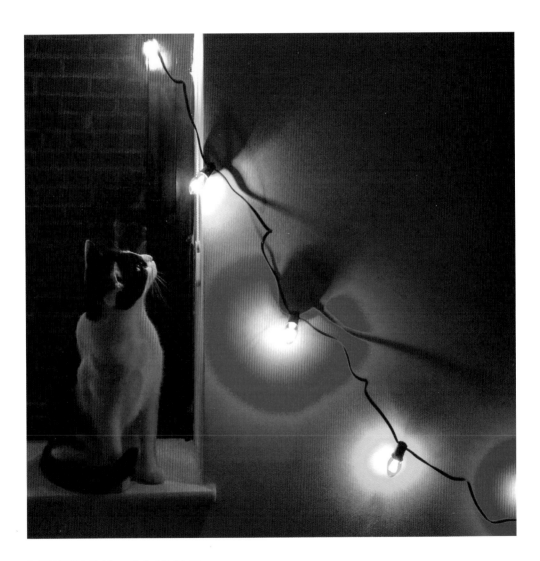

 Kat the cat's first Christmas

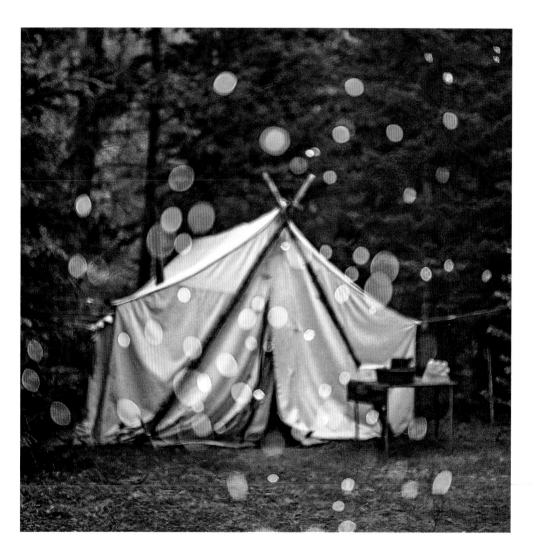

@JOERIIS *Campfire embers on the elk migration trail in Yellowstone National Park*

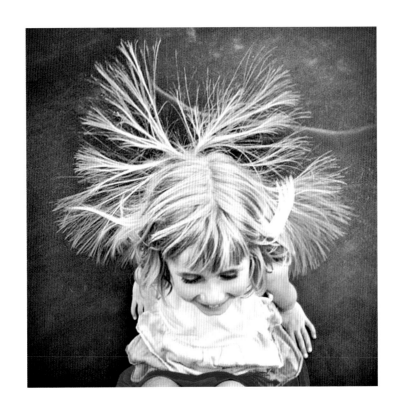

@MICHAELCHRISTOPHERBROWN *Bouncing on her trampoline gives a young girl a static-electricity hairdo.*
OPPOSITE: @PAULNICKLEN *A southern elephant seal bull keeps cool in the sand of South Georgia Island, Chile.*

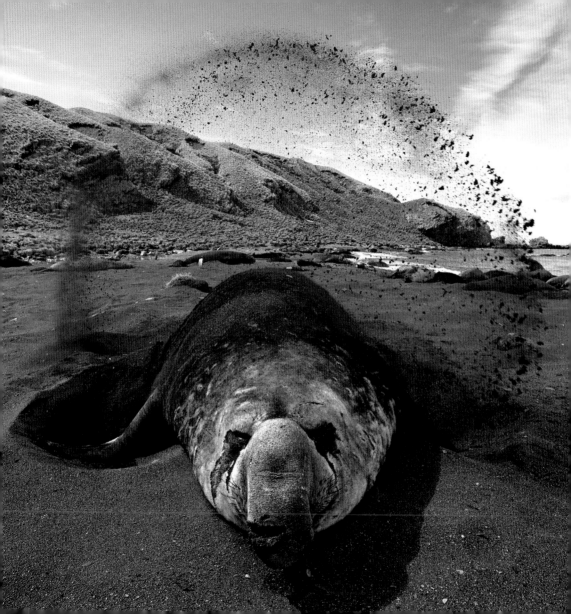

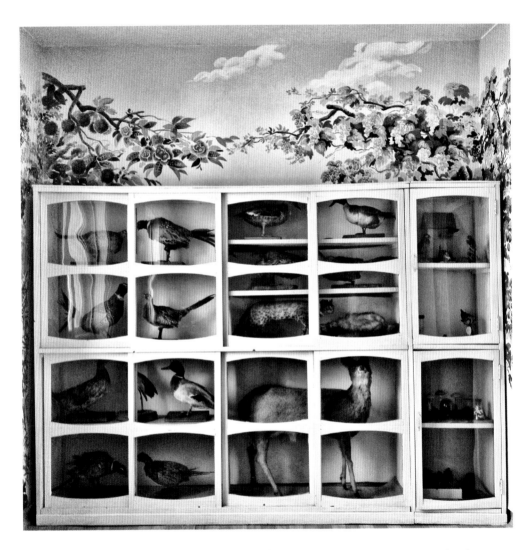

@DGUTTENFELDER *At a kindergarten in Pyongyang, North Korea, taxidermied animals are used to teach zoology.*

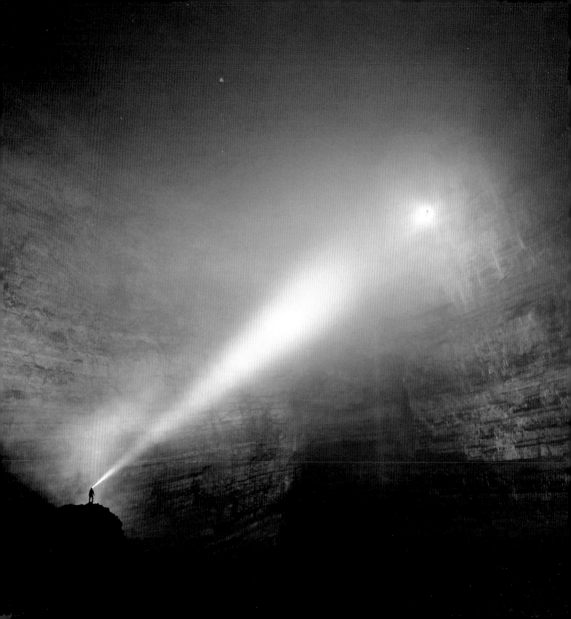

♥**414k+ Likes**
4,890+ comments

rock8teer: Absolutely amazing! I want to be that guy!

nishahettiarachchi: Whoa! Beautiful yet super scary

zeelgada: Awestruck

jpkeenan24: To be so tiny in a place like that gives you a sense of wonder.

golddawn: Mindblown

@JR *The street artist JR integrates a clock into a massive painting on an old factory in Berlin.*

@CHIEN_CHI_CHANG *A view of cataract surgery at the Da Nang Eye Hospital in Vietnam*

Oblong-winged katydids at the Insectarium in New Orleans exhibit natural color variants.

@THIESSENPHOTO *A water balloon bursting*

A tooth from a birdlike dromaeosaur, found in Grand Staircase–Escalante National Monument, Utah 115

@BEVERLYJOUBERT

Giraffes are famous for long necks, but their 20-inch (50 cm) tongues are also impressive. These gentle herbivores spend most of their time eating, consuming hundreds of pounds of leaves each week and traveling miles to find enough food. Given that they eat for hours, the darker coloring of their tongues helps prevent sunburn! Giraffe tongues have also developed a thick skin and exceptional dexterity as protection against the vicious thorns that grow on their favorite food, the acacia tree. Although they are largely classified as a species of least concern, wild giraffes declined by 40 percent in the past 15 years and need protection from poaching and habitat loss.

❤575k+ Likes

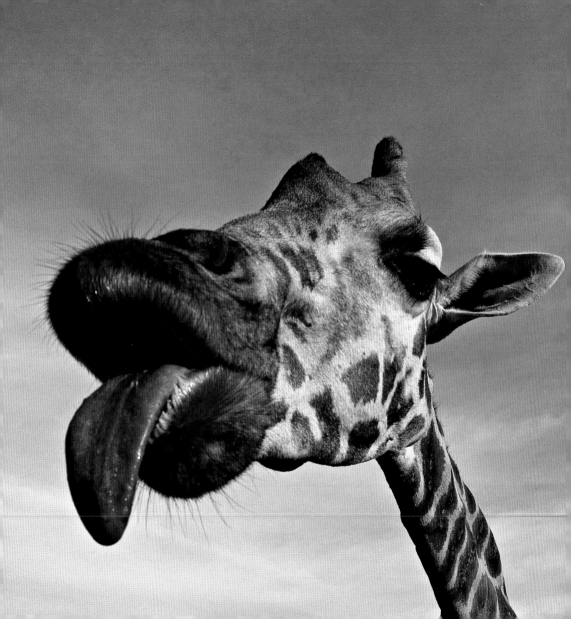

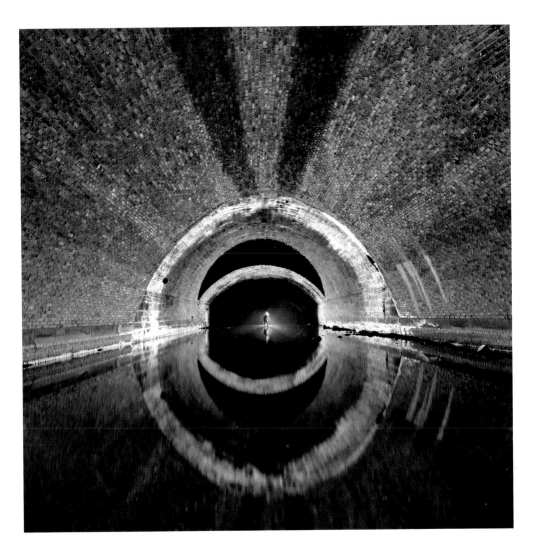

@SHONEPHOTO *A 17th-century storm drain built under Sheffield, England, is dubbed Megatron by urban explorers.*

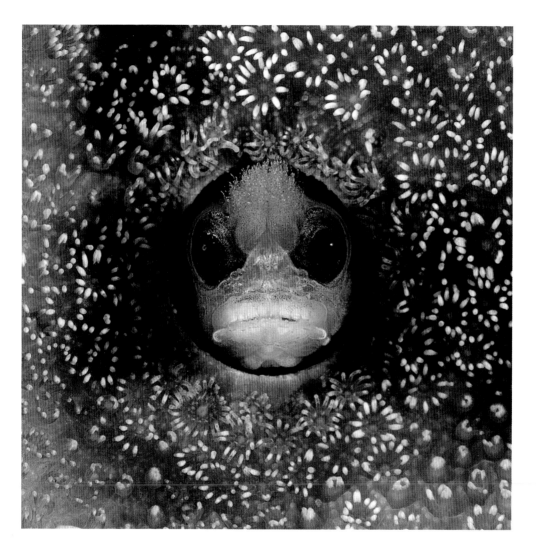

@TIMLAMAN *A tufted blenny peers out of coral in Coiba Island, Panama.* 119

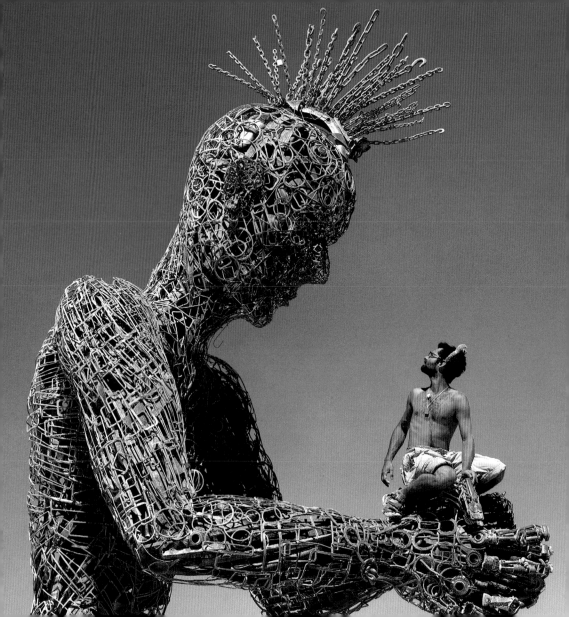

@PETERESSICK *Three generations of Native American women weave reed baskets at Tolay Lake near San Francisco.*
OPPOSITE: @MIKE_HETTWER *Temporary sculpture at Burning Man in Nevada's Black Rock Desert* 121

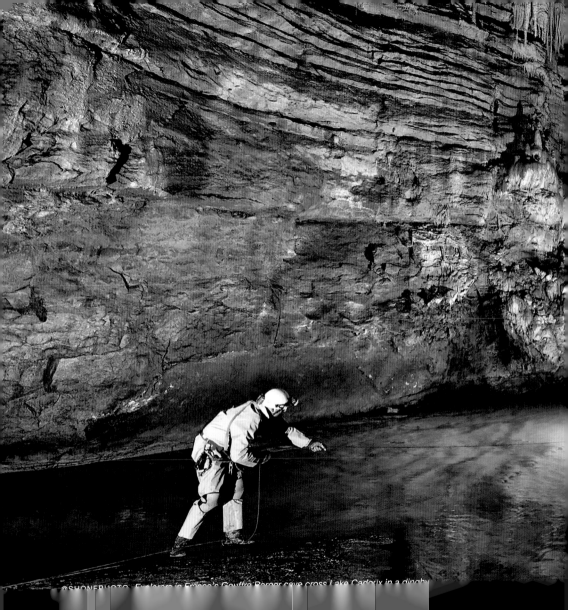

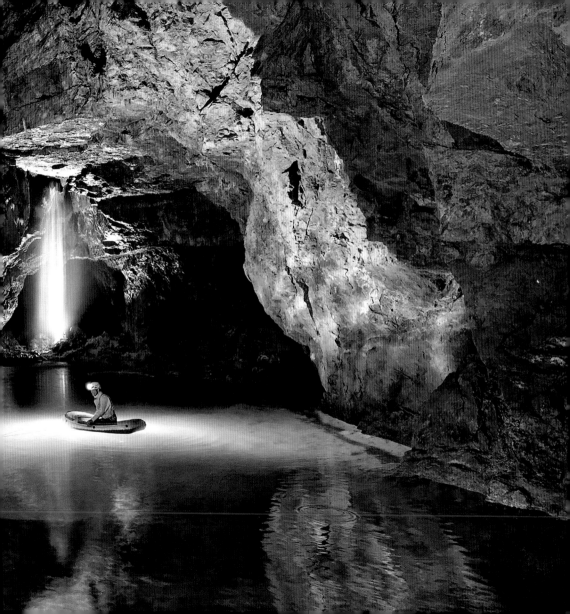

#TBT

W. Robert Moore | 1942

The manager of an ostrich farm in Oudtshoorn, South Africa, was kind enough to organize an ostrich derby for touring National Geographic photographer W. Robert Moore. With no way to guide their mounts, derby riders like this young woman can only cling to the young cock's wings as he dashes off in any direction. The trick is to stay astride this flightless yet quick-footed animal for as long as possible. Indigenous to Africa, the birds were domesticated by Boer farmers, South Africans of colonial Dutch descent, who profited from their prized feathers. To this day, Oudtshoorn remains the ostrich capital of the world.

♥ **265k+ Likes**

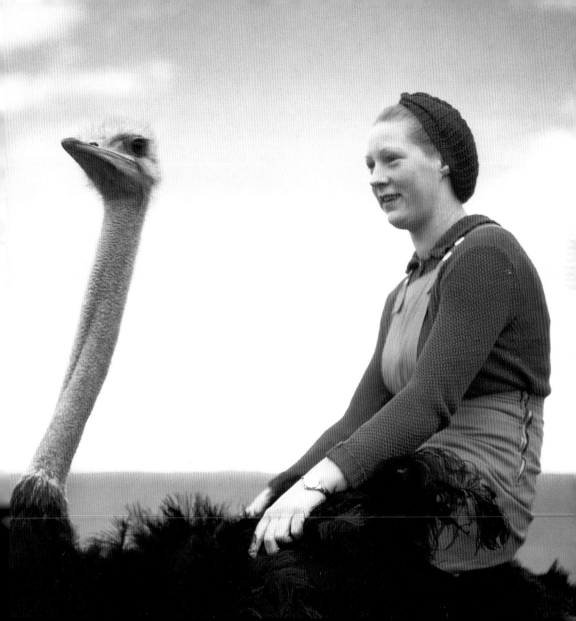

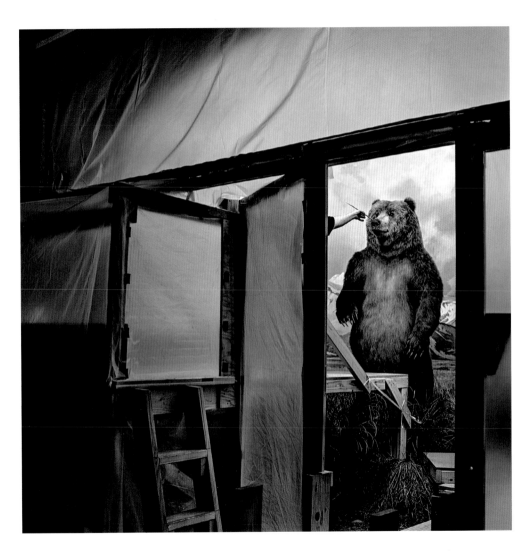

126 @ROBERTCLARKPHOTO *A taxidermist touches up a brown bear in New York City's Museum of Natural History.*

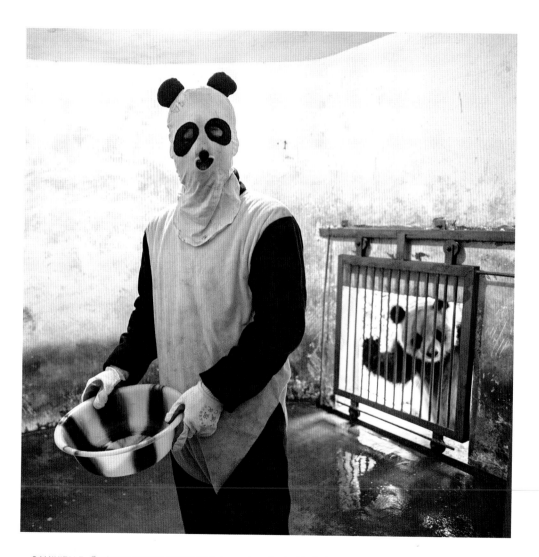

@AMIVITALE *Costumes prevent pandas from becoming attached to their caretakers at a conservation center in China.*

@STEFANOUNTERTHINER *In winter, large flocks of whooper swans gather in Hokkaido, Japan.*
OPPOSITE: @JOELSARTORE *Ruffled lemur at the Plzeň Zoo in the Czech Republic*

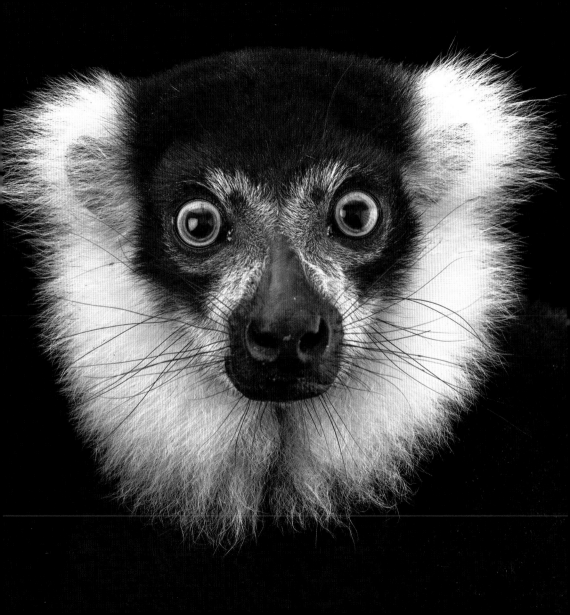

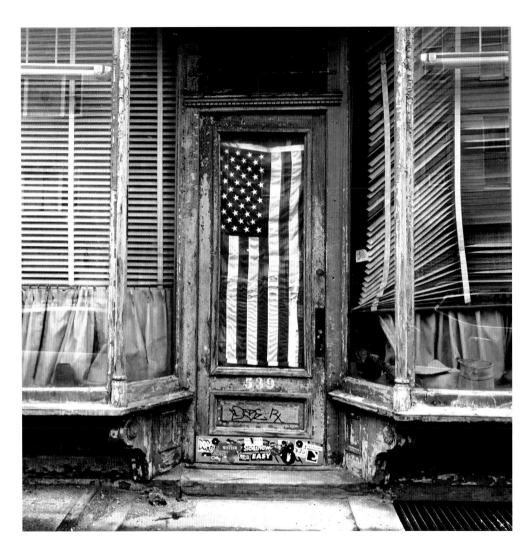

@ROBERTCLARKPHOTO *The American flag in Williamsburg, Brooklyn, New York*

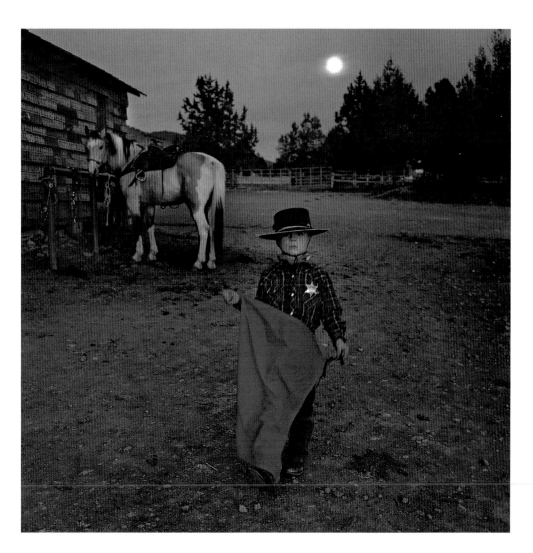

@MELISSAFARLOW *A diminutive cowboy, son of a wild horse trainer, on a ranch near Prineville, Oregon* 131

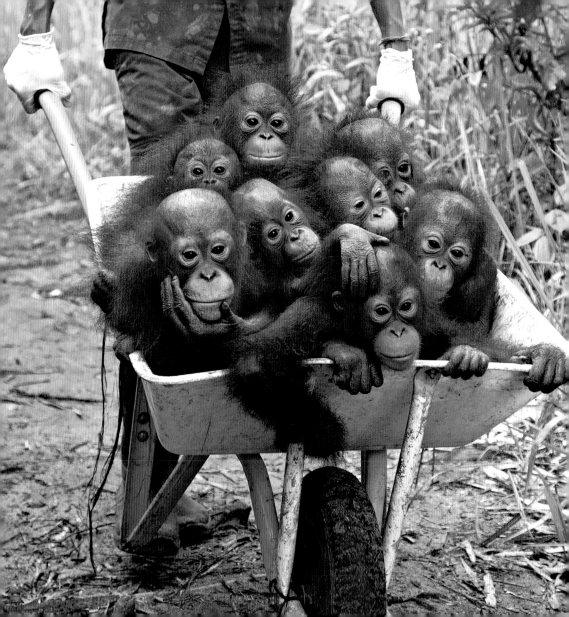

@TIMLAMAN

These baby orangutans are wards of the International Animal Rescue center in Ketapang, Indonesia. They are transported by wheelbarrow from their night cages to a forest play area, where they spend the day learning skills to survive in the wild. Orangutans have an uncommonly long childhood. Our primate cousins cling to their mother's body for the first years of their life and will remain close to her for 7 to 11 years. Unfortunately, many baby orangutans are kept illegally as pets; they're obtained by killing their mothers in the wild. When confiscated, the babies end up at centers like this. Successful release is challenging, but some do make it back to the wild.

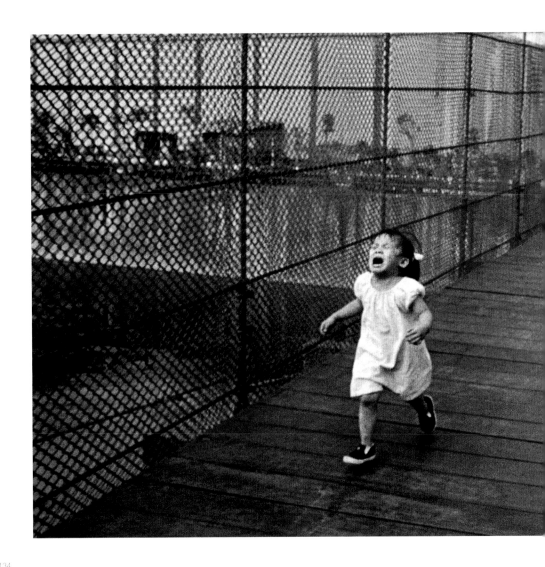

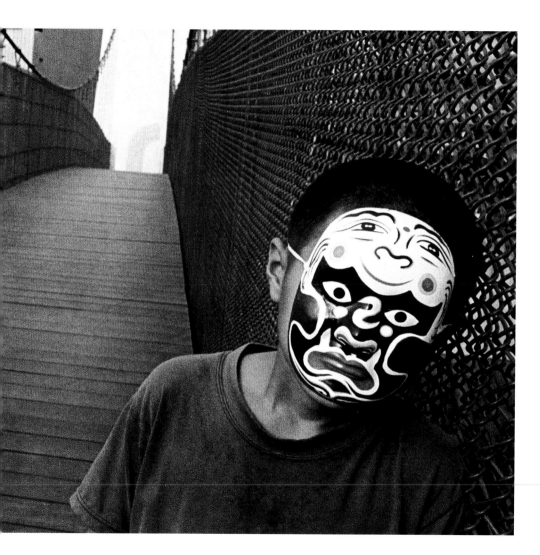

@CHIEN_CHI_CHANG *An innocent prank provokes tears on a bridge in Taiwan.* 135

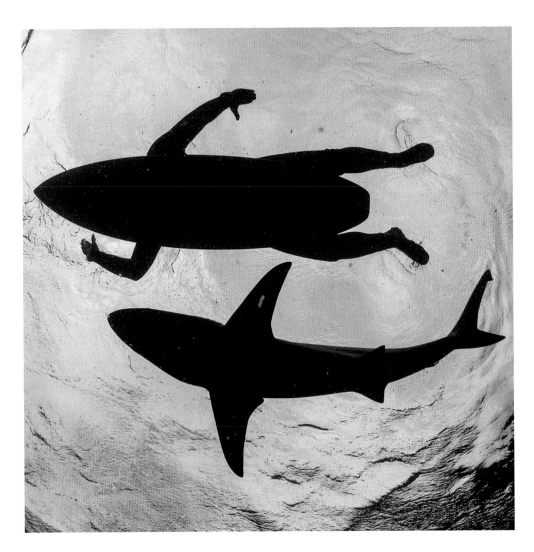

@THOMASPESCHAK *A prototype shark-deterring surfboard gets a test run in South Africa.*

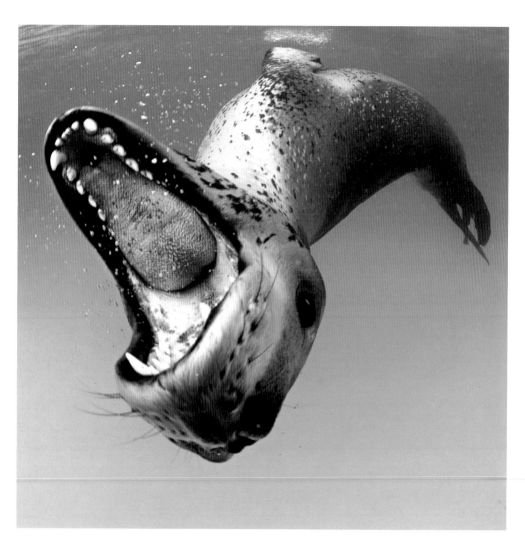

@PAULNICKLEN *A large, friendly female leopard seal in Antarctica.*

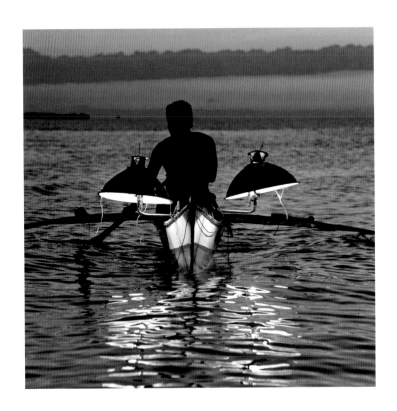

@THOMASPESCHAK *A nocturnal free-diving fisherman paddles to a Danajon Bank reef in the Philippines.*
OPPOSITE: @STEPHSINCLAIRPIX *The Jar Mahal stands partially underwater in a lake in Jaipur, India.*

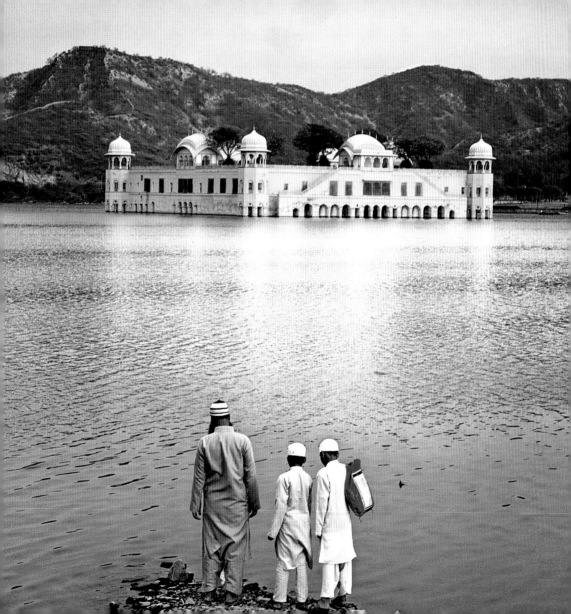

#TBT

B. Anthony Stewart & David S. Boyer | 1953

In an earlier era, the London Zoo permitted its better-behaved animals to play with children, as long as the children, too, were polite. The policy usually led to mutual admiration and only occasionally to nipped fingers and plucked feathers. In the zoo's children's corner, young guests interacted freely with a wandering baby elephant, took camel rides, and attended a tea party with trained chimpanzees. Before these 30-pound (14 kg) king penguins were ready to play with boys from nearby Aylesford House School, they first had to acclimate to England's weather, which was far warmer than their home in the frigid waters near the Arctic Circle.

♥**311k+ Likes**

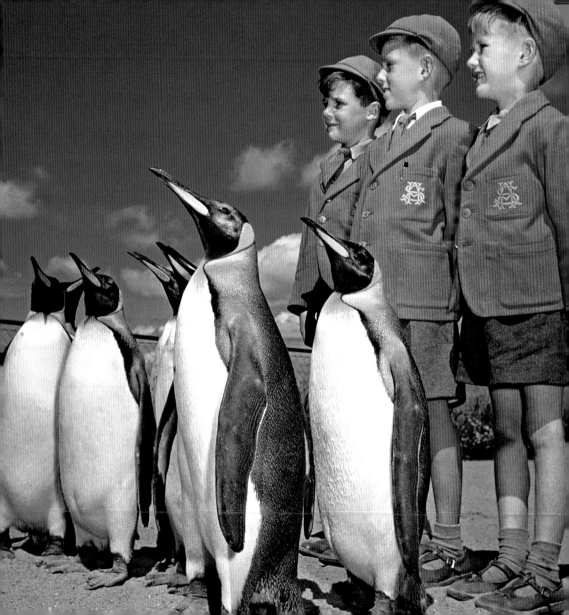

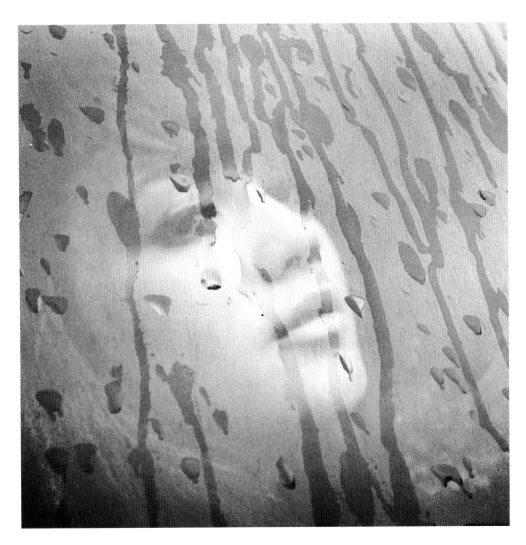

@DAVIDALANHARVEY *Early morning rain in the Outer Banks, North Carolina*

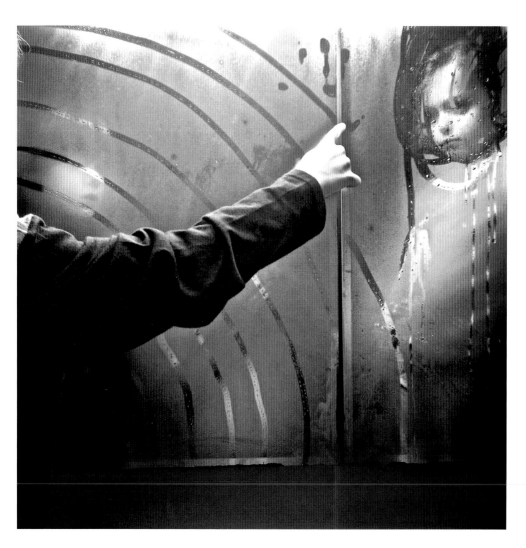

@JOHNSTANMEYER *The photographer's children doodle on a fogged bathroom mirror.* 143

@DAVEYODER *Radio telescopes in Chile's Atacama Desert read messages from distant galaxies.*
OPPOSITE: @BRIANSKERRY *The DeepSee submersible descends into a dormant volcano in the Pacific Ocean.*

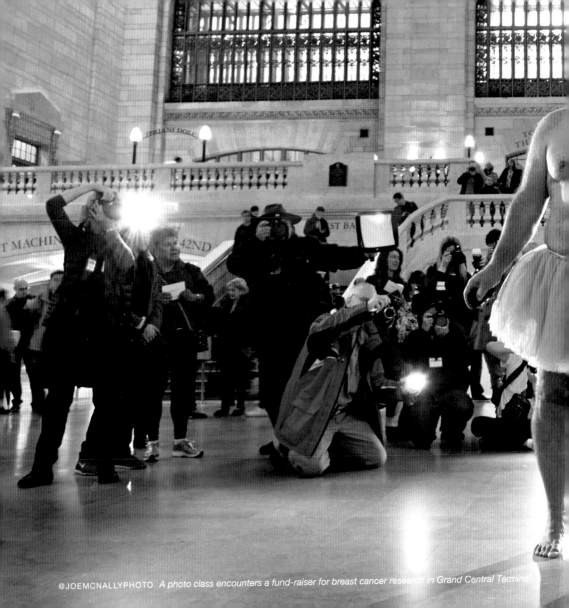

@JOEMCNALLYPHOTO *A photo class encounters a fund-raiser for breast cancer research in Grand Central Terminal.*

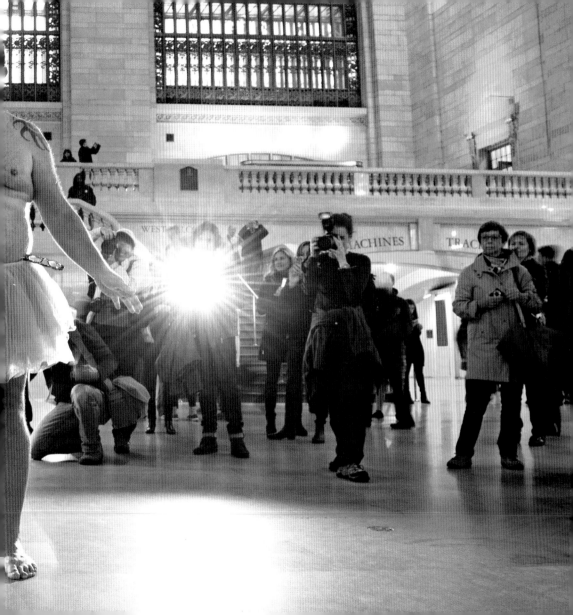

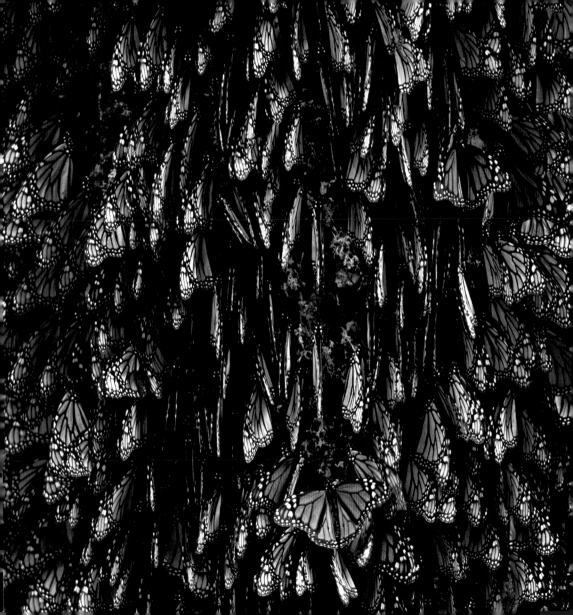

❤ 594k+ Likes
8,268+ comments

lettymadri: The butterflies rest like this when it's dark out. When the sun comes up they fly around in a beautiful giant cloud of orange! It's breathtaking!

ijkiesel: I visited this area during monarch migration. The driver had to stop the car to brush off the butterflies. I've never seen anything equal to it! Indescribable.

making.moments: Makes me happy to hear that people are doing something to keep such beautiful creatures alive. It's inspiring to do my part.

bissonettebayou: We plant milkweed in the backyard for them now!

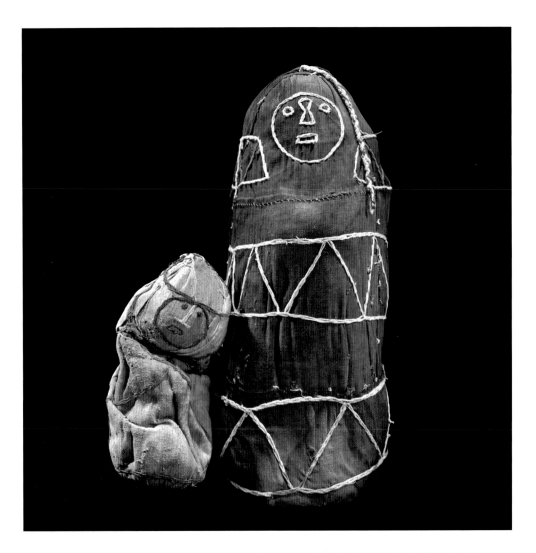

@ROBERTCLARKPHOTO *Two mummies of the pre-Inca Chachapoya civilization discovered in the Peruvian Andes*

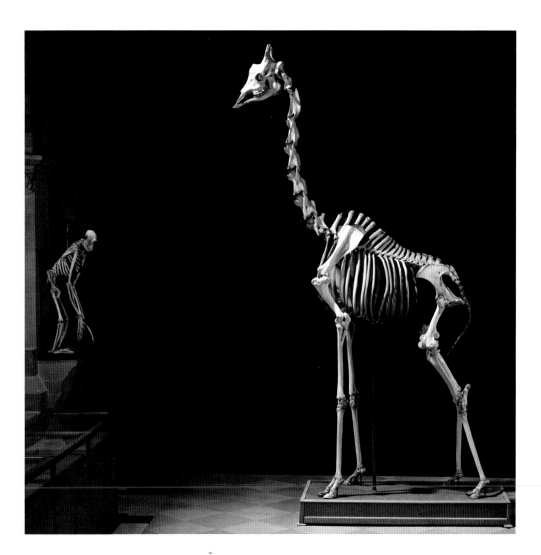

@ROBERTCLARKPHOTO *Skeletons of a giraffe and an orangutan at the Oxford Museum of Natural History, England* 151

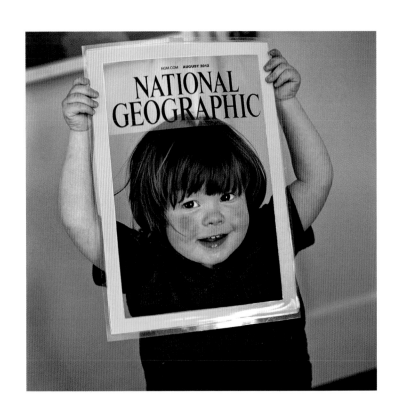

@ARGONAUTPHOTO *The photographer's son, at age two, grins on a mock-up cover.*

OPPOSITE: @GEOSTEINMETZ *Post-party Mardi Gras float*

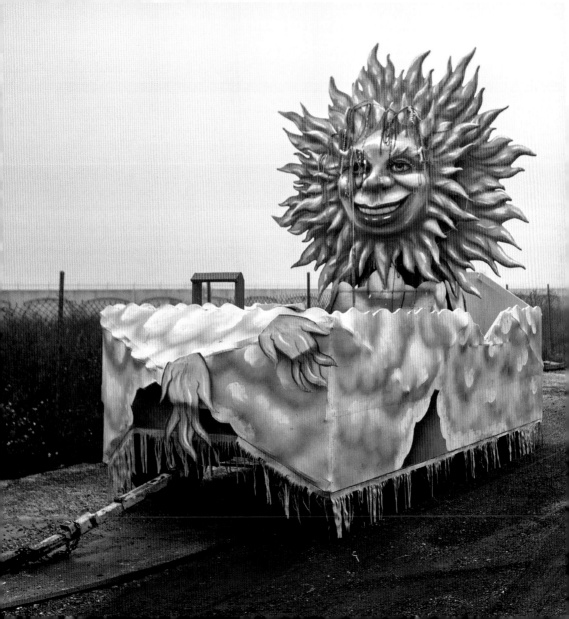

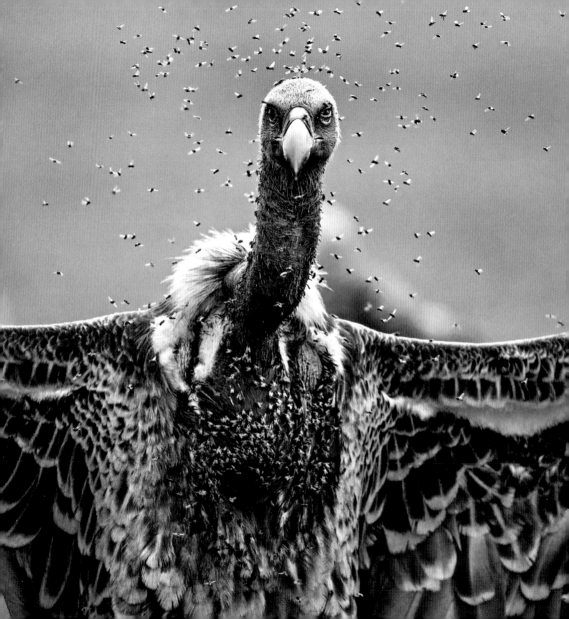

Even Darwin called them "disgusting," but vultures are more vital than vile. They clean up carcasses that would otherwise rot and spread pestilence. A group of birds can strip the carcass of a zebra — nose to tail — in 30 minutes. Naturally gifted morticians, they have beaks built for scavenging, and their bald heads are easy to wipe clean of gore. Revolting? Perhaps, but the grandiose vultures of the Serengeti are hardly without other redeeming values. They don't (often) kill other animals, they probably form monogamous pairs, and we know they share parental care of chicks. Most important, though, is their massively underrated ecosystem service of rapidly cleaning up and recycling dead animals. Without vultures, insect populations would boom, and diseases would spread — to people, livestock, and other wild animals.

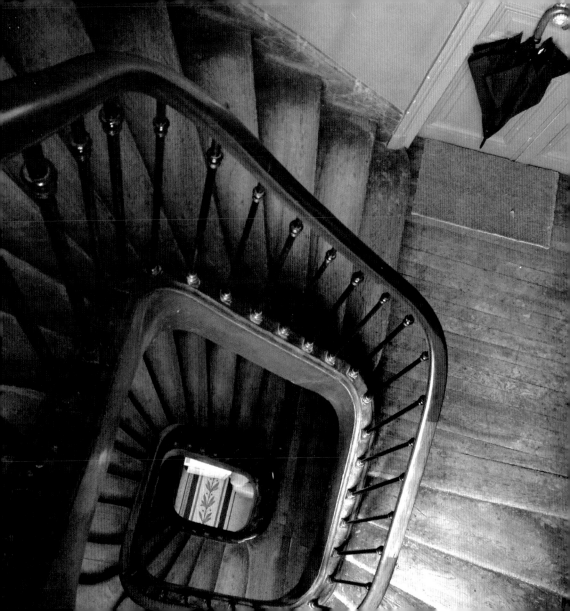

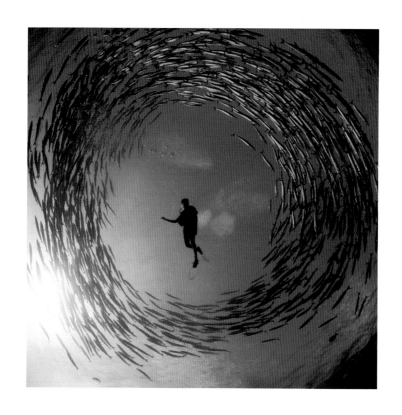

@DAVIDDOUBILET *A school of barracuda circles a diver in Papua New Guinea.*
OPPOSITE: @TOMASVH *A lone umbrella occupies a staircase in Paris dating to the 18th century.* 157

@JOELSARTORE *A red-eyed tree frog, native to the South American rain forest, at the Miller Park Zoo in Illinois*

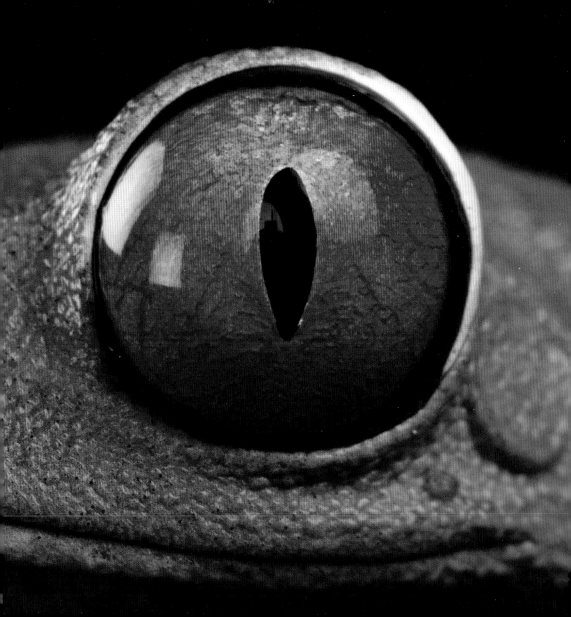

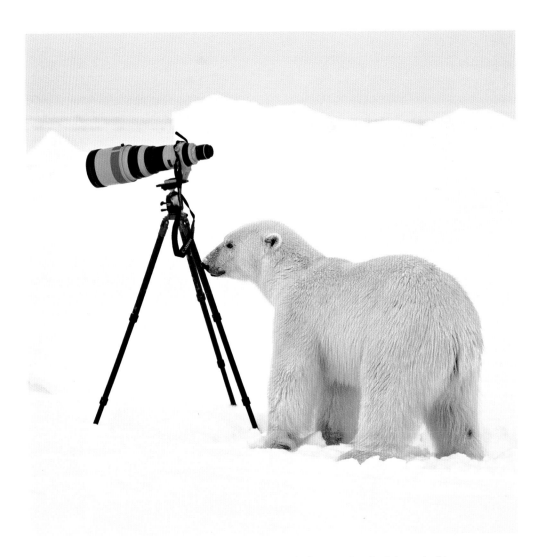

@PAULNICKLEN *An inquisitive polar bear inspects the photographer's gear as he retreats to a safe distance.*

@MARKLEONGPHOTOGRAPHY

When the Naga of Northeast India converted to Christianity over the past century, church elders insisted they bury the skulls that were once headhunted for power and fertility. This Konyak village is one of the few places that still maintains its collection—machete blows, bullet holes, and all—hidden away in a small display room. According to the Nagas' animist beliefs, human skulls could ensure the prosperity of crops, livestock, and tribal clans. The state of Nagaland is home to 16 indigenous hill tribes, of which 90 percent are now baptized Christians. Warrior ways have continued, however, with 60 years of armed insurgencies fighting the Indian government for autonomy. A peace accord was signed in 2015.

♥324k+ Likes

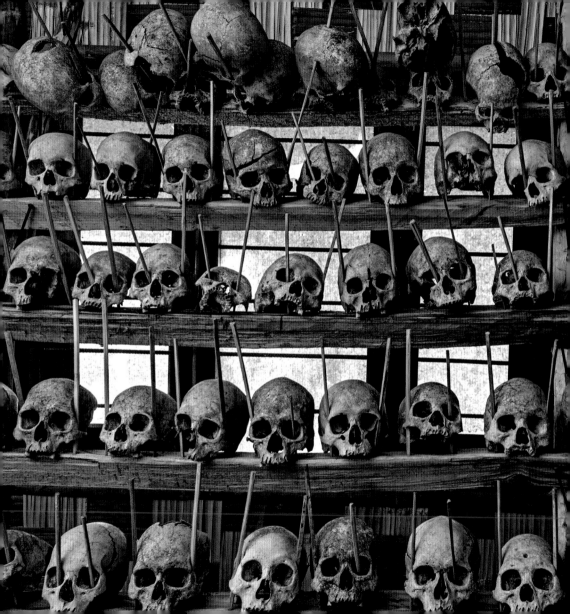

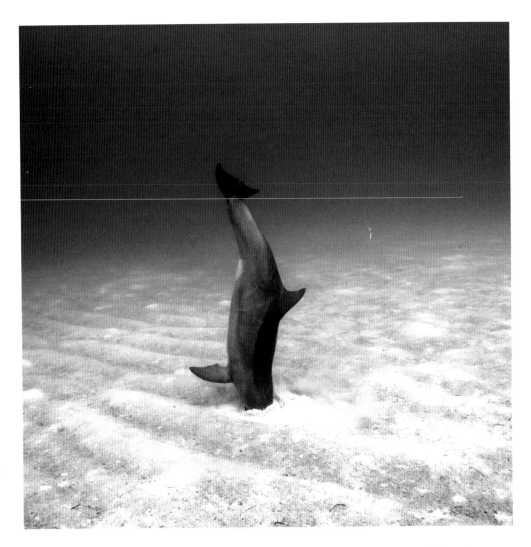

@BRIANSKERRY *A bottlenose dolphin in the Bahamas uses echolocation to find fish hidden beneath the sand.*

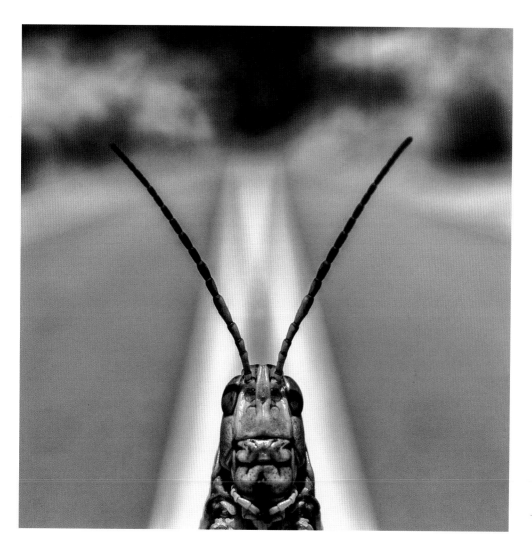

A bold grasshopper in the South Florida Everglades crosses the road.

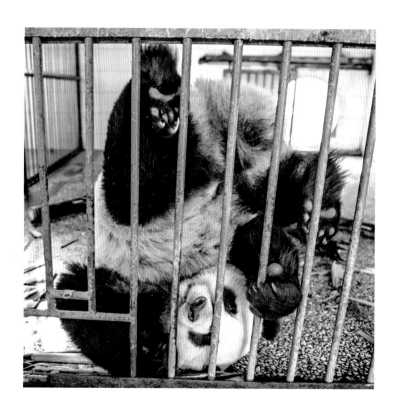

@AMIVITALE *A female exhibits playful mating behavior at China's Bifengxia Giant Panda Base.*
OPPOSITE: @ROBERTCLARKPHOTO *St. Cuthbert's pillow is kept in a locked box at an abbey on Iona, Scotland.*

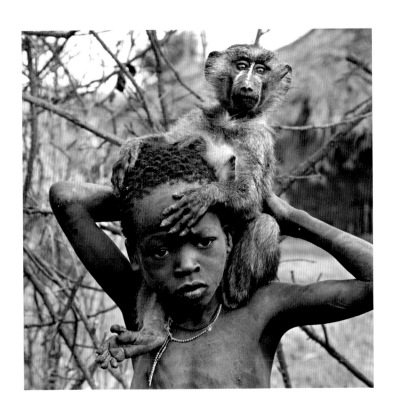

@RANDYOLSON *A boy and his pet baboon wander a Suri village in Ethiopia.*
OPPOSITE: @SHAULSCHWARZ *Man's best friend fares well at a gas station on the road to Kyoto, Japan.*

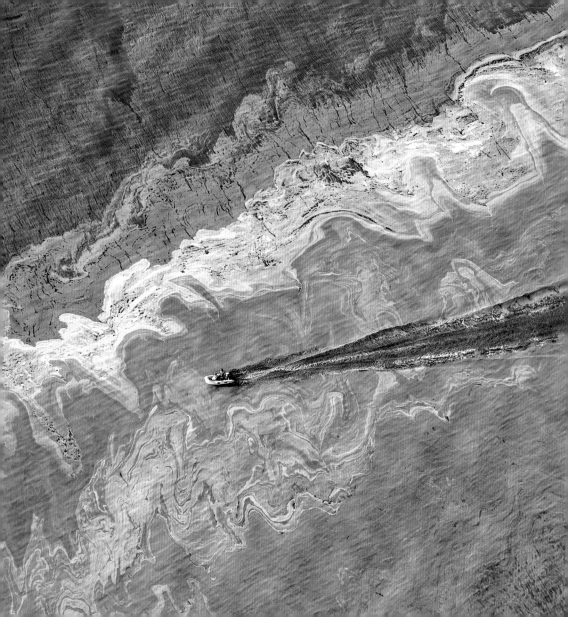

poquita: A wonderful picture indeed but let us remember that this is NOT what a healthy lake looks like. Less an issue of what we're eating as what we're dumping.

maxato: Yup, algae bloom isn't good in these proportions. It's choking life underneath.

bottle_nose: Why do we call them algae blooms and not nitrogen runoffs? I did the research and found that it is nitrogen and phosphorus fertilizer from farming which runs off into the water and makes algae bloom. That's what fertilizers do! And in turn kills marine life.

christielouxoxo: It's very sad. I have a summer home in the Upper Peninsula of MI and the lake is starting to look like this.

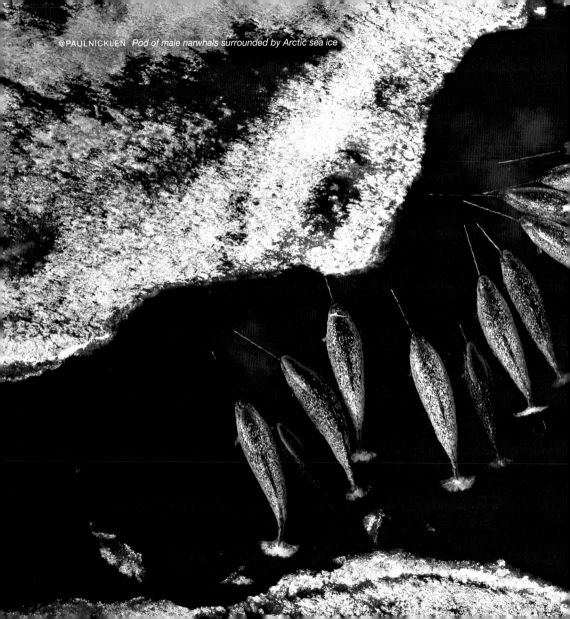

@PAULNICKLEN *Pod of male narwhals surrounded by Arctic sea ice*

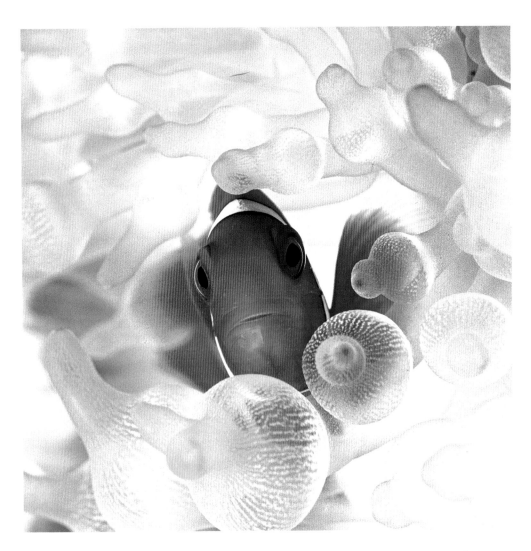

@DAVIDDOUBILET *A clownfish hides in an anemone bleached by warming water in Kimbe Bay, Papua New Guinea.*

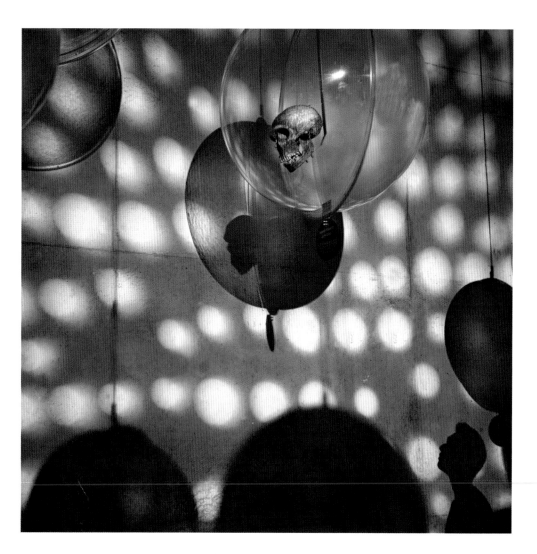

@ROBERTCLARKPHOTO *Neanderthal skull displayed at the Maropeng Visitor Centre in South Africa* 175

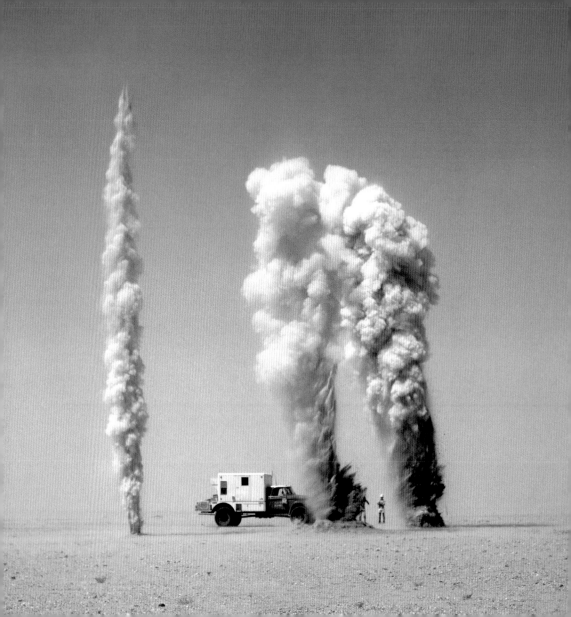

#TBT

Thomas J. Abercrombie | 1966

Geysers of sand explode from the desert of eastern Saudi Arabia as geologists probe for oil-bearing layers a mile beneath the surface. The surrounding wind-whipped landscape, named Rub al Khali, meaning "empty quarter," appears vacant, save for nomadic Bedouins. But it is far from empty—a fortune lies out of sight beneath the shifting sands. The Standard Oil Company made the first survey agreements with the Saudi government in 1933 and struck crude five years later. The post–World War II development boom catapulted the desert kingdom into prosperity. The awed photographer, Thomas J. Abercrombie, estimated Saudi Arabian oil reserves at 60 billion barrels. He didn't know the half of it: A 2015 report puts the estimate at 268 billion.

EAUTY

'BYÜ-TĒ

noun: *the qualities in a person or a thing that give pleasure to the senses or the mind*

@IVANKPHOTO *Patterns collide when a book of photography is placed on a woven mat from Mexico.*

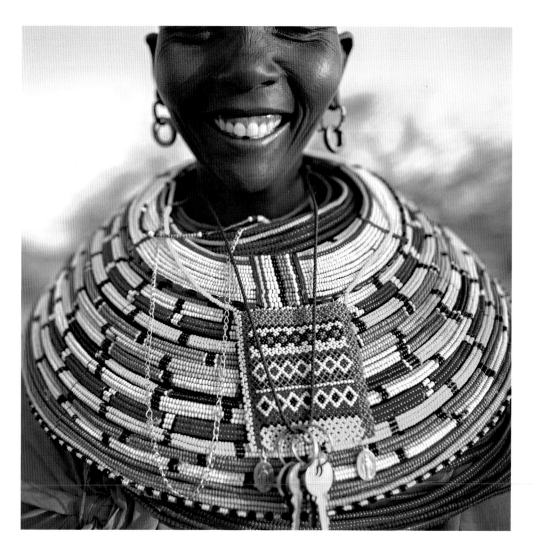

@AMIVITALE *This Kenyan woman is of the Samburu people, called "butterflies" for their colorful jewelry.* 181

@ROBERTCLARKPHOTO *The fist of a lowland gorilla anesthetized for an operation*
OPPOSITE: @ARGONAUTPHOTO *The blessing of 90 years of life*

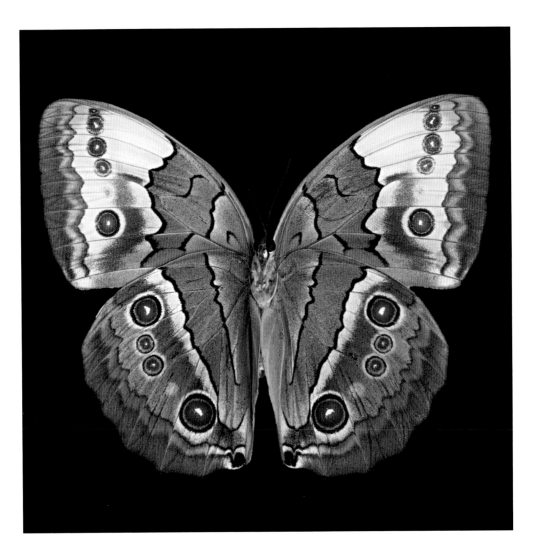

@ROBERTCLARKPHOTO *The underside of a* Stichophthalma camadeva *butterfly*

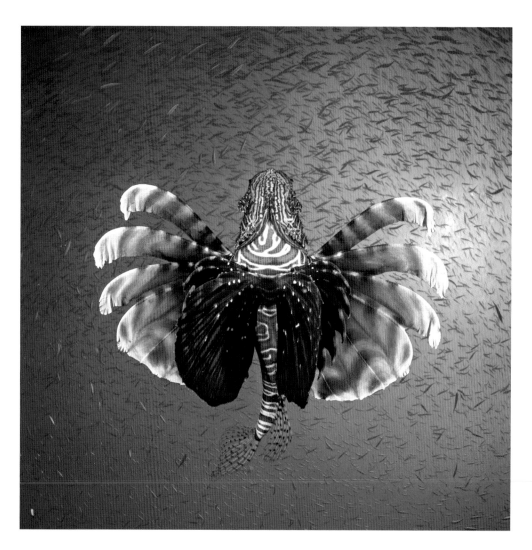

@THOMASPESCHAK *A venomous lionfish hunts baitfish in Mozambique's Ponta do Ouro marine reserve.* 185

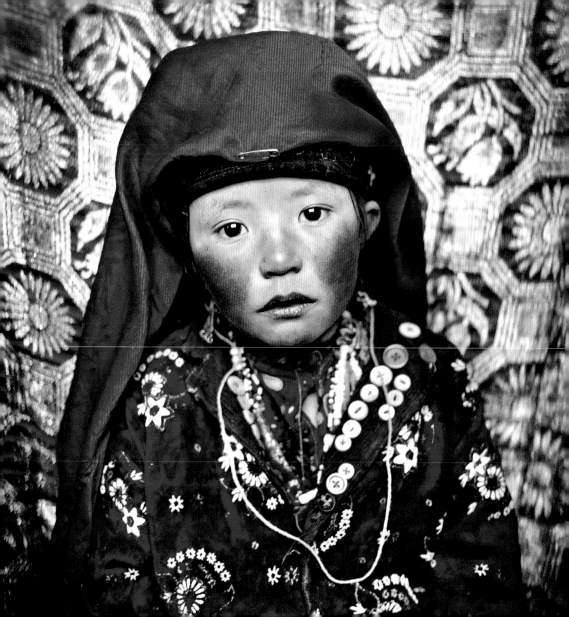

No, it's not makeup, and it's not retouched. Her cheeks burned by the bitter cold, Marbet, a seven-year-old Kyrgyz girl, just returned from gathering the yak herd in her camp in the middle of winter. Life is harsh at 14,000 (4,200 m) feet in the Pamir Mountains of Afghanistan, where there is an estimated 50 percent child mortality rate. Though largely unaffected by war, the region contends with a lack of health facilities, opium addiction, and poverty. The Kyrgyz survive in this remote, bewitching landscape as nomads by necessity. As men handle herding and trading, much of the hard labor of daily life falls to the women. On the roof of the world, they live suspended in time.

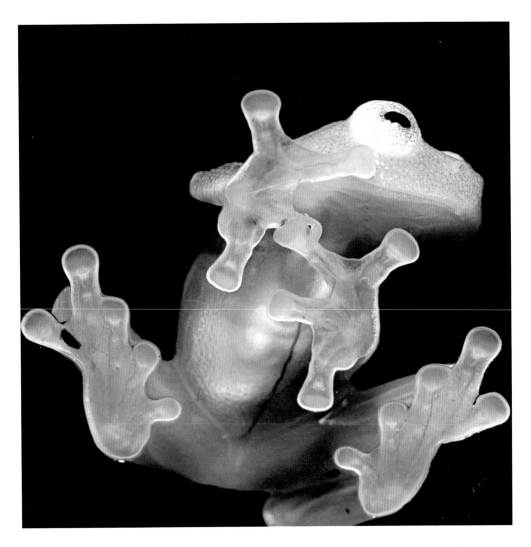

@PETERESSICK *Fleischmann's glass frog, a South American species struggling to survive in the warming climate*

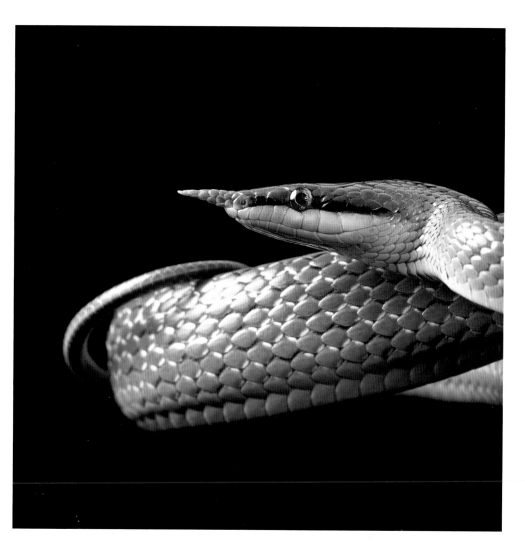

@JOELSARTORE *An emerald rhinoceros snake—shot at the St. Louis Zoo but native to the jungles of Vietnam*

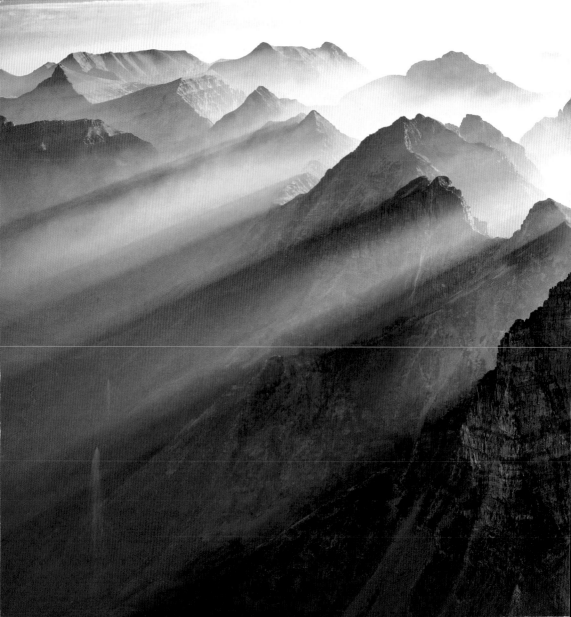

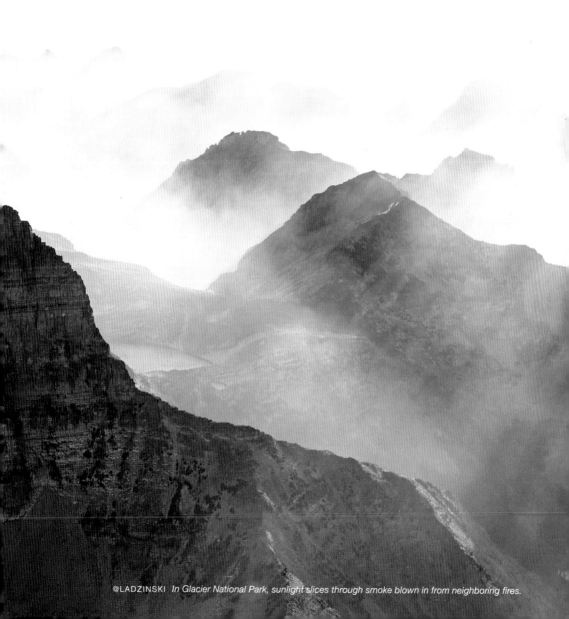

@LADZINSKI *In Glacier National Park, sunlight slices through smoke blown in from neighboring fires.*

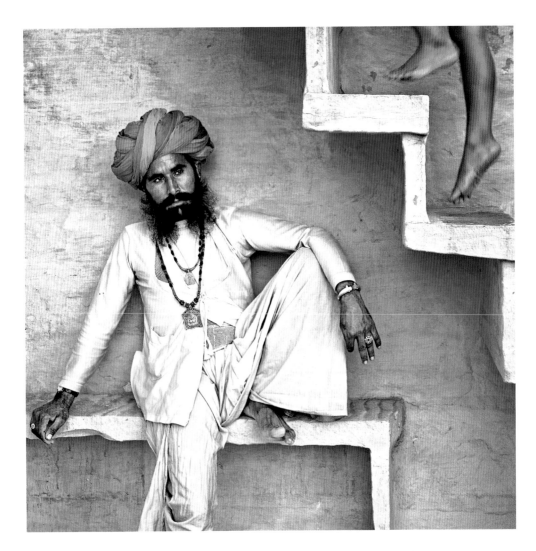

@STEVEMCCURRYOFFICIAL *Pensive portrait in the blue-hued city of Jodhpur in Rajasthan, India*

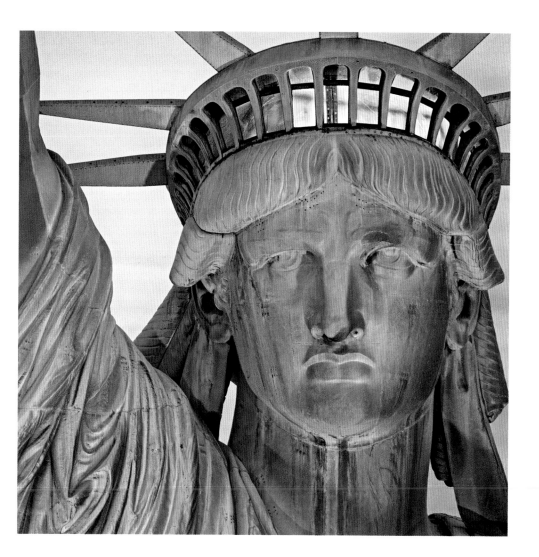

@GEOSTEINMETZ *Resolute Lady Liberty in New York City* 193

♥**437k+ Likes**

2,796+ comments

lollyknowsbest: This is such a beautiful photo.
It almost looks mythic.

the_indifferent_drifter: I've seen a lot of photos of the
Mundari tribe recently and this has to be the best so far.
Kudos to you Marco Grob.

cami.art.photo: This looks like a painting.

@MARCOGROB *The land mines peppering South Sudan are a great risk to the nomadic Mundari and their livestock.*

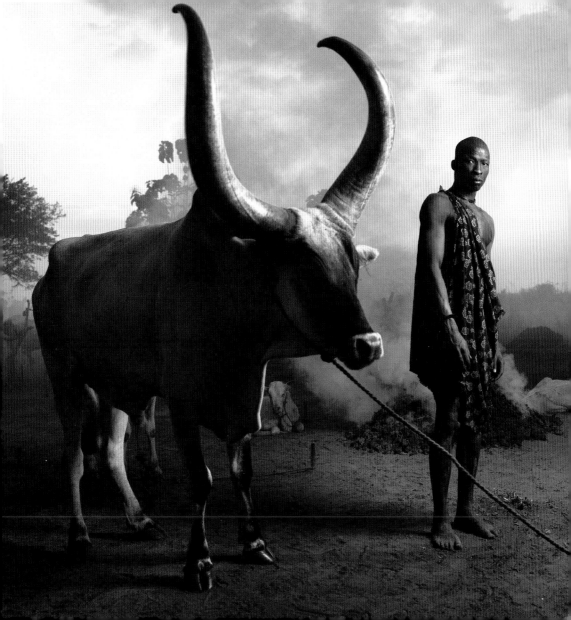

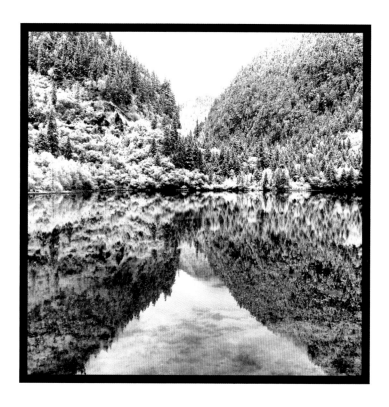

@YAMASHITAPHOTO *Mirrored mountains in Jiuzhaigou National Park in Sichuan Province, China*
OPPOSITE: @PAULNICKLEN *Tridacna clams form an alluring pattern in the Phoenix Islands, Kiribati.*

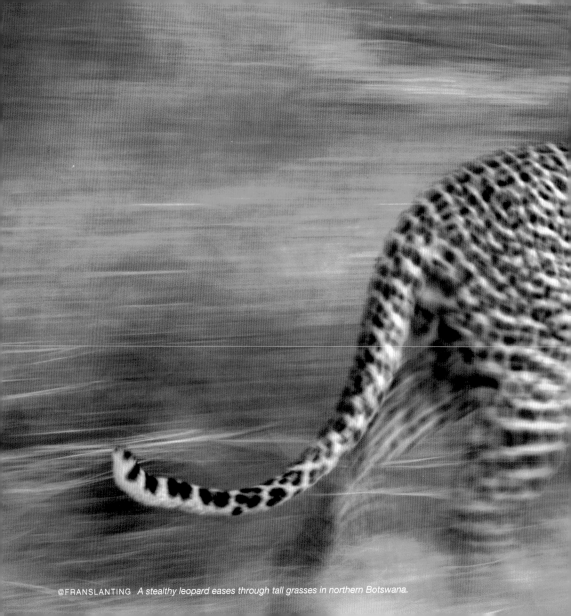

A stealthy leopard eases through tall grasses in northern Botswana.

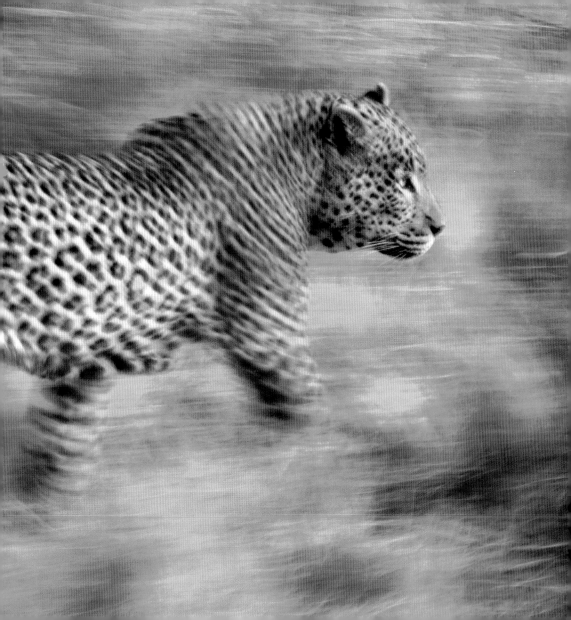

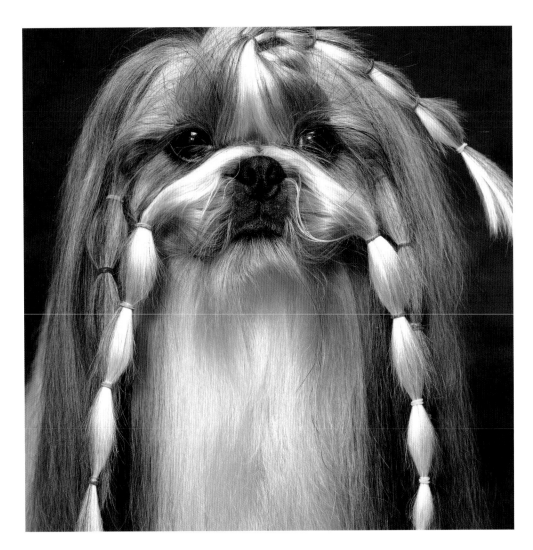

@ROBERTCLARKPHOTO *A primped shih tzu backstage at the Westminster Dog Show*

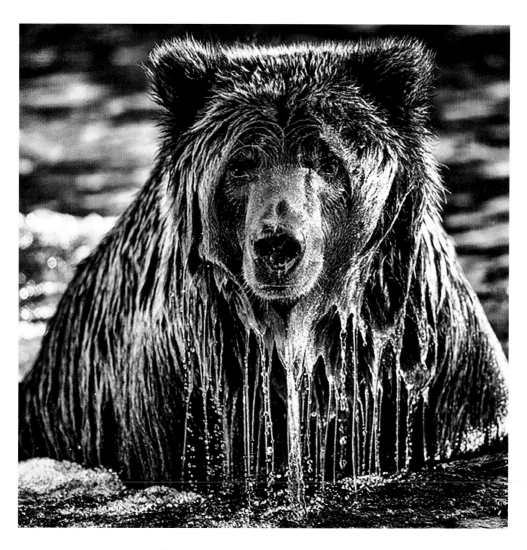

#TBT

J. Baylor Roberts | 1938

The annual lotus bloom on a man-made lake in Iowa offers a rare treat for girls from the nearby Amana Colony. Winter may find them skating or fishing on the same lake. During the photographer's visit near the end of the Great Depression, their insular prairie villages were undergoing a significant transformation. European immigrants founded the Amana Colony of seven German-speaking villages as a self-sustaining commune in 1855. Property was held in common, the church allocated living quarters, and meals were shared. But due to economic stress and the flight of young people, the colony underwent "The Great Change" in 1932, dividing the residents' remaining wealth in equal shares and converting to cooperative capitalism. For the first time in their lives, Amanites earned wages and owned property. Evocative of another age, life in the villages carries on largely unchanged today.

♥**351k+ Likes**

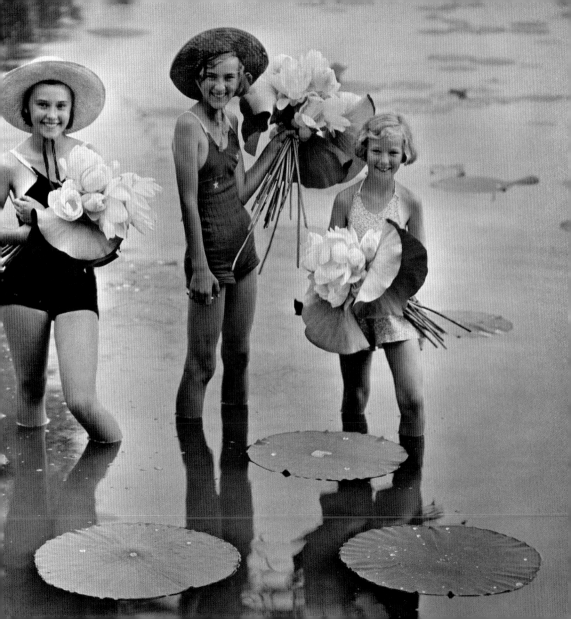

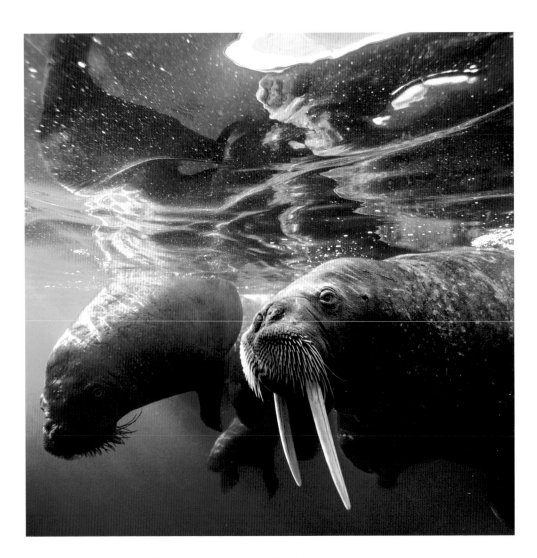

 Walruses off Hooker Island in Franz Josef Land, Russia

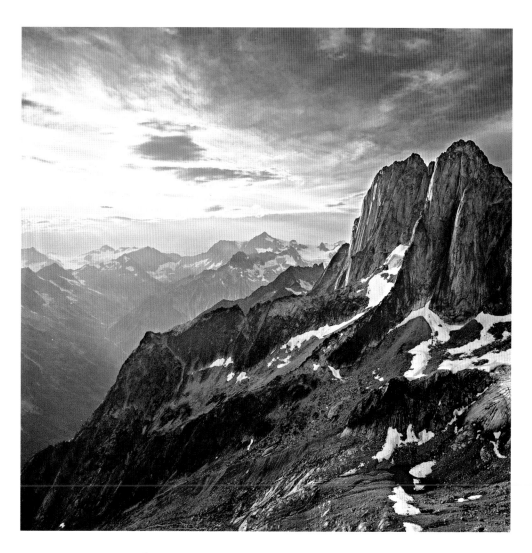

@JIMMY_CHIN *The sun sets on Howser Towers, a trio of granite peaks in Canada favored by rock climbers.*

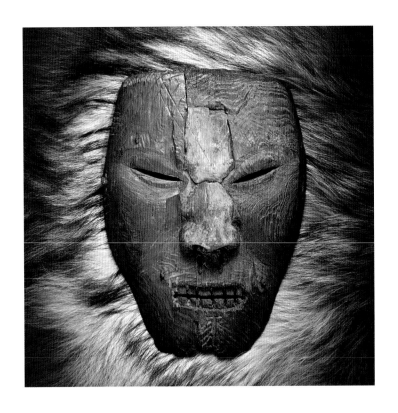

@DAVIDCOVENTRY *Ancient Paleo-Eskimo people in northern Canada used this mask for shamanic rituals.*
OPPOSITE: @PAULNICKLEN *Arctic breeze teases the faux-fur parka of a nautical cadet in Svalbard, Norway.*

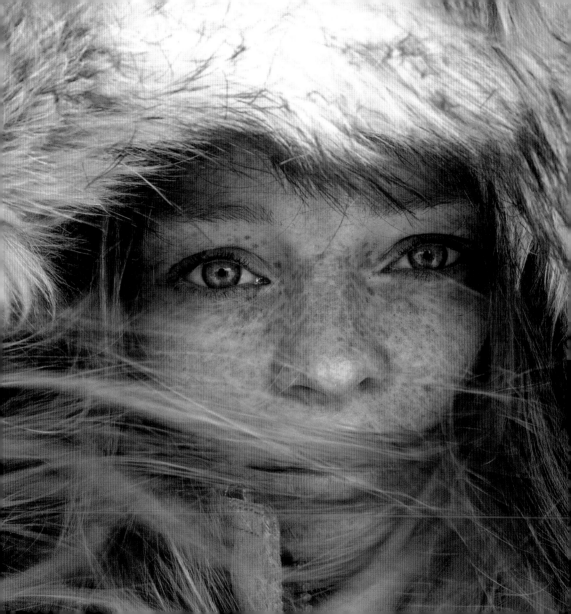

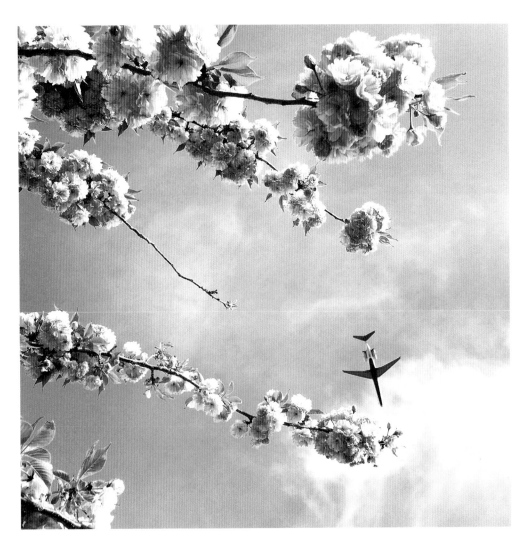

@IRABLOCKPHOTO *Spring brings cherry blossoms to New York City.*

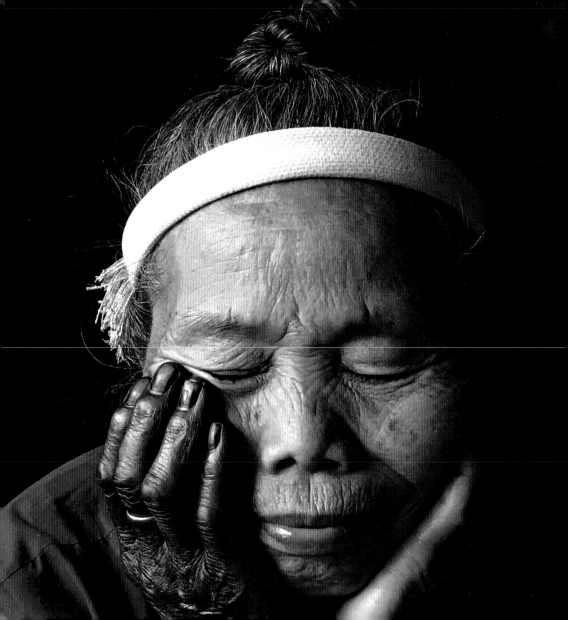

@MARKLEONGPHOTOGRAPHY

Despite rapid modernization in China's Guangxi region, Dong minority women still often have blue hands from dyeing their traditional fabrics in vats of indigo. When I first visited China in the summer of 1989, I came to see the place that my family had left for California a century before. I spent three weeks in the sleepy backpacker town of Sanjiang. I captured its rural residents on rolls of black-and-white film well suited to the monochromatic socialist palette. Returning 25 years later, I arrived by high-speed train rather than dirt road. In the Sanjiang of 2015, I found a neon night scene that wouldn't be out of place in Hong Kong. Sanjiang was not the only thing to change over the years—I shot on an iPhone 6.

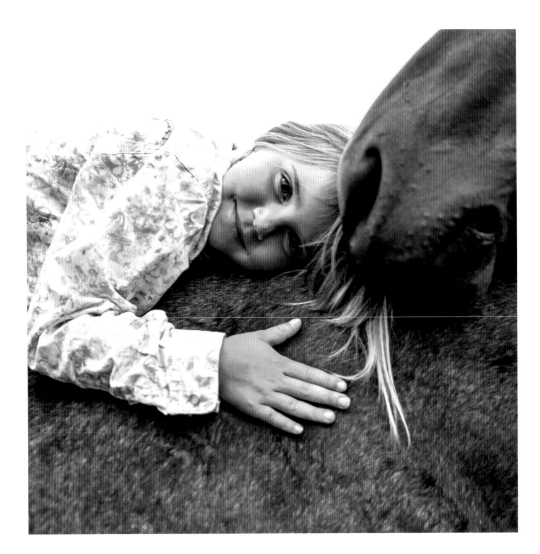

@AMIVITALE *This Montana girl and her horse started riding together when she was five months old.*

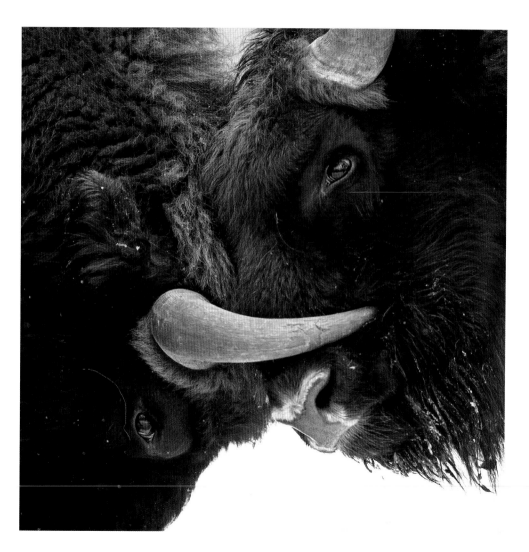

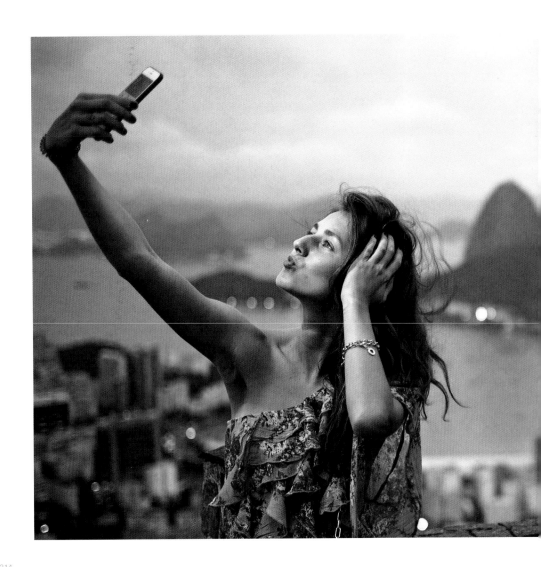

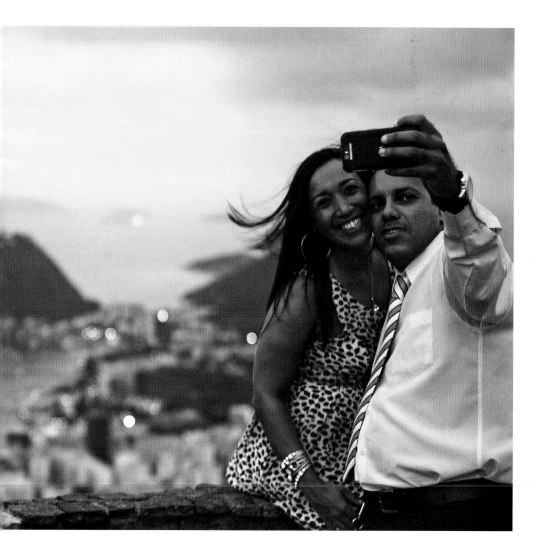

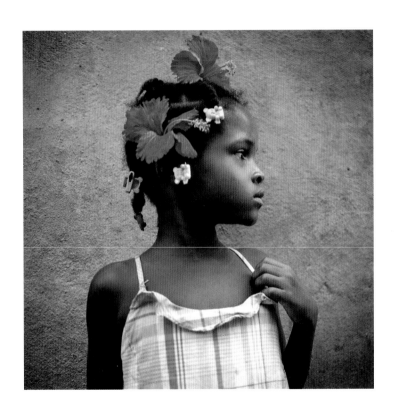

@NATGEO *A Haitian girl dons hibiscus, the unofficial national flower, for student photographer Myrmara Prophète.*

OPPOSITE: @ROBERTCLARKPHOTO *An elegant flamingo preens during a photo shoot.*

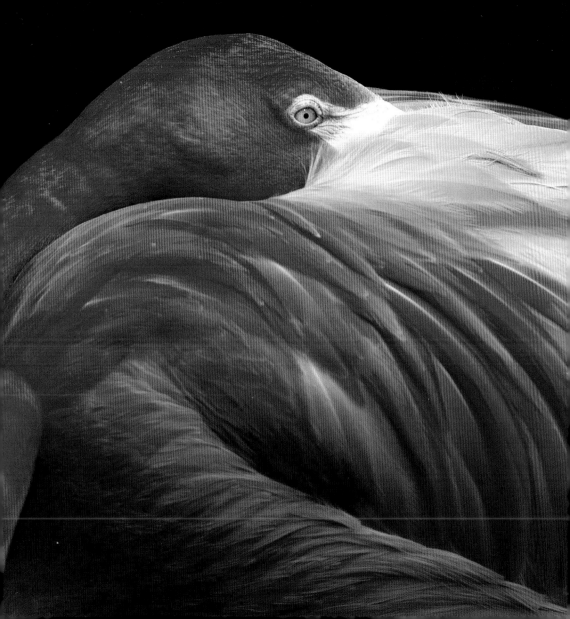

#TBT

W. Robert Moore | 1941

A stylish couple rides in a motorboat on Lake Villarrica in Chile, a scenic haven in the Araucania Region. When National Geographic visited in 1941, the area was rapidly opening up to outsiders. Some called these lake lands "Chilean Switzerland" because of the German refugees populating many villages. Tourists whizzed down volcano slopes on skis or fished for trout in the lakes below. Meanwhile, traditional Chilean cowboys, called huasos, *herded sheep and cattle from horseback. This blend of cultures has long been central to the Chilean identity. However, the land is the ancestral territory of the Mapuche Indians, who successfully fought off the Spanish conquistadors and adopted allegiance to the Chilean government with reluctance. In recent years, the uneven distribution of land, power, and wealth in the region has escalated into confrontations between dispossessed Mapuche and expanding industry.*

♥**361k+ Likes**

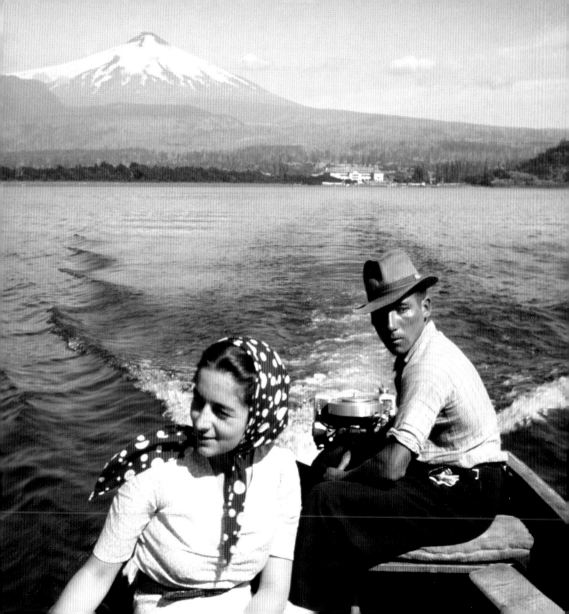

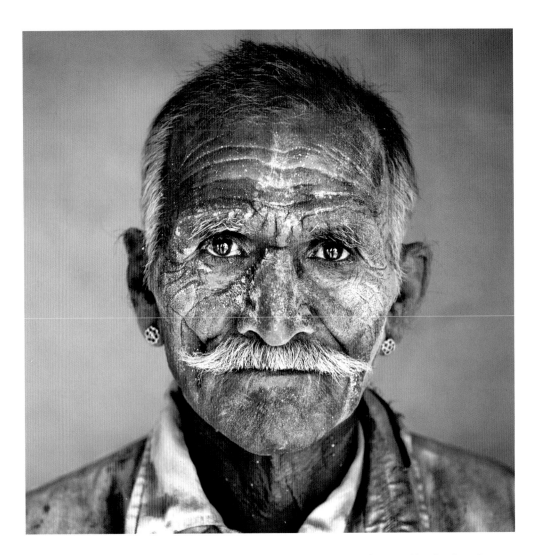

@STEVEMCCURRYOFFICIAL *Celebrating the Hindu festival Holi, a man finds himself showered in colored powder.*

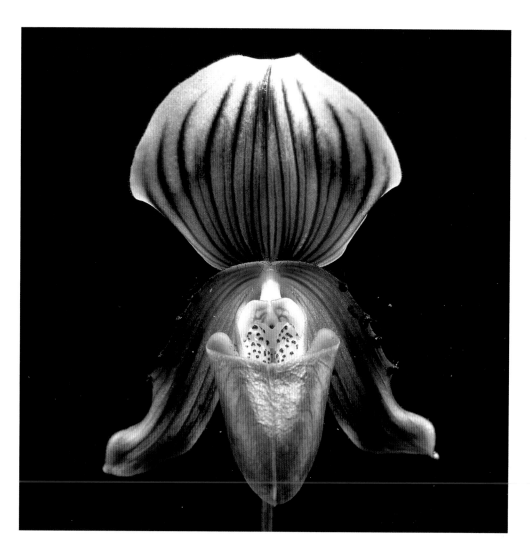

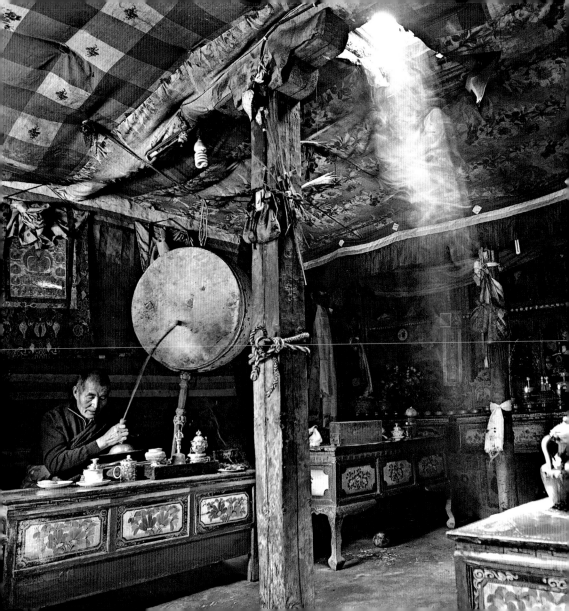

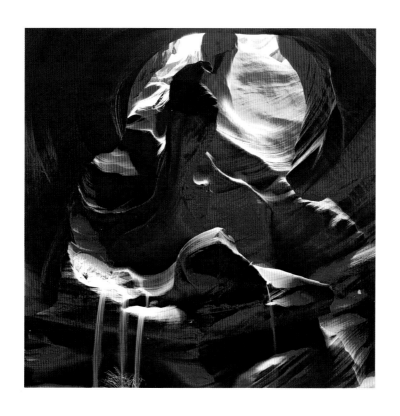

@LADZINSKI *Sculpted sandstone in Antelope Canyon in Arizona*
OPPOSITE: @CORYRICHARDS *A Buddhist lama performs a rite with cymbals and incense in Lo Manthang, Nepal.*

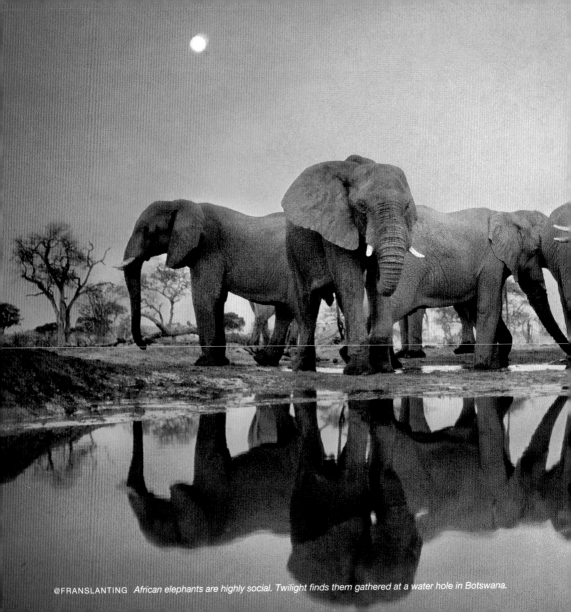

African elephants are highly social. Twilight finds them gathered at a water hole in Botswana.

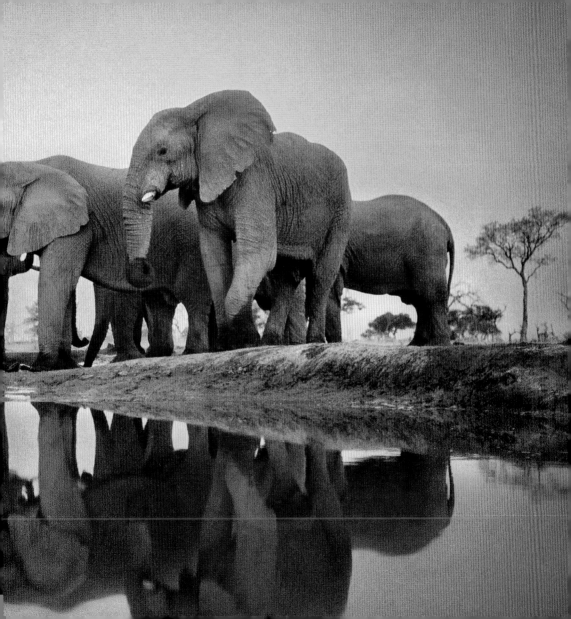

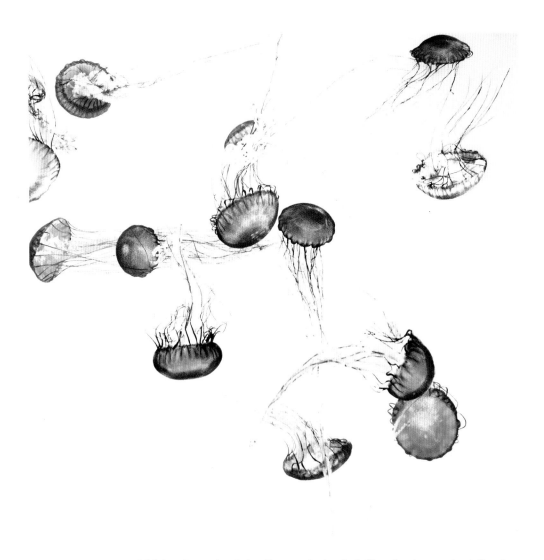

@ROBERTCLARKPHOTO *Jellyfish are the most ancient multi-organ animal on Earth. These live at an aquarium in Toronto.*

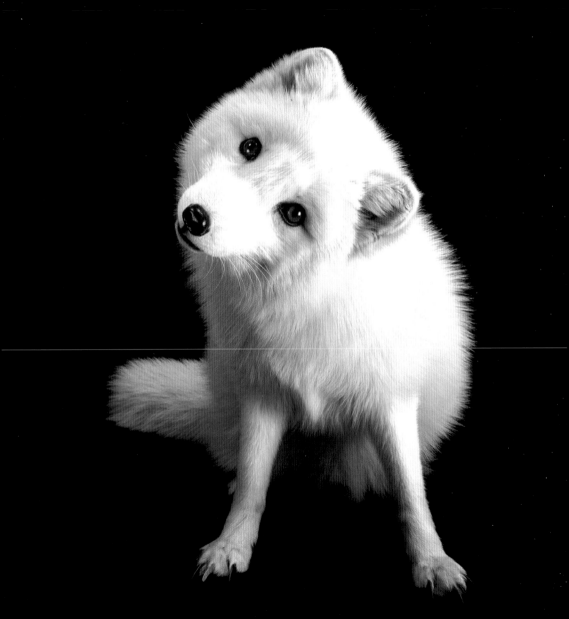

♥503k+ Likes
10,947+ comments

crissycabral: Awww! He is so curious

_lace_of_base_: I loved seeing that this is at the Great Bend zoo! Thanks for visiting my hometown, @natgeo.

zukazula: I can't believe people wear clothes made out of their fur. It's so sad.

kolesin: How can anyone resist that face!

@ROBERTCLARKPHOTO *The lustrous* Allotopus rosenbergi *beetle at the Montreal Insectarium*

OPPOSITE: @TYRONEFOTO *A New Orleans high school student's graduation day finery*

@ROBERTCLARKPHOTO *Wirehaired pointing griffons have a coat bred for hunting in thick undergrowth.*
OPPOSITE: @ROBERTCLARKPHOTO *Waves of marsh grass in Northumberland, England*

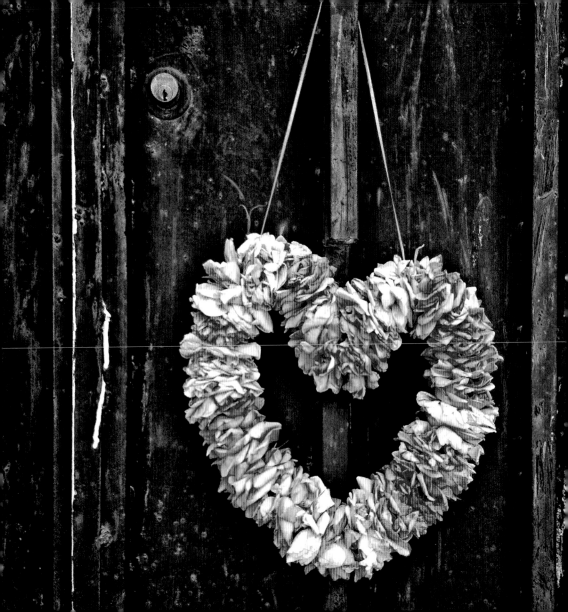

@KENGEIGER

I make a habit of collecting hearts. I picked up this little wreath at a market in Morocco's aptly romantic Valley of Roses. A weathered barn nearby offered the perfect backdrop for a photograph. But with Valentine's Day nearly a year away, I decided to sit on the photo rather than share it. Finally today—the day we celebrate love, especially romantic love—I could give it to Karine. Her heart is the undisputed prize of my collection. Happy Valentine's Day!

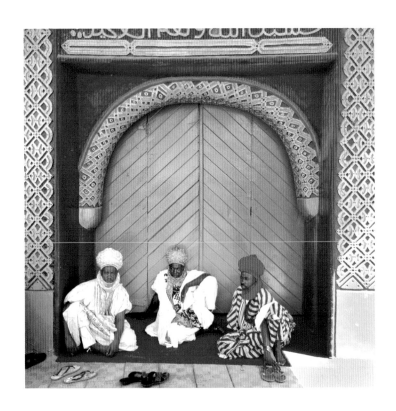

@EDKASHI *Nigerian men relax in the Emir of Kano's palace as he celebrates his 50th year on the throne.*
OPPOSITE: @STEPHSINCLAIRPIX *A girl in Nepal prepares to greet devotees in her role as a kuman, or living goddess.*

@JOELSARTORE *A keel-billed toucan at Tracy Aviary in Utah, America's oldest bird park*

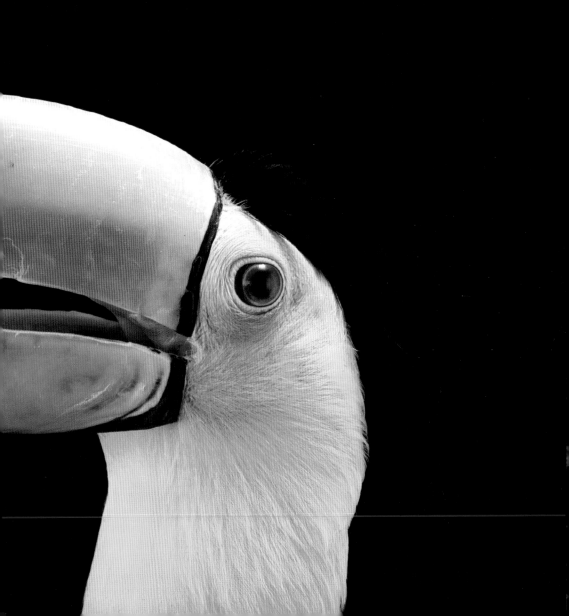

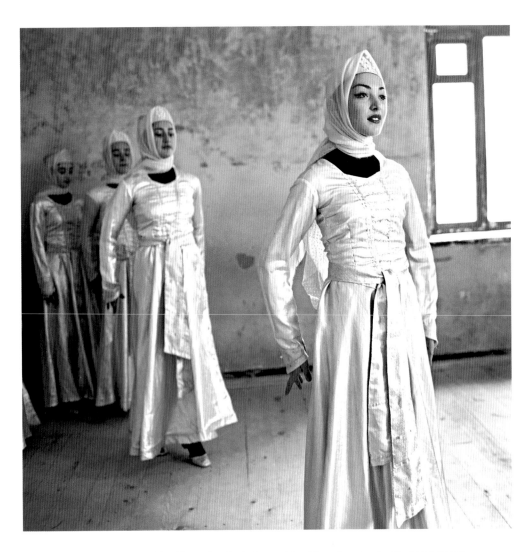

 An ensemble of Svaneti youths in the republic of Georgia revives traditional folk dances.

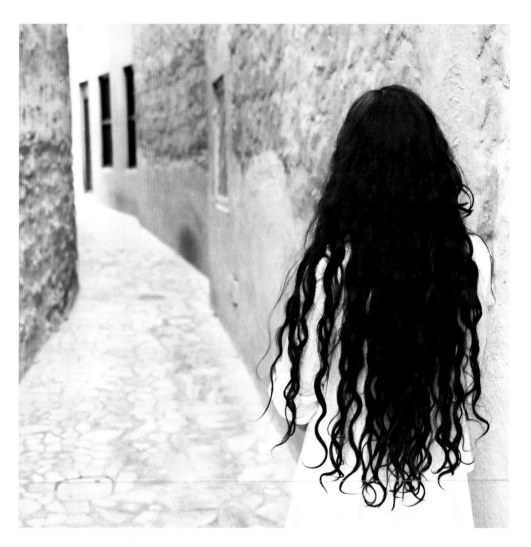

@PAULNICKLEN

The indefatigable Ha'a Keaulana runs across the ocean floor with a 50-pound (23 kg) boulder. Her father, legendary waterman Brian Keaulana, pioneered this technique to train lifeguards. Building endurance prepares Ha'a for one of surfing's great dangers—a wipeout on a massive wave that holds you underwater. She visits these waters almost every day to refresh both body and spirit, like generations of Hawaiians before her have done. On assignment in Makaha on the west coast of Honolulu, I was very humbled to learn from the Hawaiians, who have saltwater running through their veins. To you, I say thank you very much, mahalo nui loa.

♥404k+ Likes

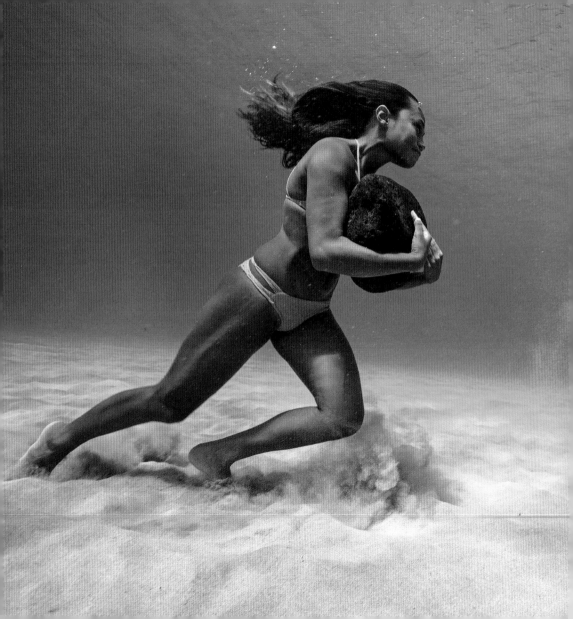

244 **@AMIVITALE** *A Bulgarian teen poses for a double-exposure shot along the banks of the Danube River.*

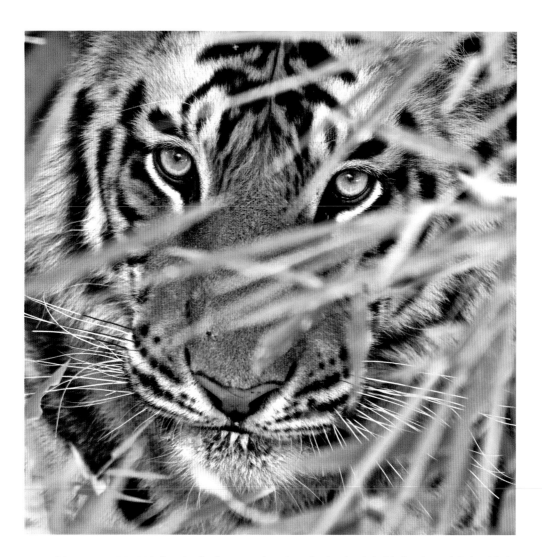

@STEVEWINTERPHOTO *Smasher the tiger peers through rustling bamboo in India's Bandhavgarh National Park.*

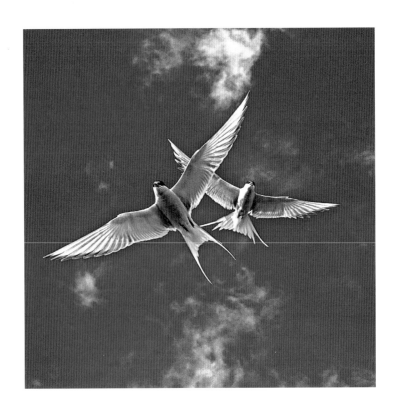

@CORYRICHARDS *The little arctic tern has the longest migration of any known animal on the planet.*
OPPOSITE: @THOMASPESCHAK *Sub-adult whale sharks gather off the coast of Djibouti to feed on plankton blooms.*

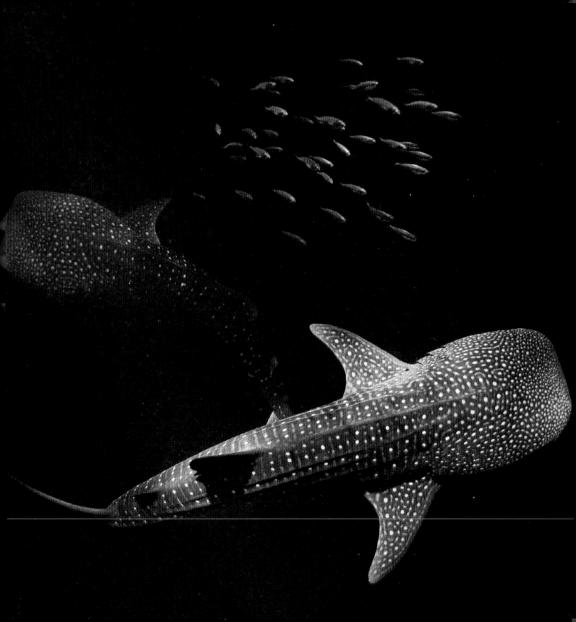

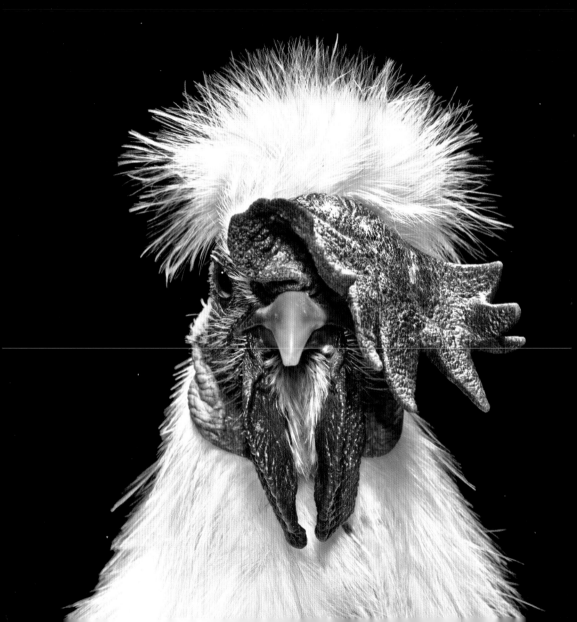

This is a Silkie, a breed of domestic chicken. The first documented appearance of a Silkie appears in the written accounts of Marco Polo's journeys through Asia in the 13th century. He declared them strange birds but "very good to eat." Their plumage is not "fur," as he claimed. The semi-plume feathers lack barbules, the little hooks that keep other contour feathers stuck together, creating a loose down that is as soft as silk. Feathers are a particularly curious effect of evolution. Archaeologists determined that they were probably around for millions of years before a single dinosaur began to take flight. They hypothesize many other purposes, such as insulation, sheltering young, or attracting mates. Though Silkies are now domesticated animals bred by humans, their fashionable shag may still serve them in this way.

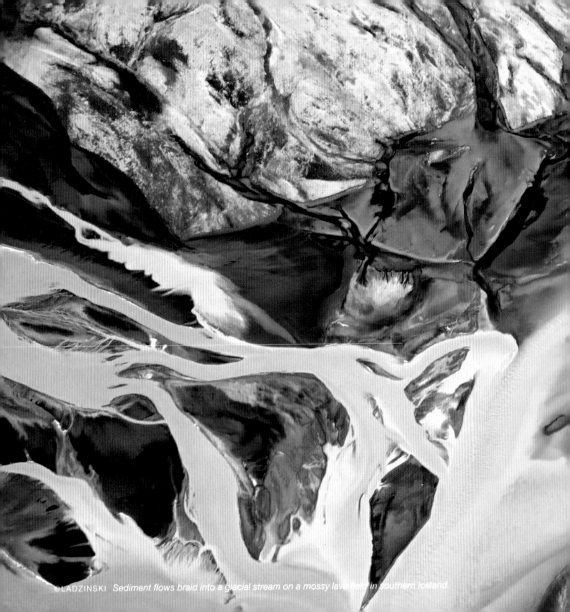

©LADZINSKI Sediment flows braid into a glacial stream on a mossy lava field in southern Iceland.

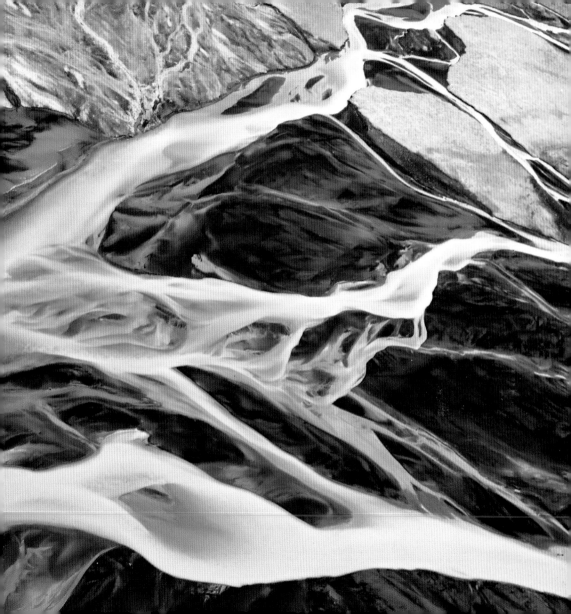

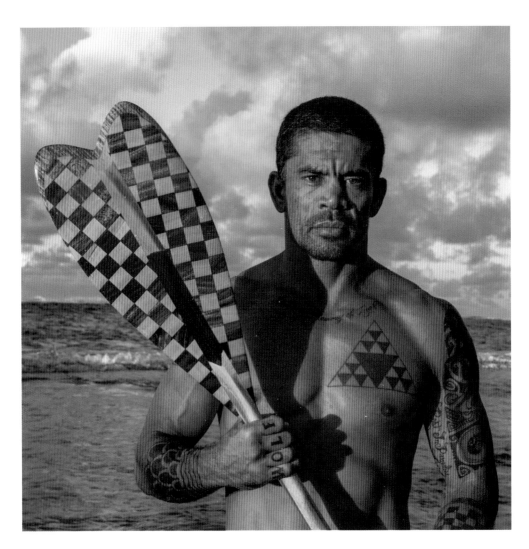

@PAULNICKLEN *A member of Hawaii's surfing elite displays tattoos that epitomize Islander pride.*

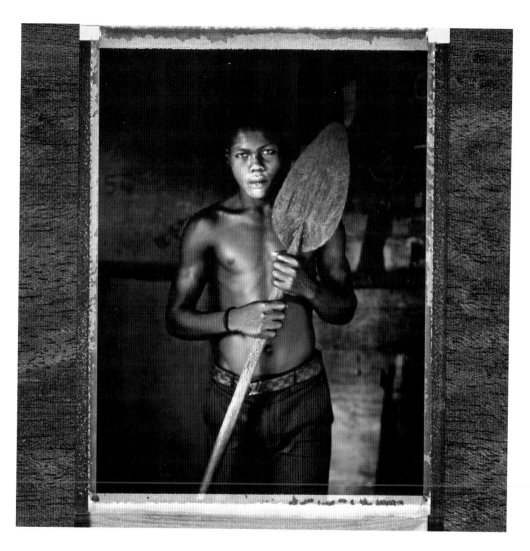

#TBT

Roland W. Reed | 1907

A Chippewa girl stands wrapped in a blanket in the shadowy mist of northern Minnesota. Also called Ojibwe, the Chippewa are a large tribe of the Great Lakes region and Canada. Growing up in a log cabin in the Indian country of Wisconsin, photographer Roland W. Reed had been enamored of his Native American neighbors. As an adult, he owned a commercial studio in a town near the Ojibwe's Red Lake Reservation. He began laboriously hauling his camera and glass plate negatives to the reservation's scattered camps. As Native American culture was fading from memory, he asked the residents to pose in traditional dress or to re-create activities that were once common. His photos show not a reservation-ravaged people but proud individuals and a rich community. Reed's completed ethnographic study of several tribes comprised 2,200 photos published in 20 volumes— precious documentation of a vanished past.

♥ **285k+ Likes**

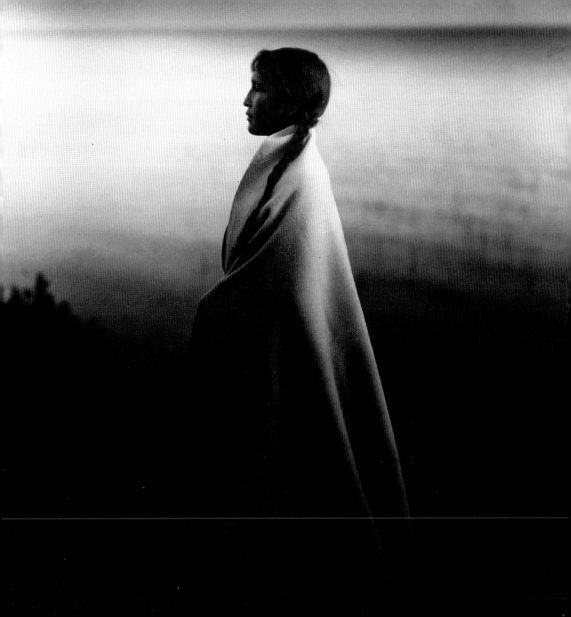

ˈMÄRVəL

noun: *one that causes wonder or astonishment;*
intense surprise or interest

@GEOSTEINMETZ *Water sports reach new heights with Aquajet jetpack escapades in Miami Harbor.*

Monks at the Shaolin Monastery in China find serenity in physical strength and dexterity.

@THOMASPESCHAK *Graceful mantas feed on krill as silverside fish swirl around them in Hanifaru Bay, Maldives.*
OPPOSITE: @PETEKMULLER *A colony of fruit bats in the Ivory Coast swarm by the tens of thousands for protection.*

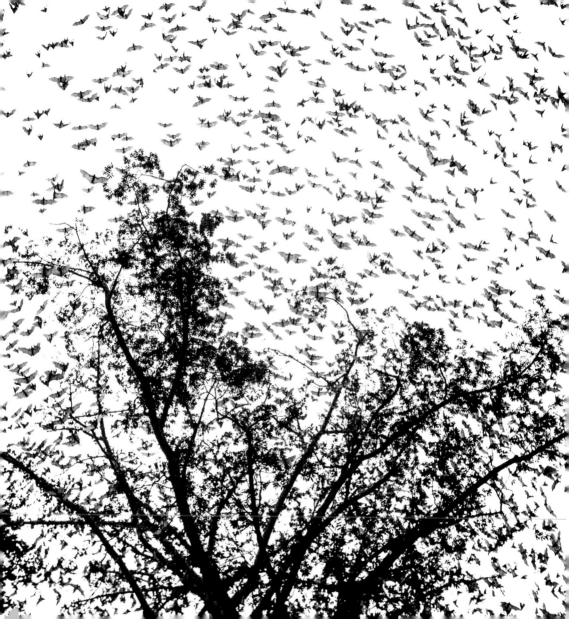

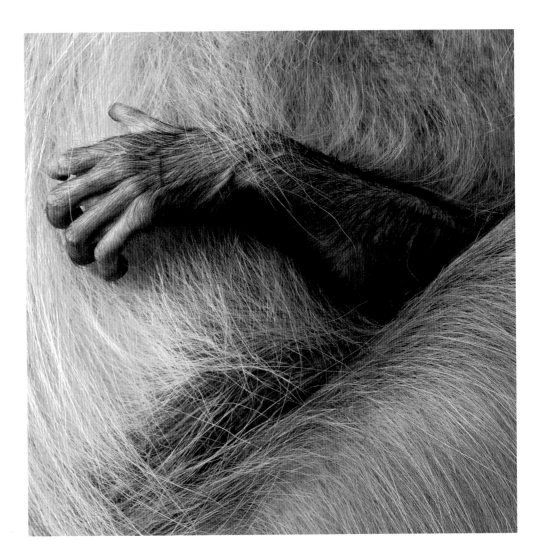

@STEFANOUNTERTHINER *A newborn Hanuman langur monkey in India is protectively enveloped by its mother.*

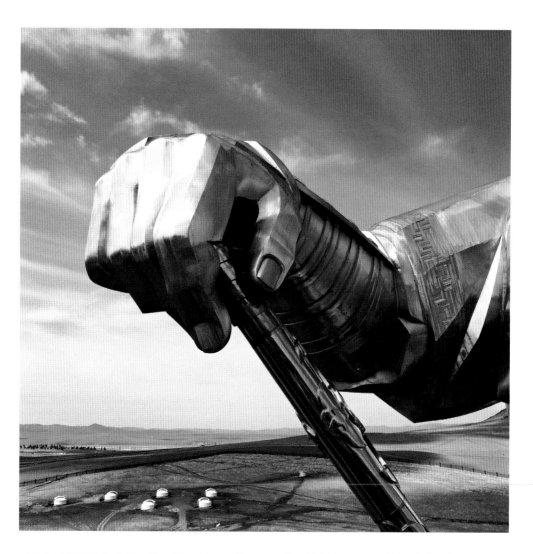

@IRABLOCKPHOTO *Holding his golden whip, a stainless-steel Genghis Khan overlooks Mongolia from Tsonjin Boldog.*

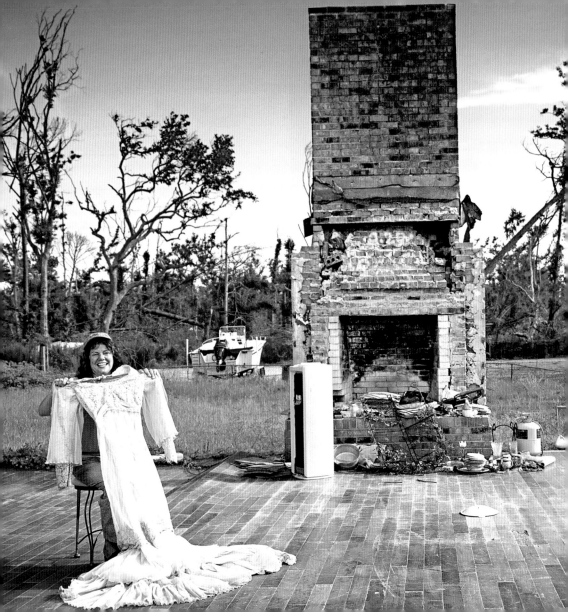

@STEPHENWILKES

In the months following Hurricane Katrina, I traveled the Gulf Coast meeting the people left in the wake of the storm. Time and time again, I found that in the aftermath of devastating loss, there was hope. In the waterfront city of Bay St. Louis near Biloxi, Mississippi, I met Melanie Mitchell. The storm brought tremendous hurt and chaos into her life, but also an uncanny moment of serendipity. "We had just paid off the house, and it was swept clean off its foundations," said Melanie, pictured in the vestige of that home in 2006. "We lost everything. But I found my wedding dress in a neighbor's tree. Isn't that something? There were just a few rips in it."

@PAULNICKLEN *Prepping for a lengthy assignment means double- and triple-checking equipment.*

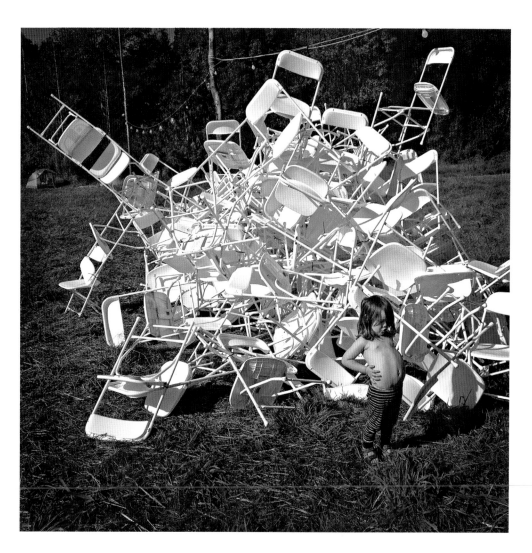

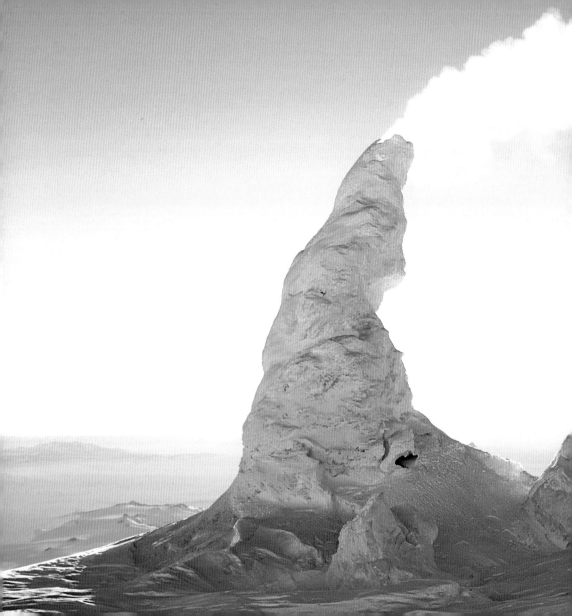

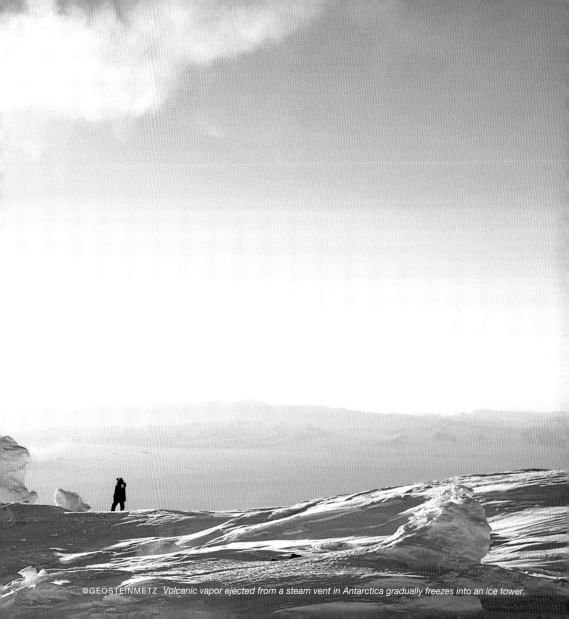

@GEOSTEINMETZ *Volcanic vapor ejected from a steam vent in Antarctica gradually freezes into an ice tower.*

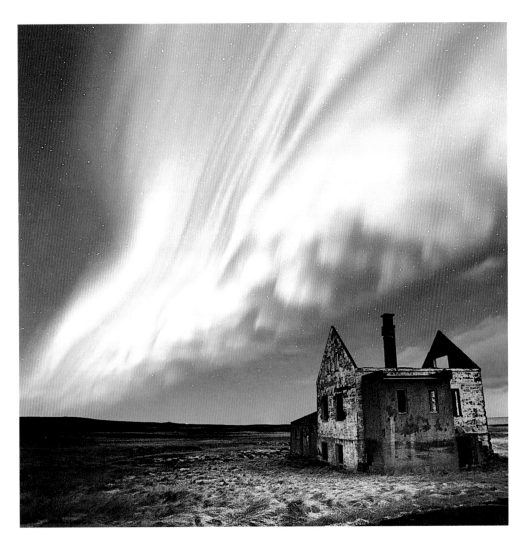

@ARGONAUTPHOTO *A stream of the northern lights flows over an abandoned building in western Iceland.*

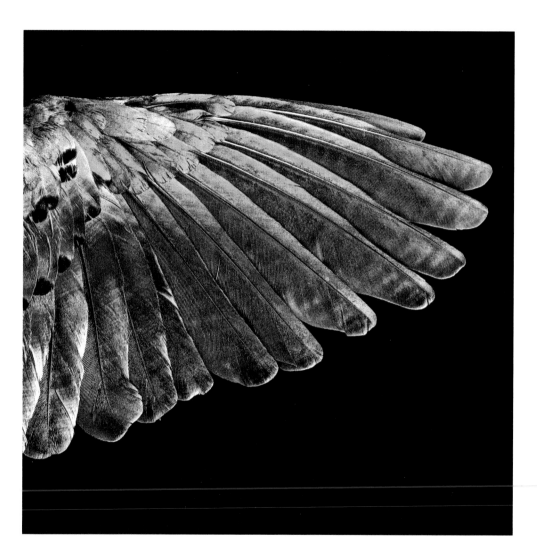

@ROBERTCLARKPHOTO *The wing of a superb starling appears brownish, but in light it shines an iridescent emerald.* 271

♥ **272k+ Likes**

3,377+ comments

marieorama: Great photo of a great woman.

servinghumanity: None of the Pakistanis commenting hate for Malala speak for me. She makes me proud to be a Pakistani. Truly an inspiration for all women

pray_for_peshawar: @servinghumanity She makes me proud to be a Pakistani too.

whitjones1: She shows girls that their voices matter.

@DAVIDCOVENTRY *Malala Yousafzai, pictured at age 17, defied Taliban rule in Pakistan with her calls for girls' education. The youngest Nobel laureate in history, Yousafzai is a dauntless humanitarian and activist.*

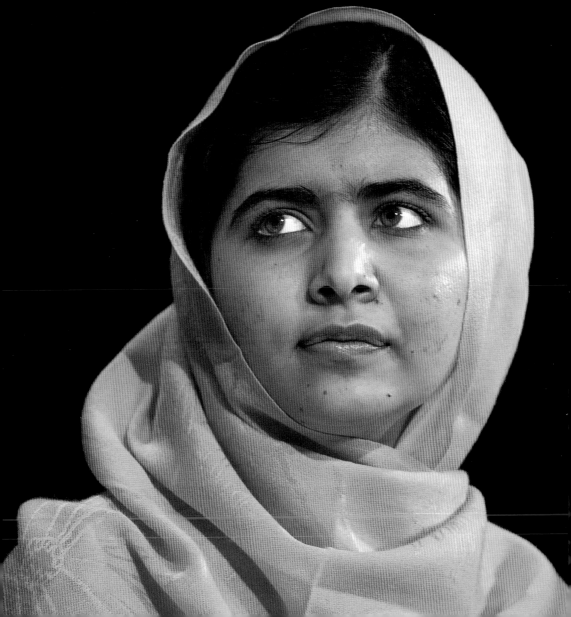

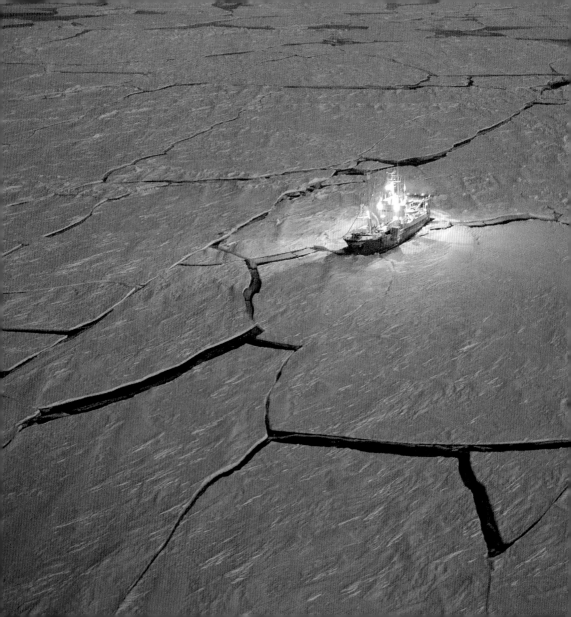

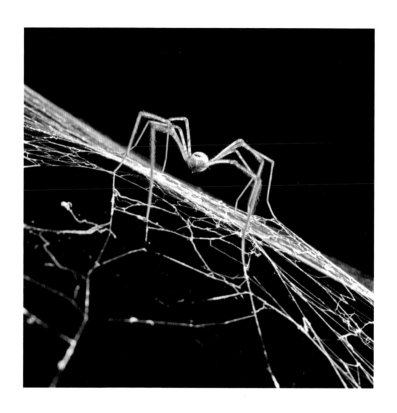

@SHONEPHOTO *A cave-dwelling spider weaves a subterranean web in Malaysia's Deer Cave.*
OPPOSITE: @NICKCOBBING *The Lance research vessel, a floating laboratory, frozen into the Arctic Ocean* 275

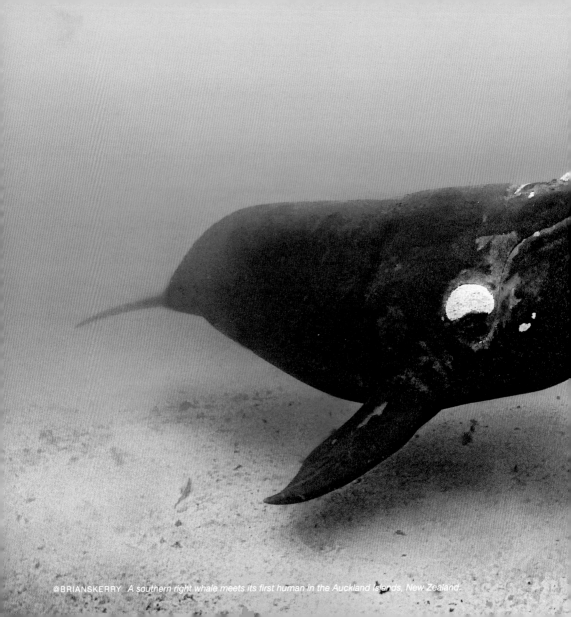

@BRIANSKERRY *A southern right whale meets its first human in the Auckland Islands, New Zealand.*

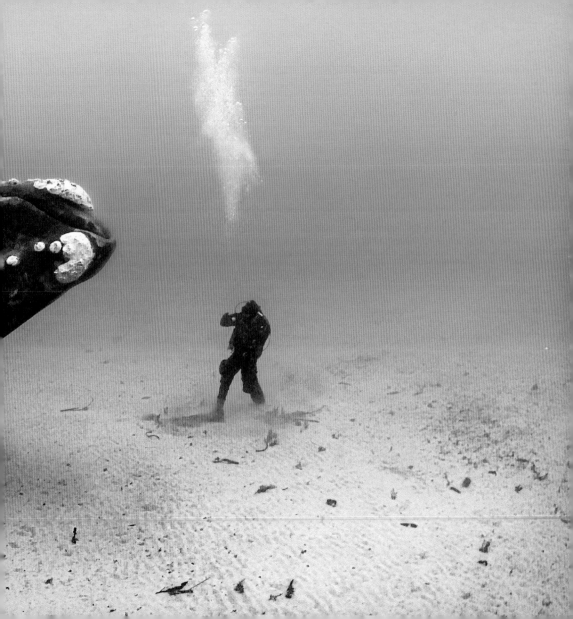

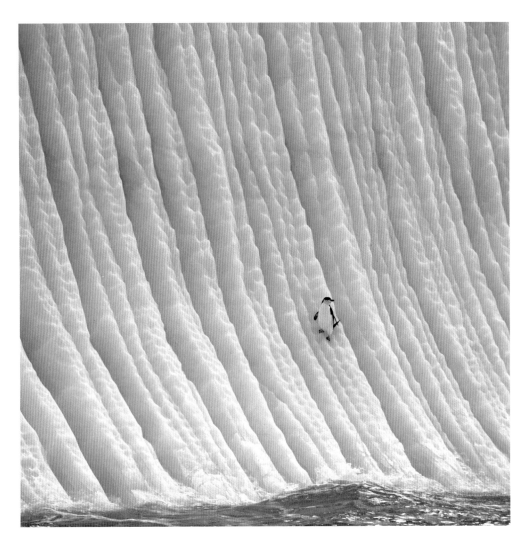

@PAULNICKLEN *A plucky chinstrap penguin skates the grooves of an overturned iceberg.*

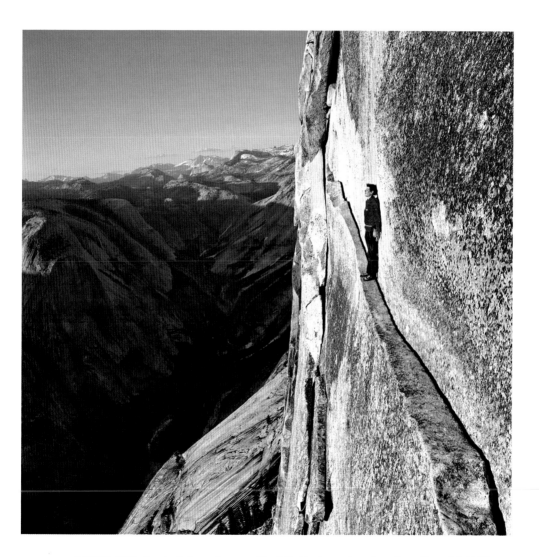

@JIMMY_CHIN *A rock climber walks across Thank God Ledge, a sliver of granite on Yosemite's Half Dome.*

#TBT

Acme News Pictures, Inc. | 1942

What look like satellites are in fact cargo ship cowl vents waiting to be affixed to the prestigious World War II "Liberty fleet." Since the ships were badly needed at the front, the worker is welding the metal together rather than using rivets, cutting construction time in half. The California Shipbuilding Corporation (CalShip) accounted for about half of all cargo ships produced during the war. Hastily erected in 1941 on marshy Terminal Island outside Los Angeles, CalShip operated until war contracts dried up in 1945. By mustering a civilian army of 40,000 employees and implementing shrewd cost-cutting and time-saving measures, the corporation turned out a vessel every 60 days.

♥ **239k+ Likes**

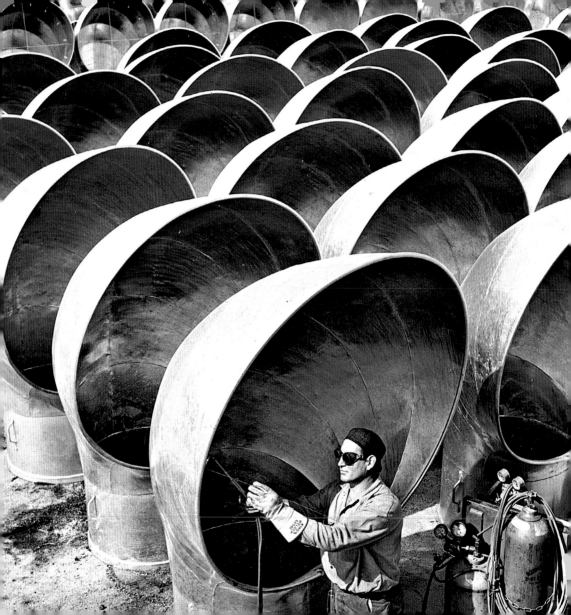

@YAMASHITAPHOTO *In the predawn hours, Singapore rehearses its 50th anniversary celebration while the city sleeps.*

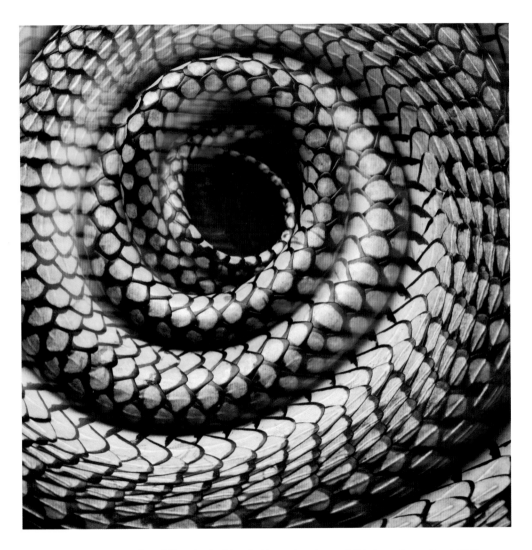

@MATTIASKLUMOFFICIAL *Beautiful but deadly, this coiled boomslang is one of Africa's most venomous snakes.*

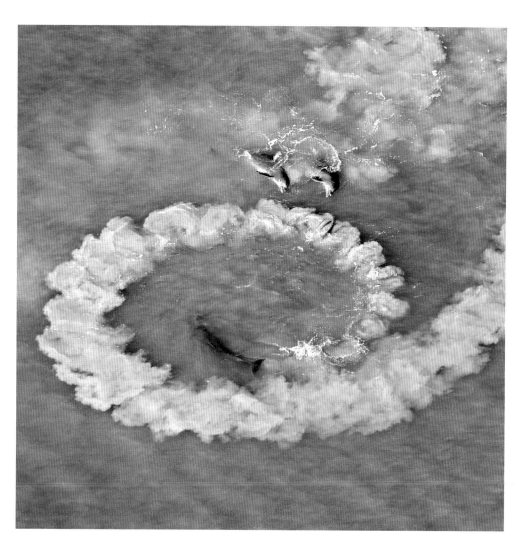

@BRIANSKERRY *A bottlenose dolphin creates a mud ring to drive fish toward its waiting companions.* 285

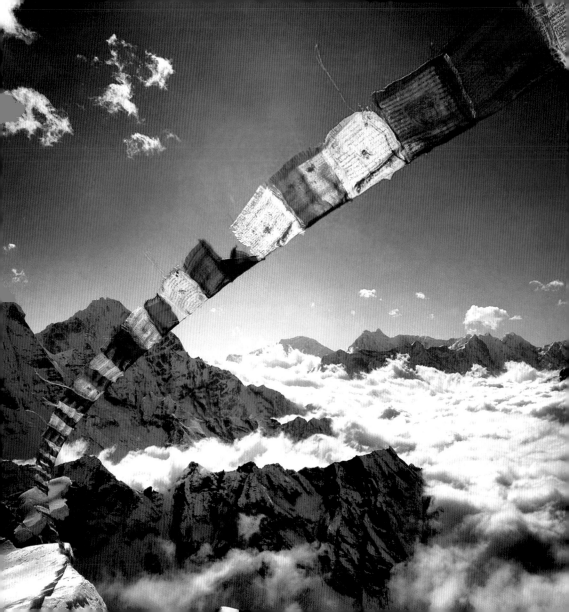

This is how it works sometimes: Phone rings. Photo editor says, "Can you leave for Everest Base Camp tomorrow or the next day?" You, of course, say yes and cancel all other plans. To be honest, I'm a little out of my element on Everest. I'm a rock climber, and I love heights and exposure, but this kind of ice-covered pain was new to me. I happened to arrive just before the Indian cyclone, a tropical storm that triggered blizzards in the Himalaya. Lots of people were stranded, some were killed, and many mountains were deemed unclimbable. The places I was supposed to visit were covered in ten feet (3 m) of dangerous fresh snow. But I knew what shots I needed and where to find them, and so I walked into the belly of this white whale. I caught this magnificent view from Ama Dablam on my last day.

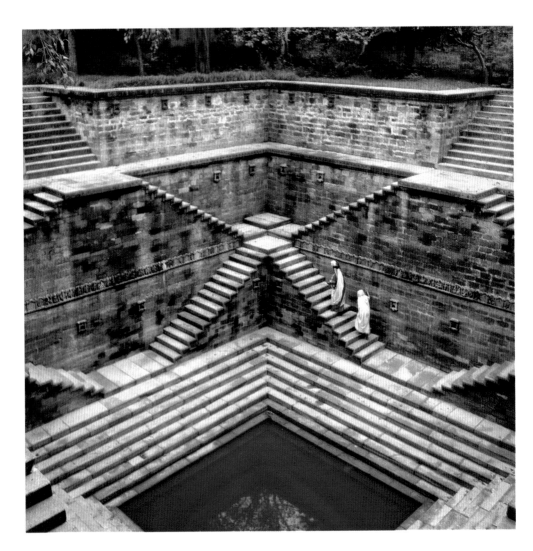

@STEVEMCCURRYOFFICIAL *Stepwells in India are built for water storage but double as beautiful spaces for socializing.*

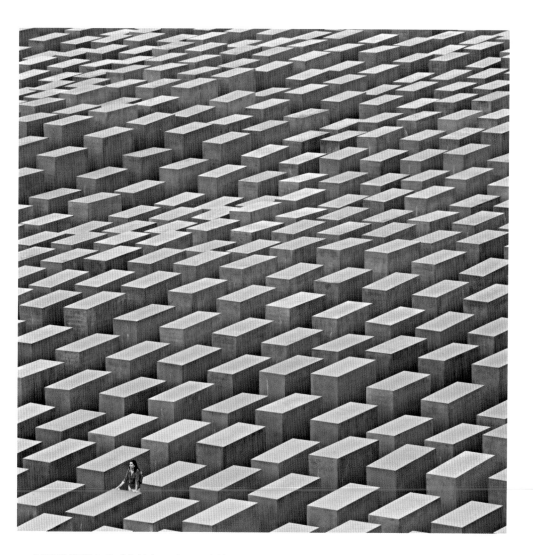

@GERDLUDWIG *Berlin's Holocaust memorial is meant to represent an ordered system that lost touch with humanity.* 289

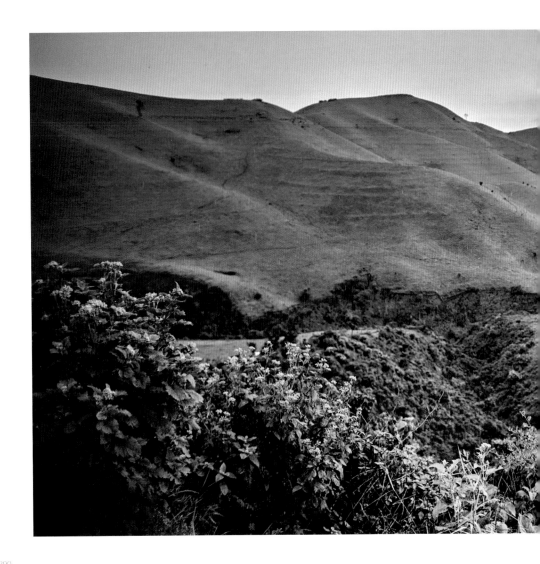

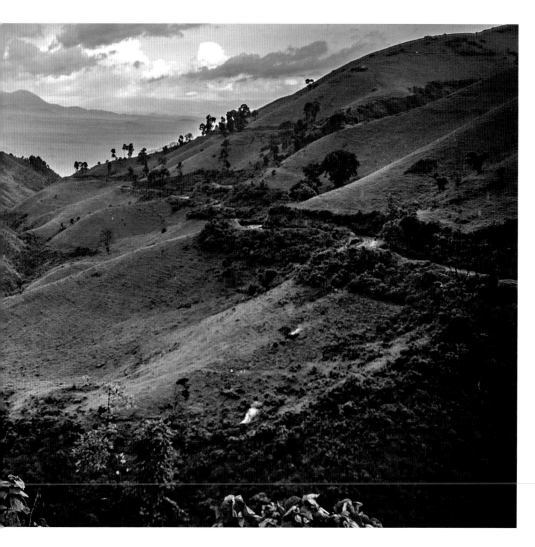

@PETEKMULLER *The lush valleys of the Dem. Rep. of the Congo make for good grazing and renowned artisanal cheese.*

@JOELSARTORE *A brown-throated sloth at the Panamerican Conservation Association in Gamboa, Panama*

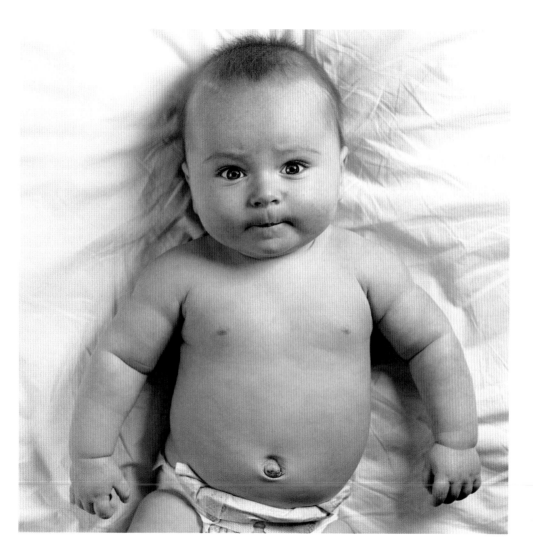

@ROBERTCLARKPHOTO *A diminutive cover model for* National Geographic *magazine's 2013 story on longevity* 293

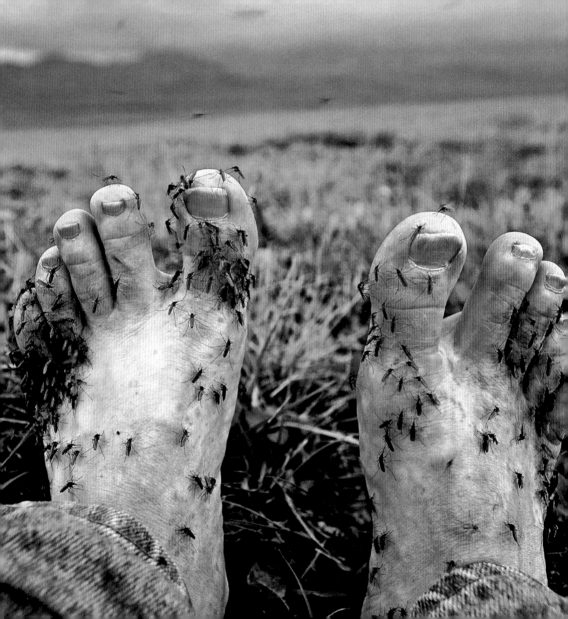

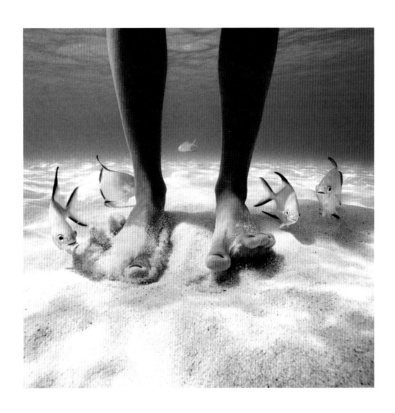

@DAVIDOUBILET *Pompano fish come looking for morsels of food as a swimmer stirs up sand in the Virgin Islands.*
OPPOSITE: @JOELSARTORE *Mosquitoes swarm the photographer's exposed feet on Alaska's North Slope.*

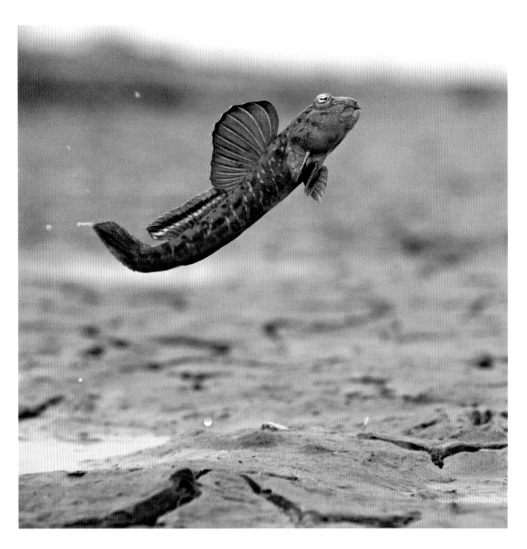

@THOMASPESCHAK *A male mudskipper launches into the air to attract a mate on Kuwait's mudflats.*

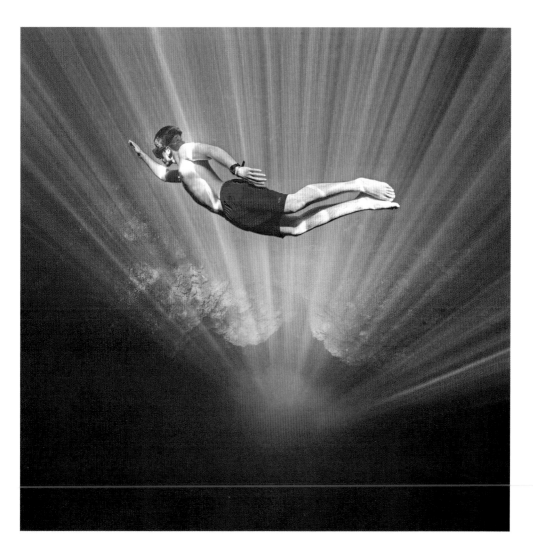

#TBT

Hans Hildenbrand | 1923

Like many street acts, snake charming is an illusion. Snakes don't have external ears and don't hear sounds like humans do. What spectators interpret as dancing is the snake following the swaying motion of the gourd flute or responding to vibrations. Snake charmers once merited much respect for mastering these animals, which were both feared and revered in Indian folklore and religions. The skill was passed from father to son for generations until the government banned pet snakes under the Wildlife Protection Act of 1972. Some handlers defang their snakes, remove their venom pouches, or even sew the snakes' mouths shut, letting them starve. The law proved difficult to enforce because of the cultural significance of the practice and the lack of alternative livelihoods. Today, former snake charmers are recruited to be conservationists. They use their knowledge of the animals and credibility in the community to protect native species.

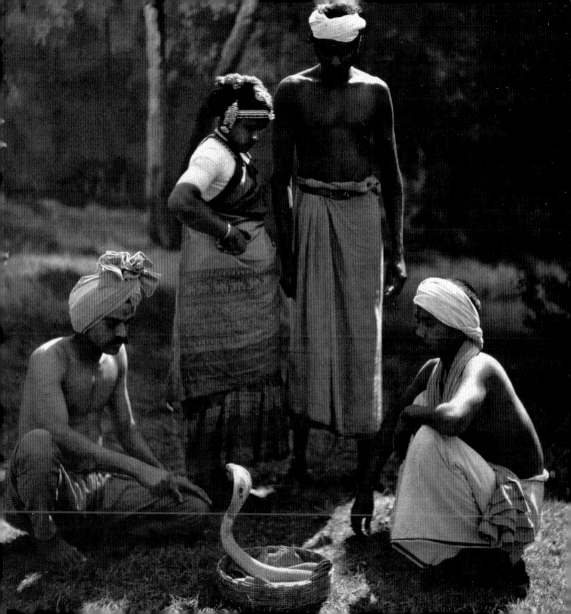

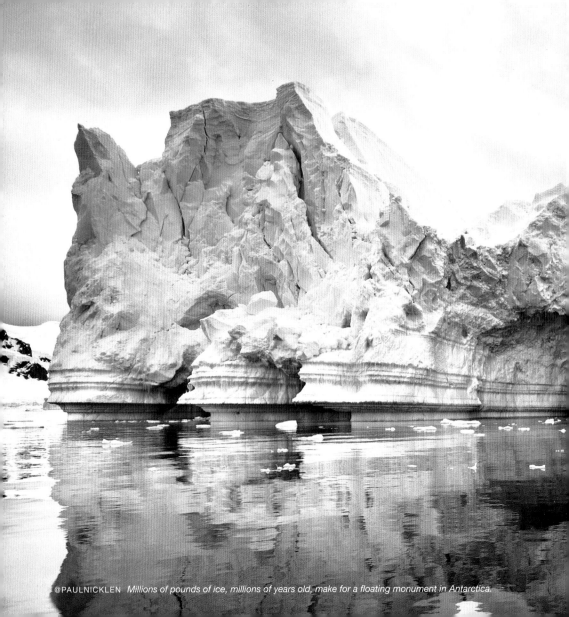

@PAULNICKLEN *Millions of pounds of ice, millions of years old, make for a floating monument in Antarctica.*

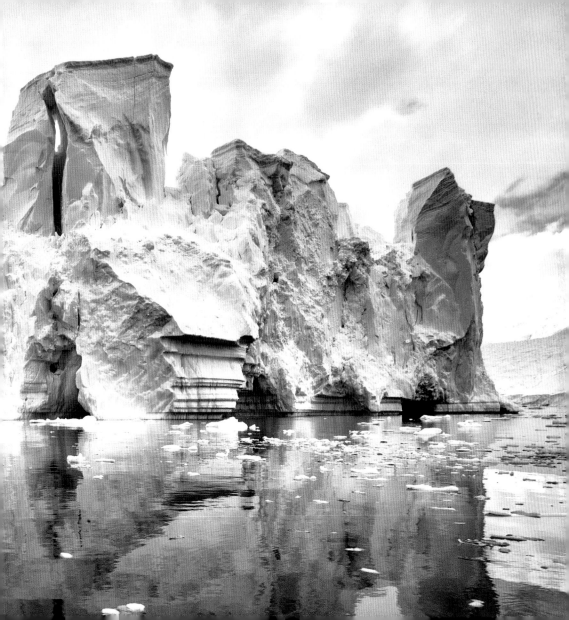

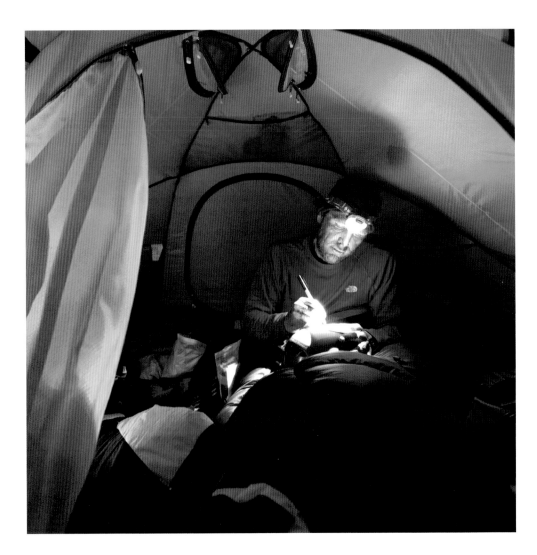

@ANDY_BARDON *On assignment, writer Mark Jenkins improvises a desk with paper, pen, and a headlamp.*

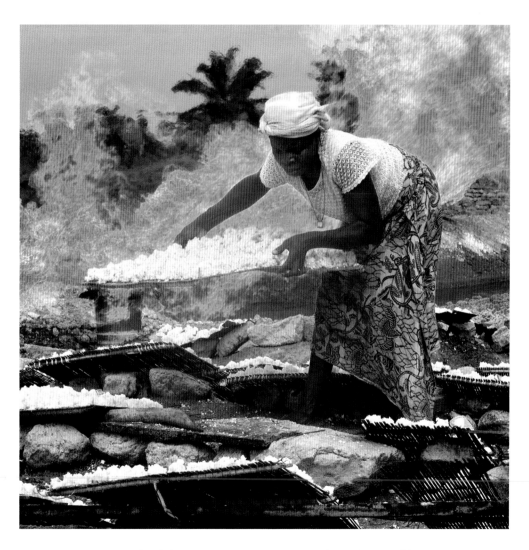

An Urhobo woman bakes tapioca in the heat of a gas flare in an oil field in her Nigerian town.

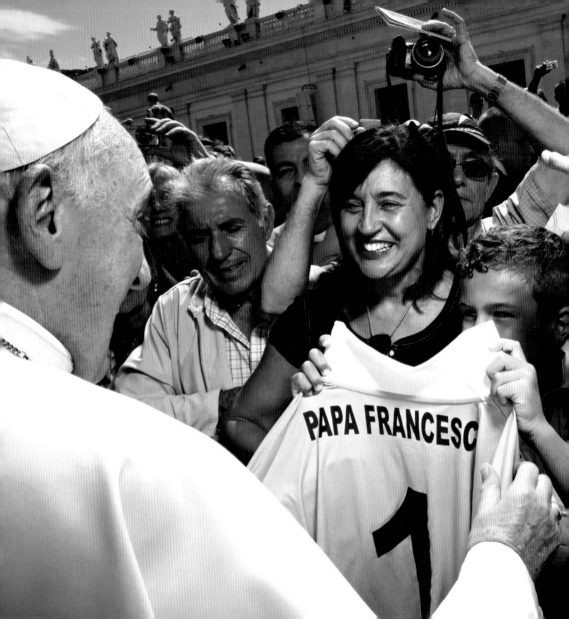

♥**143k+ Likes**
1,536+ comments

mel_goes: This is so sweet!

micagarbi: Papa Francisco genio!

aidanmandude: He is the ray of hope in religion.
We should all focus on the bigger picture.

halseyb: I love how outspoken the pope is on climate change
and how he's making the church more accepting

dj_c_mon: Bless

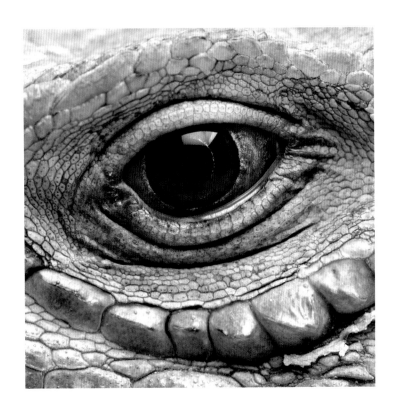

@JOELSARTORE *The Grand Cayman blue iguana is nearly extinct in the wild. This one lives at Sedgwick County Zoo.*
OPPOSITE: @GEOSTEINMETZ *From a helicopter view, Stuyvesant Town in New York City looks like a toy village.*

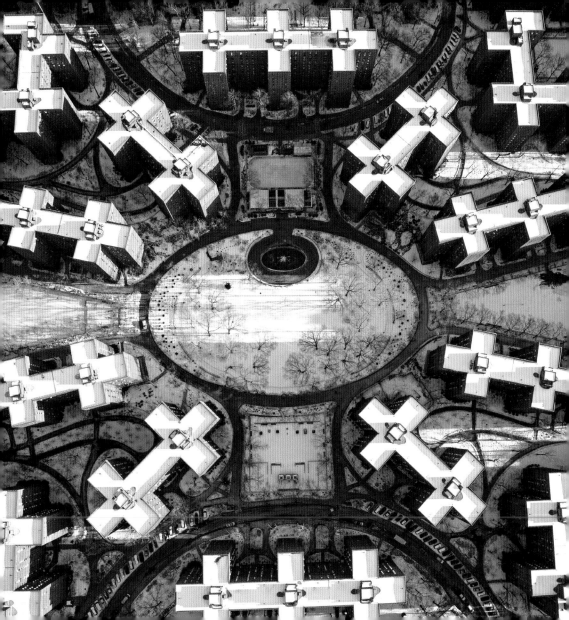

When Wendy Andersen visited the Milwaukee zoo as a child, she marveled at Samson the gorilla. He was a celebrity—earning a Guinness world record for his 652-pound (296 kg) peak weight. The ape's subsequent diet only drew more public fascination. Samson passed away in 1981, long before Andersen became the taxidermist at the Milwaukee Public Museum, so she was tasked with making a replica without using any parts of the actual animal. Her work was unveiled in the 2007 exhibit "Samson Remembered," where the city honored their beloved gentle giant, a resident of Milwaukee for more than 30 years.

@AMIVITALE *Not a two-headed dog, but one puppy sitting behind another on the streets of Angola*

OPPOSITE: @KENGEIGER *A life-size* Spinosaurus *is installed outside National Geographic headquarters*

310

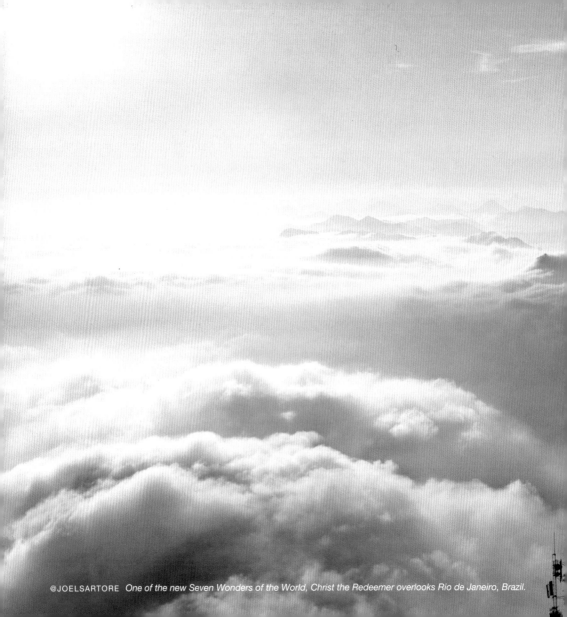

@JOELSARTORE *One of the new Seven Wonders of the World, Christ the Redeemer overlooks Rio de Janeiro, Brazil.*

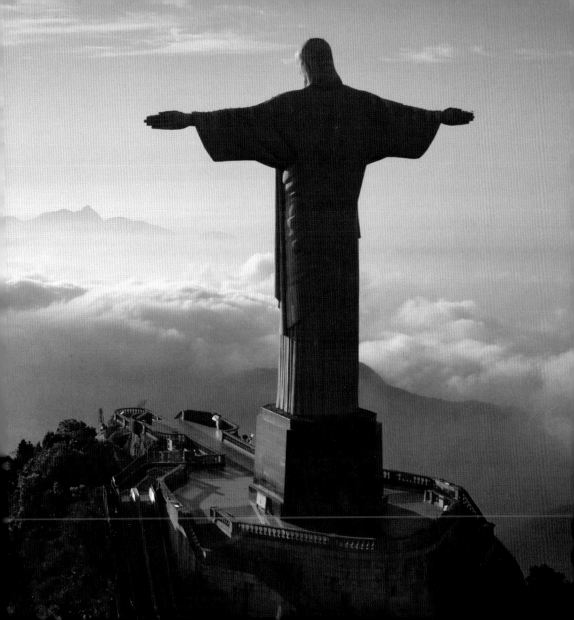

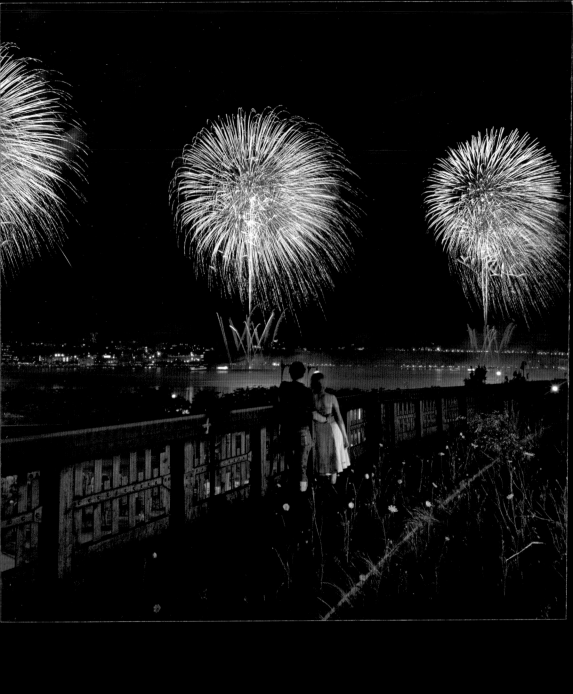

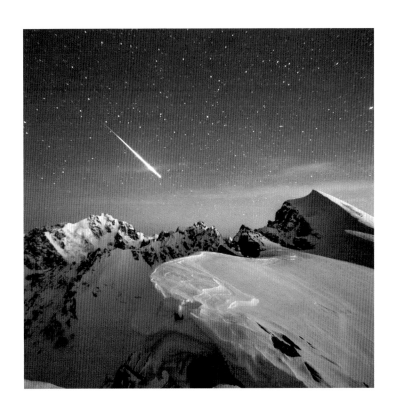

@ANDY_BARDON *The original firework—a shooting star streaks a path above the Tian Shan range in Kazakhstan.*
OPPOSITE: @COOKJENSHEL *Synchronized Fourth of July fireworks over the Hudson River in New York City* 315

@PETEKMULLER

During my assignment in northeastern Democratic Republic of the Congo, I shared a few photos of these hunters dressed in traditional masks and vests. The vests are used for camouflage, while the masks confuse their prey and encourage it to investigate rather than flee—a remarkably effective tactic. While the craftsmanship and purpose of the attire were fascinating and visually captivating, I noticed recurring comments about the frightening or "exotic" nature of the outfits. Concerned by the understandable aversion that some had to the masked portraits, I wanted to share an image of the same hunters unmasked. Here, they stand for a portrait wearing their designated hunting clothes, which are tattered on account of extensive hiking among thorns. Once they return to their homes, they put on different clothes. I had a fascinating experience with these kind and very capable guys. Their ability to navigate and survive in the woods was humbling and unsurpassable.

♥320k+ Likes

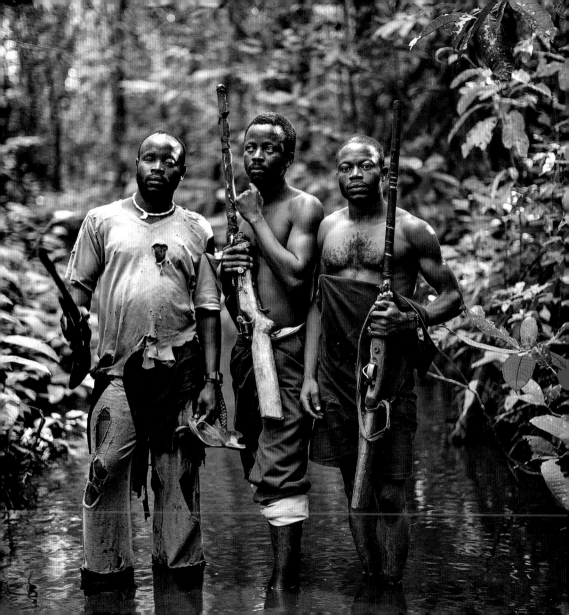

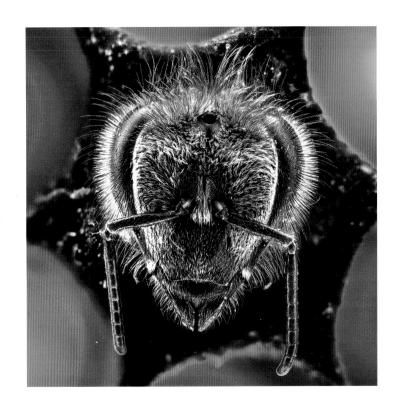

@ANANDAVARMA *A fresh young honeybee halfway emerged from its brood cell*

OPPOSITE: @CIRILJAZBEC *At a community event in Greenland, a man watches an outdoor movie screened on an iceberg.*

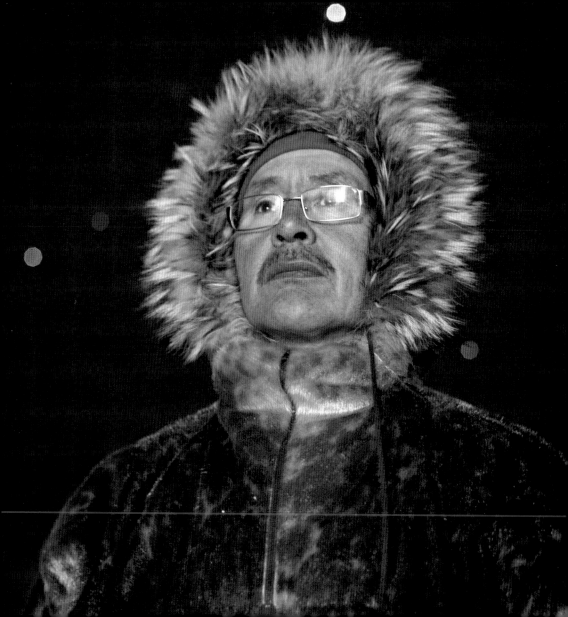

@YAMASHITAPHOTO *A common sight in Sri Lanka, a peacock struts across a tree branch in Yala National Park.*

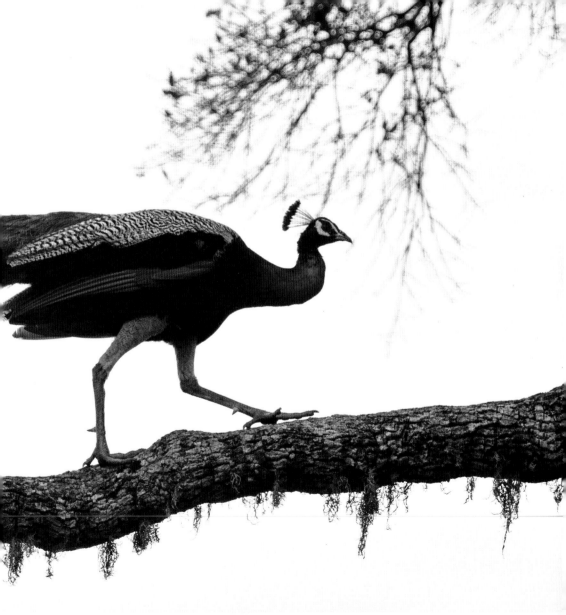

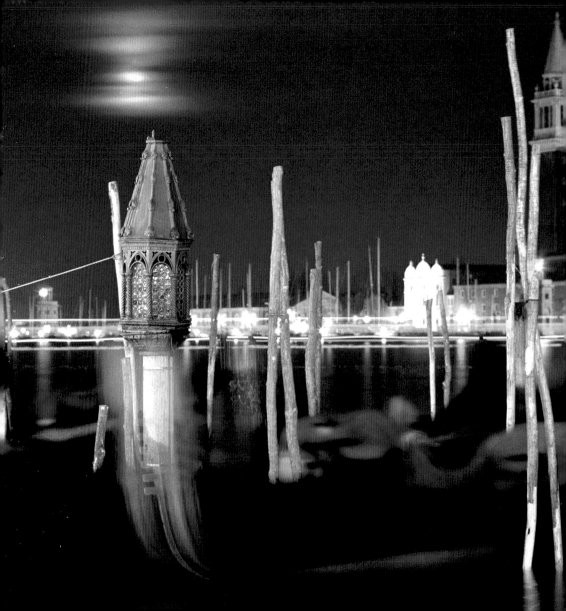

gailyn123: An architectural & artistic masterpiece … that is Venice

juliabremke: Looks like a ghosttown … it's amazing

_lucindan: Wow, looks unreal. I love Venice in winter.

bosshoskins: tell me you see superman flying by lol

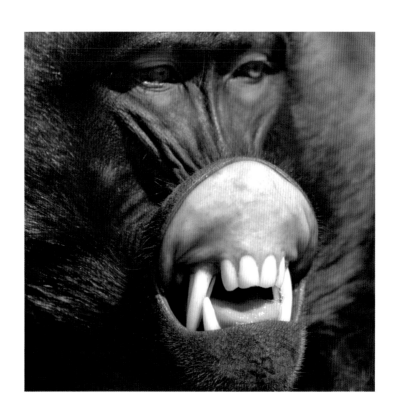

@TBFROST *A male gelada monkey defends his territory with a flash of teeth.*
OPPOSITE: @THOMASPESCHAK *A bohar snapper, a carnivorous fish, shows off its fanglike teeth in the Indian Ocean.*

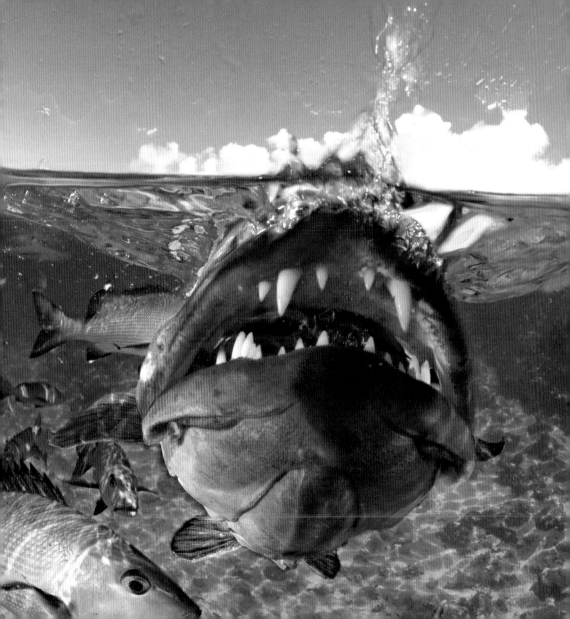

#TBT

Westinghouse Electric Company | 1941

Is it a microphone? A lightbulb? Nope, it's an early generation electric razor: that ingenious invention that ensures a close shave while minimizing the hazard of taking a sharp blade to your face. Historically, humans have used everything from shark teeth, clamshells, iron razors, and knives to remove body hair. The first electric razor, invented by retired army intelligence officer Jacob Schick, went on sale in the United States in the 1930s. It is said that Schick believed a daily shave could lengthen a man's life up to 120 years of age. The razors were so common by 1941 that Westinghouse Electric Company included one in this image demonstrating new x-ray technology. Note how the man's metal accessories—glasses and ring—also appear on the x-ray film.

♥**224k+ Likes**

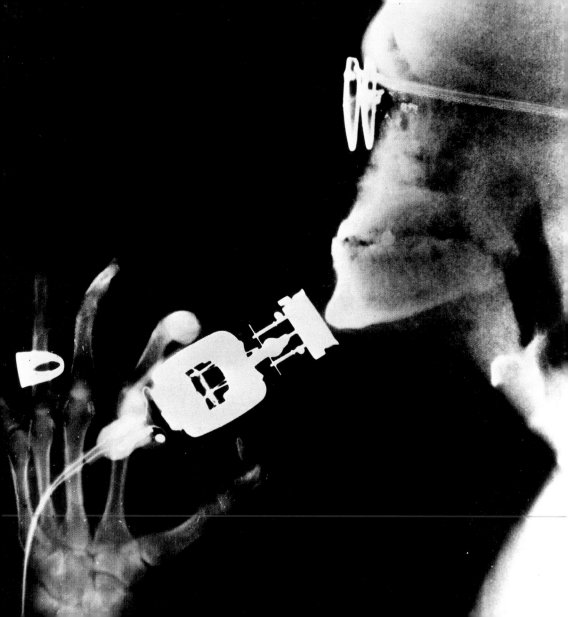

CONTRIBUTORS

JAMES BALOG | @JAMES_BALOG

James Balog has become a global spokesman on climate change and human impact on the environment. An avid mountaineer and geographer, he founded the most extensive photographic survey of melting glaciers. James's project is the central storyline of the award-winning documentary *Chasing Ice*.

ANDY BARDON | @ANDY_BARDON

Andy Bardon is a versatile outdoorsman who spends his days sliding on fresh snow, surfing on crystal blue water, or scaling sheer rock. His photography and films explore the relationship between human beings and the natural world.

IRA BLOCK | @IRABLOCKPHOTO

Ira Block is a classic National Geographic photographer who is a master at capturing landscapes, people, artifacts, and complicated concepts. His technical skills in lighting and composition are superb, but Ira is also able to draw interest and integrity from any subject matter.

MICHAEL CHRISTOPHER BROWN (MAGNUM) | @MICHAELCHRISTOPHERBROWN

Michael Christopher Brown was raised in a farming community in Washington State but found a passion for world travel. He has used traditional cameras as well as iPhone photography to capture the youth scene in Havana, Cuba, the ongoing conflict in the Democratic Republic of the Congo, and a traveling circus in China.

CHIEN-CHI CHANG (MAGNUM) | @CHIEN_CHI_CHANG

The photography of Chien-Chi Chang explores the ties of family and culture as well as the abstract concepts of alienation and connection. Chien-Chi's own experience as an immigrant to the United States from Taiwan has shaped his extensive documentation of Asian immigrants.

JIMMY CHIN | @JIMMY_CHIN

Jimmy Chin, a premier rock climber, is able to carry a camera where few dare to go, capturing endeavors of the world's most extreme athletes while participating in breakthrough expeditions from Yosemite to Oman to Everest. His documentary *Meru* won the Audience Award at the 2015 Sundance Film Festival.

ROBERT CLARK | @ROBERTCLARKPHOTO

Based in New York City, Robert Clark is a freelance photographer known for his innovation. Robert once traveled the United States for 50 days with only a cellphone camera to document its beauty and diversity. He is building an extensive visual study of the science of evolution.

NICK COBBING | @NICKCOBBING

Nick Cobbing is a photographer driven by a curiosity about the natural world and the relationship between humans and the environment. He has worked extensively in the Arctic and Antarctica on the themes of science and climate change and currently lives in Stockholm, Sweden.

DIANE COOK AND LEN JENSHEL | @COOKJENSHEL

Diane Cook and Len Jenshel are two of America's foremost landscape photographers and have interpreted culture and environment for more than 25 years. This husband-and-wife team captures both the beauty and impermanence of landscapes from Greenland's melting glaciers to New York City's boroughs.

DAVID COVENTRY | @DAVIDCOVENTRY

Australian David Coventry is a photographer and filmmaker based in New York City. His skill in the studio can bring timeworn artifacts into sharp relief, offering modern readers a glimpse into ancient times. David's preferred subjects include natural history, landscapes, fashion, and travel.

DAVID DOUBILET | @DAVIDDOUBILET

Acclaimed underwater photographer and conservationist David Doubilet has spent five decades exploring the world's waters. David's images express a tireless effort to create a visual voice for the ocean and share its wonders with people on the surface.

PETER ESSICK | @PETERESSICK

Peter Essick started with National Geographic as a summer intern and launched into a career as an influential photojournalist and nature photographer. Some of his favorite and most rewarding stories show the impact of human development and the enduring power of the land.

MELISSA FARLOW | @MELISSAFARLOW

With a background in newspaper reporting, Melissa Farlow specializes in long-form narrative photography. She has worked extensively in the American West, documenting wild mustangs and wilder ranchers, and road-tripped South America to chronicle life along the Pan-American Highway.

TREVOR BECK FROST | @TBFROST

Explorer and storyteller Trevor Beck Frost is happiest anyplace where "nature is wild, as it should be." An adventurer and a travel guide, Trevor has faced crocodiles in Australia, mapped caves in Gabon, photographed monkeys in Ethiopia, and navigated the vast Sahara.

KEN GEIGER | @KENGEIGER

Pulitzer Prize–winning photographer Ken Geiger is the former deputy director of photography at *National Geographic* magazine. He joined the organization after 24 years of newspaper journalism. Ken helped shape editorial content for both print and digital platforms.

MARCO GROB | @MARCOGROB

Marco Grob is a master portrait photographer who has worked with today's top celebrities and political figures. Marco takes equally stunning portraits of the people he meets while traveling with the United Nations Mine Action Service as a spokesperson and an educator on land mines.

DAVID GUTTENFELDER | @DGUTTENFELDER

David Guttenfelder is a photojournalist who reports on global geopolitics and conservation. Until recently, he spent his entire career living outside his native United States. David has also been an industry leader in smartphone photography and social media reporting.

ORSOLYA HAARBERG | @HAARBERGPHOTO

Along with her partner—and husband—Erlend, Orsolya Haarberg specializes in photographing the natural beauty of Nordic countries. They look for the unexpected moment when light adds atmosphere, drama, or magic to a landscape, or when an animal is peacefully undisturbed by their presence.

ROBIN HAMMOND | @HAMMOND_ROBIN

Robin Hammond documents human rights and development issues around the world. He works on long-term projects in difficult conditions and on undercover investigations to authentically illustrate incidents of oppression, exploitation, discrimination, and violence.

DAVID ALAN HARVEY (MAGNUM) | @DAVIDALANHARVEY

David Alan Harvey was born in 1944 and bought his first camera with savings from his paper route. Trained as a journalist, David covers a range of topics, including extensive work in Cuba. Intent on mentoring emerging photographers, he founded *Burn* magazine and teaches workshops.

MIKE HETTWER | @MIKE_HETTWER

Mike Hettwer is a photojournalist specializing in archaeology and dinosaur expeditions as well as unique geo-cultural stories around the world. His travels have taken him to 70 countries since 2000. Mike is also a serial entrepreneur who has started and built six tech companies.

TOMAS VAN HOUTRYVE (VII PHOTO) | @TOMASVH

A photojournalist with a background in philosophy, Tomas van Houtryve specializes in contemporary issues and critical examinations of power. He reported on Guantánamo detainees for the Associated Press, published a book on life in communist countries, and is an innovator of drone photography.

AARON HUEY | @ARGONAUTPHOTO

Aaron Huey is widely known for his solo trek across the United States and his coverage of the Pine Ridge Reservation. He travels the world documenting unique cultures and characters. Follow his young son, Hawkeye, seen in this book, on Instagram (@hawkeyehuey).

CHARLIE HAMILTON JAMES | @CHAMILTONJAMES

Charlie Hamilton James is a Britain-based photographer and filmmaker who specializes in natural history and wildlife subjects. His zeal for conservation led him to spend more than two decades exploring Peru's Amazonian rain forest and becoming immersed in the local culture.

CIRIL JAZBEC | @CIRILJAZBEC

Slovenian photographer Ciril Jazbec is repeatedly drawn to stories of climate change for his long-term documentary photography. Whether shooting on Greenland's thin ice or on sinking islands in the South Pacific, he captures the personal impact of changing landscapes and disappearing cultures.

BEVERLY JOUBERT | @BEVERLYJOUBERT

Beverly Joubert is a National Geographic explorer-in-residence, filmmaker, photographer, and co-founder of the Big Cats Initiative.

Together with her husband, Dereck, she has been documenting the plight of African wildlife for more than 30 years.

JR | @JR

JR is an elusive street artist who exhibits his work uninvited and for free on the streets of the world. His trademark portrait photographs raise questions about identity, power, and politics. When he won the TED Prize, JR initiated a participatory art movement dubbed the Inside Out project.

ED KASHI (VII PHOTO) | @EDKASHI

Ed Kashi's work has been recognized for its compelling rendering of the human condition. A sensitive eye and an intimate relationship to his subjects are the signatures of his work. In addition to his own filmmaking and assignments, Ed is an educator who mentors students of photography.

IVAN KASHINSKY | @IVANKPHOTO

Ivan Kashinsky is a documentary photographer who has worked extensively in Latin America. Much of his work has focused on the impacts of globalization and consumerism on people and the environment. His artistic and eye-catching images draw attention to these marginalized stories.

MATTIAS KLUM | @MATTIASKLUMOFFICIAL

Swede Mattias Klum has risen to the status of international superstar in the fields of nature photography and activism. After experiencing the secret lives of plants and animals on the most intimate level, Klum became an avid environmentalist, using art as a tool to effect change.

KEITH LADZINSKI | @LADZINSKI

Keith Ladzinski is a highly recognized adventure and nature photographer and filmmaker. Life behind the camera lens has taken Keith across all seven continents. His images capture the spirit of extreme athletes and views of Earth's most extraordinary landscapes.

TIM LAMAN | @TIMLAMAN

Tim Laman is a field biologist, wildlife photographer, and filmmaker, on top of holding a Ph.D. in ornithology from Harvard University. By doggedly tracking birds and orangutans through the tropics, Tim gained a reputation for getting images of nearly impossible-to-capture subjects.

FRANS LANTING | @FRANSLANTING

Frans Lanting's photographs often hold meaning that goes beyond the initial visual beauty. He is a world-renowned wildlife and landscape photographer, speaker, and creative collaborator. His artistic partners have included an aboriginal painter and composer Philip Glass.

MARK LEONG | @MARKLEONGPHOTOGRAPHY

Mark Leong is fifth-generation American Chinese. His family immigrated to California more than 100 years ago. Mark has decided to make his home in Beijing and uses his camera to document Asian culture, development, nature, and wildlife.

LUCA LOCATELLI | @LUCALOCATELLIPHOTO

Milan-based visual artist Luca Locatelli began his career in IT and communications, and as a result, his work often studies the relationship between humans and technology. He experiments with multimedia storytelling and nontraditional ways of reaching an audience.

GERD LUDWIG | @GERDLUDWIG

German-born Gerd Ludwig is one of the foremost photographers covering Eastern Europe. His long-term projects have focused on the reunification of Germany, cultural shifts in the former Soviet Union, and coverage of the Chernobyl nuclear disaster that brought him deep into the contaminated zone.

PETE MCBRIDE | @PEDROMCBRIDE

A self-taught photographer, writer, and filmmaker, Pete McBride is a devoted conservationist with an ability to make the personal universal. He has documented rivers around the world, navigating two of the mightiest from source to sea: the Ganges and his local river, the Colorado.

STEVE MCCURRY (MAGNUM) | @STEVEMCCURRYOFFICIAL

Steve McCurry, recognized universally as one of today's finest image makers, is best known for his evocative color photography. In the best documentary tradition, Steve captures the essence of human struggle and joy. He often works in regions tormented by conflict and war.

JOE MCNALLY | @JOEMCNALLYPHOTO

A seasoned photojournalist, Joe McNally is known for being incredibly versatile and excelling in any assignment. His career has spanned 35 years and 60 countries. Joe's searing portraits of 9/11 first responders became the exhibit "Faces of Ground Zero," seen by almost a million people.

PETE K. MULLER | @PETEKMULLER

Pete K. Muller is a fearless photojournalist whose intimate, sensitive photographs depict the individual consequences of war, poverty, and social unrest. Weaving together images, audio, video, and text, he invokes personal stories to illustrate broader issues in historical and political context.

IAN NICHOLS | @FNORDFOTO

Ian Nichols is a wildlife photographer whose work has focused on great apes. A trained biologist, he mixes photography with research. Mentored by his father, National Geographic photographer Michael Nichols, Ian is now emerging with his own developed body of work and aesthetic vision.

PAUL NICKLEN | @PAULNICKLEN

A Canadian-born polar specialist and marine biologist, Paul Nicklen spent his childhood among the Inuit people, who taught him to survive in icy ecosystems. Much of his work focuses on polar wildlife and climate change. Paul founded conservation organization SeaLegacy to turn his art into action.

RANDY OLSON | @RANDYOLSON

A master at telling deeply human stories, Randy Olson is a photojournalist whose beat covers the whole world. He celebrates the diversity of humankind while documenting threats to cultures, resources, and the natural world. Randy has completed more than 30 projects for National Geographic.

KATIE ORLINSKY | @KATIEORLINSKY

Katie Orlinsky is a photographer and cinematographer from New York City. Her body of work is inspired by a long-held interest in international politics and a desire to raise awareness of social issues. She shoots for independent projects, magazines, and nonprofit campaigns.

MATTHIEU PALEY | @PALEYPHOTO

French-born photographer Matthieu Paley explores themes of remoteness and isolation. To understand life at the ends of the Earth, Matthieu has lived with Mongolian nomads and walked the savanna with indigenous Hadza, and he was one of the first Westerners to reach the Afghan Pamir Mountains.

THOMAS P. PESCHAK | @THOMASPESCHAK

Originally trained as a marine biologist, Thomas P. Peschak retired from science to become an environmental photojournalist after realizing that he could have a greater conservation impact with photographs than with statistics. His stories take readers into underwater worlds.

COREY RICH | @COREYRICHPRODUCTIONS

Creativity, athleticism, and a burning desire for exploration led Corey Rich to a world-class career as an adventure sports photographer. He has shot ultramarathon racing in the Sahara, freight-train hopping in the American West, and underwater cave exploration in Mexico.

CORY RICHARDS | @CORYRICHARDS

Cory Richards's camera has taken him to extreme locations in an attempt to capture not only their beauty but also the soul of exploration and the adventurer lifestyle. Cory is a passionate mountain climber and has carved a niche as a premier adventure and expedition photographer.

JIM RICHARDSON | @JIMRICHARDSONNG

Jim Richardson is a photographer, writer, speaker, teacher, and champion of unsung people, places, and issues. His stories mirror these concerns, documenting the essentials of a healthy planet, neglected landscapes, and the lives of uncelebrated peoples, small towns, and wee islands.

JOE RIIS | @JOERIIS

Wildlife photojournalist Joe Riis approaches his work as a trained biologist and core conservationist, believing that photographs can give wild animals and places a voice in our culture. Joe lives in a cabin he built on the South Dakota prairie where his ancestors homesteaded.

DREW RUSH | @DREWTRUSH

Before embarking on a career in photography, Drew Rush spent ten years as a wilderness guide in Yellowstone National Park. As he tracks wildlife around the world, Drew is always seeking a new perspective, whether that means using remote cameras or flying high in a powered paraglider.

JOEL SARTORE | @JOELSARTORE

Joel Sartore is a versatile photographer and conservationist who documents a world worth saving. His much loved animal portraits come from the Photo Ark, a multiyear mission to document species threatened with extinction. Joel's hallmarks are a sense of humor and a Midwestern work ethic.

SHAUL SCHWARZ | @SHAULSCHWARZ

Shaul Schwarz started his career in the Israeli Air Force and covered news in Israel and the West Bank before relocating to New York. He continues to cover civil unrest, dodging bullets to capture footage of a Haitian uprising, Kenyan riots, and narco-culture in Juárez, Mexico.

ROBBIE SHONE | @SHONEPHOTO

A caver and visual storyteller, Robbie Shone is recognized as one of the most accomplished cave photographers in the world. Through skilled lighting and composition he reveals the deepest, largest, and longest cave systems known. Robbie is based in Austria in the heart of the Alps.

STEPHANIE SINCLAIR | @STEPHSINCLAIRPIX

Based in Brooklyn, Stephanie Sinclair is known for gaining unique access to the most sensitive gender issues, particularly through the Too Young to Wed project. She has produced in-depth reporting on human rights in the Middle East, using her work to inspire social justice and intercultural exchange.

BRIAN SKERRY | @BRIANSKERRY

A specialist in marine wildlife, Brian Skerry has spent more than 10,000 hours underwater over the past 30 years. His creative images tell stories that not only celebrate the mystery and beauty of the sea but also help bring attention to the many issues that endanger our oceans.

JOHN STANMEYER | @JOHNSTANMEYER

John Stanmeyer is a photographer and filmmaker who uses his camera to tell the story of humanity at a crossroads. Through visual storytelling, John aims to distill the complex issues that define our times and present them in poetic and understandable narratives.

GEORGE STEINMETZ | @GEOSTEINMETZ

Best known for his exploration and science photography, George Steinmetz sets out to reveal the few remaining secrets in our world today: remote deserts, obscure cultures, and new developments in science. His innovative aerial shots are captured using drone and paragliding technology.

LAURA EL-TANTAWY | @LAURA_ELTANTAWY

Laura El-Tantawy is an Egyptian photographer who grew up in Egypt, Saudi Arabia, and the United States. She began her career in news-gathering and now focuses on fine art photography inspired by questions on her identity, exploring social and environmental issues pertaining to her background.

MARK THIESSEN | @THIESSENPHOTO

Mark Thiessen has been a photographer with National Geographic since 1990 and on staff since 1997. Mark has documented wildland firefighters in a decade-long project that takes him to the front lines of wildfires every summer. He is also a certified wildland firefighter.

TYRONE TURNER | @TYRONEFOTO

Tyrone Turner's work has focused on social and environmental issues such as health care and youth incarceration. On assignments from Brazil to Baghdad to the bayous of Louisiana, Tyrone puts himself in the center of the action, capturing the one fleeting moment that makes a stunning photograph.

STEFANO UNTERTHINER | @STEFANOUNTERTHINER

Stefano Unterthiner took up photography as a hobby while growing up in a village in Italy. After earning a Ph.D. in zoology, he launched a career as an environmental journalist. Stefano tells the life stories of animals, often living in close contact with his chosen species for long periods.

ANAND VARMA | @ANANDAVARMA

Anand Varma's photographs tell the story behind the science of complex issues. Anand worked on a variety of field projects while pursuing a degree in integrative biology and now uses photography to help biologists communicate their research.

AMI VITALE | @AMIVITALE

Ami Vitale, best known for her international news and cultural docu-mentation, has been praised as a humane and empathetic storyteller. Ami's wildlife assignments include Kenya's last rhinos, rescued pandas, and man-eating lions. She has traveled to more than 90 countries.

STEPHEN WILKES | @STEPHENWILKES

Stephen Wilkes's defining project is "Day to Night": epic cityscapes and landscapes recorded from a fixed camera angle for up to 30 hours. Blending these images into a single photograph takes months to complete. Stephen has worked in photojournalism and film and is based in New York City.

STEVE WINTER | @STEVEWINTERPHOTO

Steve Winter is a conservation photojournalist and an expert in big cats. He once spent six months sleeping in a tent at minus 40°F (-40°C) to track snow leopards. Steve feels a great responsibility to not only show and excite readers about his subjects but also give them a reason to care.

MICHAEL S. YAMASHITA | @YAMASHITAPHOTO

Michael S. Yamashita, a third-generation Japanese American, is a landscape and location photographer and filmmaker with extensive expertise in Asian cultures. He has specialized in retracing the paths of famous travelers including Marco Polo and the Chinese explorer Zheng He.

DAVE YODER | @DAVEYODER

American-born photojournalist Dave Yoder grew up at the foot of Kilimanjaro in Tanzania and now chases human-interest projects from his base in Milan, Italy. Recent assignments have taken him on a search for a lost Leonardo da Vinci masterpiece and inside Pope Francis's Vatican.

GUEST CONTRIBUTORS:
STEVEN BENJAMIN | @ANIMAL_OCEAN

Steven Benjamin is a zoologist and an expert in ocean wildlife who leads marine photographic expeditions in Cape Town, South Africa. Steven aims to meet as many interesting aquatic creatures as he can and to capture the experience of the marine world on camera.

SHEIKH HAMDAN BIN MOHAMMED BIN RASHID AL MAKTOUM | @FAZ3

The crown prince of Dubai serves as the vice president and prime minister of the United Arab Emirates, a prosperous nation in the Middle East. This personable royal enjoys photography, horse racing, writing poetry, family time, and sharing updates with his 3.4 million Instagram followers.

MYRMARA PROPHÈTE

Fourteen-year-old Myrmara Prophète enrolled in a workshop offered by FotoKonbit, a Haitian-run, U.S.-based nonprofit that teaches photography. The student's work, published by National Geographic, captures the soul and beauty of Haiti, often omitted in the images of disaster in foreign press.

FROM THE ARCHIVE:
THOMAS J. ABERCROMBIE

Thomas J. Abercrombie joined National Geographic in 1955 and was shortly promoted to its foreign editorial staff. During his 38 years on staff, he became the first correspondent to the South Pole, charted caravan routes in North Africa, and discovered a massive meteorite in the Arabian Desert.

DAVID S. BOYER

Experienced reporter David S. Boyer joined National Geographic in 1952. He was a writer and photographer for the magazine for 37 years, specializing in national parks and wilderness areas. His famed, poignant image of young John F. Kennedy Jr. saluting his slain father won numerous awards.

HANS HILDENBRAND

Hans Hildenbrand was one of 19 German photographers employed by the Kaiser to document World War I on the front lines, and the only one to shoot in color. After the war, he continued to document Europe in color and was published by *National Geographic* magazine.

W. ROBERT MOORE

As chief of the foreign editorial staff at National Geographic, photographer W. Robert Moore had a hand in nearly 90 magazine articles. In 1937, he shot the first Kodachrome photographs (action color photography on 35mm film) to be published in the magazine. He retired in 1967.

ROLAND W. REED

Photography pioneer Roland W. Reed lived from 1864 to 1934. He had a passion for photographing Native Americans, who were gradually being wiped out. In keeping with the "pictorialist" practice of the time, most of his scenes were staged ethnographic displays meant as a historical record.

J. BAYLOR ROBERTS

Mild-mannered and self-effacing, J. Baylor Roberts was nevertheless one of the most dependable National Geographic staff photographers, prepared for assignments anywhere and on anything. He contributed to nearly 60 stories between 1936 and 1967.

ROBERT SISSON

An expert naturalist with inconceivable patience, writer-photographer Robert Sisson favored the small things in life. He would haul bulky camera gear into the wild in search of a singular flower or insect. A fiend for accuracy, he typically spent a year and a half on a single story.

B. ANTHONY STEWART

B. Anthony Stewart never considered himself an artist, but his work epitomizes the early days of documentary photography. His images of the American West and life during the Great Depression are iconic historical records. He was on the National Geographic staff from 1927 to 1969.

COVER CREDITS

FRONT COVER:

(UP LE), @JOELSARTORE Joel Sartore/National Geographic Creative; (UP CT), @ANDY_BARDON Andy Bardon/National Geographic Creative; (UP RT), @PAULNICKLEN Paul Nicklen; (MID LE), @DGUTTENFELDER David Guttenfelder; (MID CT), @STEVEWINTERPHOTO Steve Winter; (MID RT), @JIMMY CHIN Jimmy Chin; (LO LE), @FNORDFOTO Ian Nichols/National Geographic Creative; (LO CT), @IRABLOCKPHOTO Ira Block/National Geographic Creative; (LO RT), @DAVIDDOUBILET David Doubilet/National Geographic Creative.

BACK COVER:

(UP LE), @AMIVITALE Ami Vitale; (UP CT), @PAULNICKLEN Paul Nicklen/National Geographic Creative; (UP RT), @PAULNICKLEN Paul Nicklen; (MID LE), @AMIVITALE Ami Vitale; (MID CT), @ROBERTCLARKPHOTO Robert Clark; (MID RT), @JIMMY_CHIN Jimmy Chin; (LO LE), @DAVIDALANHARVEY David Alan Harvey/National Geographic Creative; (LO CT), @THOMASPESCHAK Thomas P. Peschak; (LO RT), @STEVEMCCURRYOFFICIAL Steve McCurry/Magnum.

ACKNOWLEDGMENTS

We would like to acknowledge those who worked to make this book a reality:
Declan Moore, Kevin Systrom, Liz Bourgeois, Cory Richards, Ken Geiger, Rajiv Mody, Lisa Thomas, Bridget E. Hamilton, Melissa Farris, Laura Lakeway, Moriah Petty, Patrick Bagley, Michael O'Connor, Nicole Miller, Meredith Wilcox, Chris Brown, and Andrew Jaecks.

Since 1888, the National Geographic Society has funded more than 12,000 research, exploration, and preservation projects around the world. National Geographic Partners distributes a portion of the funds it receives from your purchase to National Geographic Society to support programs including the conservation of animals and their habitats.

National Geographic Partners
1145 17th Street NW
Washington, DC 20036-4688 USA

Become a member of National Geographic and activate your benefits today at natgeo.com/jointoday.

For information about special discounts for bulk purchases,
please contact National Geographic Books Special Sales: specialsales@natgeo.com

For rights or permissions inquiries, please contact
National Geographic Books Subsidiary Rights: bookrights@natgeo.com

Definitions of chapter titles from Merriam-Webster's unabridged dictionary (unabridged.merriam-webster.com)

Library of Congress Cataloging-in-Publication Data

Names: Systrom, Kevin, 1983- writer of supplementary textual content. | National Geographic Society (U.S.)
Title: @NatGeo : the most popular Instagram photos / foreword by Kevin Systrom.
Other titles: At Nat Geo | Most popular Instagram photos
Description: Washington, D.C. : National Geographic, [2016]
Identifiers: LCCN 2016015917 | ISBN 9781426217104 (hardcover : alk. paper)
Subjects: LCSH: Photography, Artistic. | Photography--Digital techniques. |
Instagram (Firm) | National Geographic Society (U.S.)--Photograph collections.
Classification: LCC TR655 .N377 2016 | DDC 779--dc23
LC record available at https://urldefense.proofpoint.com/v2/url?u=https-3A__lccn.loc.gov_2016015917&d=CwIFAg&c=uw6TLu4h-whHdiGJOgwcWD4AjKQx6zvFcGEsbfiY9-El&r=5tkZtwhQ_OZM4AY3_OlYonuadShIJ0uA9xxRIR0Erks&m=Z3oqVMcnra7Scypz0R-WS1NAehjwibxP03S_9WI8f4AU&s=4q7euyYUp5ByAf1dBzm0ka3aEiX5ynjz468gcvdx5eU&e=

ISBN: 978-1-4262-1710-4

Printed in China

16/PPS/1

Make EVERY SHOT Count

NATIONAL GEOGRAPHIC

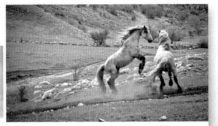

Getting Your Shot

STUNNING PHOTOS, HOW-TO TIPS,
AND ENDLESS INSPIRATION FROM THE PROS

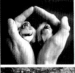

Illustrated with beautiful images from **Your** Shot, National Geographic's photo community

17
YOUR SHOT ASSIGNMENTS

22
NATIONAL GEOGRAPHIC
EXPERTS

200+
STUNNING PHOTOS

NATIONAL GEOGRAPHIC

AVAILABLE WHEREVER BOOKS ARE SOLD
and at nationalgeographic.com/books
 NatGeoBooks @NatGeoBooks